# Ken Danby

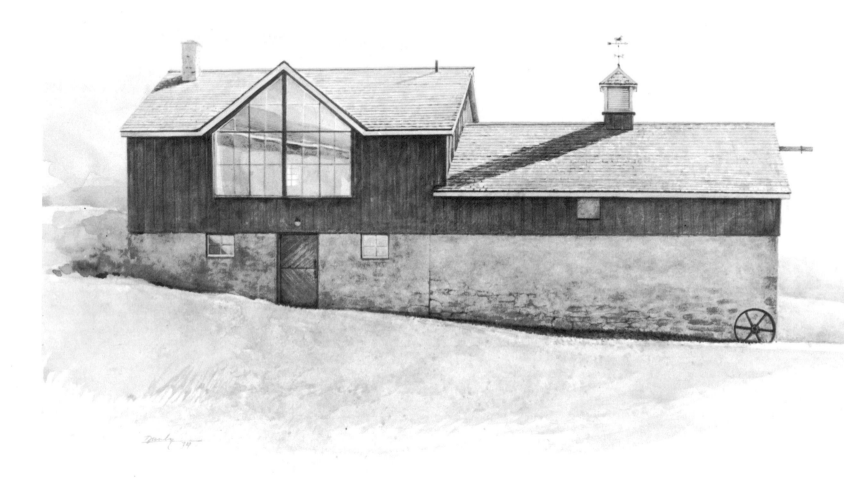

*The artist's studio*; 1974 Dry brush 13 x 21¹/₂; Gallery Moos, Toronto, Ontario.

# Ken Danby

by Paul Duval

**CLARKE, IRWIN & COMPANY LIMITED**
TORONTO/VANCOUVER

©1976 Clarke, Irwin & Company Limited
ISBN 0-7720-1093-5

Printed and Bound in Canada
2  3  4  5  /  80  79  78  77

# Contents

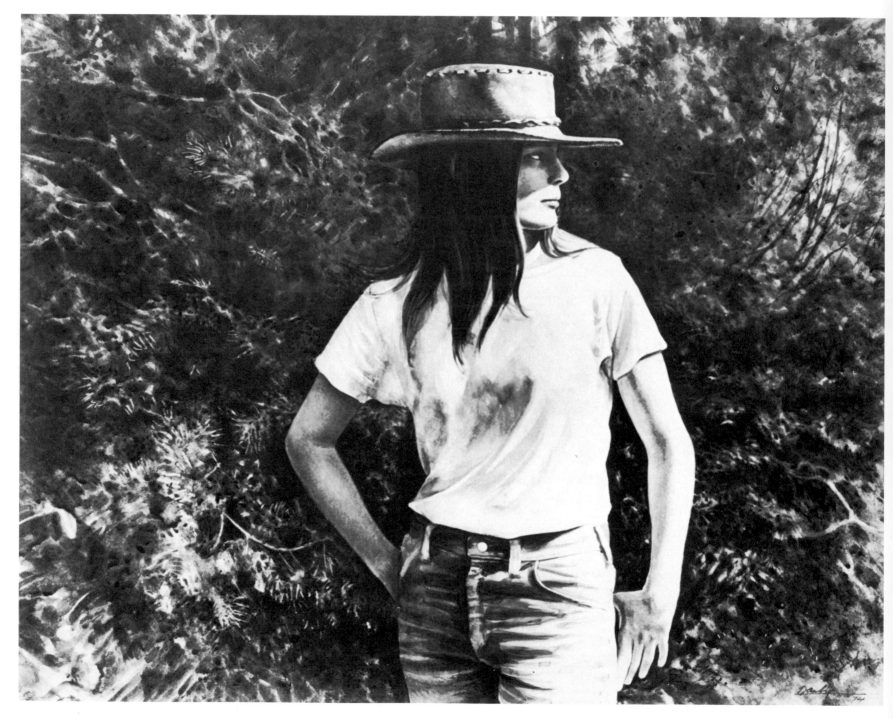

*Lynn's Hat*; 1974 Watercolour 21 x 27; Mr. S. Khan, Ottawa, Ontario

## Foreword

In-depth records of individual Canadian artists are virtually non-existent. Such few serious studies as do exist are usually a dusty compound of old catalogues, doubtful recollections and guesswork.

The best time to record an artist and his work is when he is alive, and preferably well. Then, and only then, may accuracy be assured, direct observations made, and memory captured while still fresh. Technical methods can be recorded in progress and the artist's environment studied at will.

This volume results from more than a decade of close personal acquaintance with its subject. All facts, dates and other material arise from personal knowledge or from the artist's memory, substantiated by written records. The resulting information is thus as accurate and complete as is humanly possible within the confines of this text.

In the preparation of this book, Ken Danby has assisted in every way, and I should also like to express my appreciation to his brother Marvin.

The publisher and I are most grateful to the owners of works selected for reproduction.

*Paul Duval*
*The Studio Building, Toronto*
*July 9, 1976*

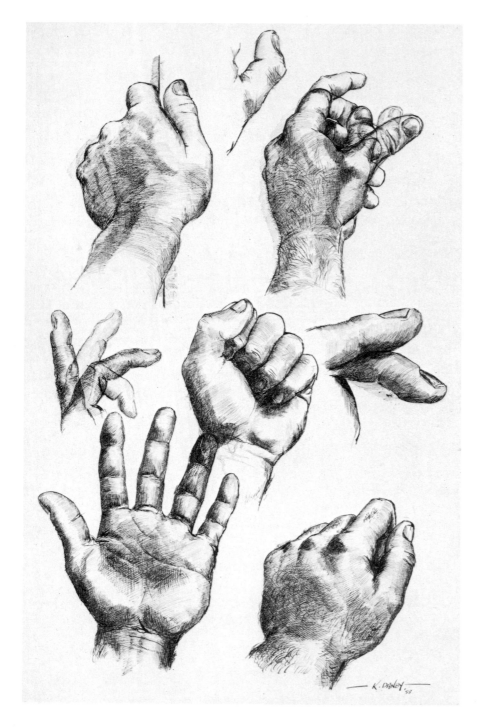

*Study of Hands*; 1958 Pen & Ink 23 x 14¹/₂; Collection the Artist

*Seated Nude*; 1961 Oil on Canvas 44 x 31; Mr. Anthony Acker, Thunder Bay, Ontario

*Realism is by essence the art of democracy*

GUSTAVE COURBET

The role of realism throughout the history of painting has been a complex and varied one. Realism has been used to enlighten, protest, propagandize, fantasize, and record, and its multiple nature has been often misunderstood.

Realism's diverse character has been too readily oversimplified. Observers frequently confuse the biting social realism of a Hogarth or Daumier and the realism of a classicist such as David, who serves up the ideals demanded by a dictatorship. Similarly, today, the musclebound portrayal of a beaming comrade commissioned by political czars to glamourize labour is equated in many minds with the frank honesty of a painting by Wyeth, Colville or Danby.

This tendency to throw all detailed figurative painting into a common "realist" pot is a widespread one, and tends to obscure the richness of realism and the special nature and diversity to be found among contemporary realist artists.

The first question to ask of any realist is what is his intent. The answer to this acutely governs the subtlety, lasting power and creative conviction of any realist work of art. Much of the realism emanating from the studios of the world has been done to specific order, to celebrate in slavish detail and judicious editing an event, individual, or ideal. The painter executing such chores is inevitably an obedient hired hand carrying out the commands of another person or group. In this area belong the detailed pictorial realist fantasies of dictatorial political movements. In such programmed realism the painter obligingly selects and emphasizes those visual facts which together will please his state employer, much as a commercial artist in the world of free enterprise exaggerates the glitter, strength or glamour of the advertizer's product to entice and convert a potential buying public.

The maximum power and lasting impact of realism emerges from the hands of painters who make their statements from a personal inner conviction, undiluted by the demands or expectations of an employer or buyer. It arises, as does most true art, from the special pressures and needs of an individual to project his unique vision, as untrammelled as possible by outside influences. From such individual compulsion has come the intensely personal realism of such great modern figures as Courbet, Daumier, Eakins and Hopper, each of whom looked at the world with a passionately personal vision and recorded it with a stubbornly personal style. It is this determination to tell it as it is from a personal attitude which is shared, to a large degree, by all significant realists.

It is the deep personal involvement with a given theme which has inevitably directed controversy and hostility against the realist. His dedicated search for pictorial truth

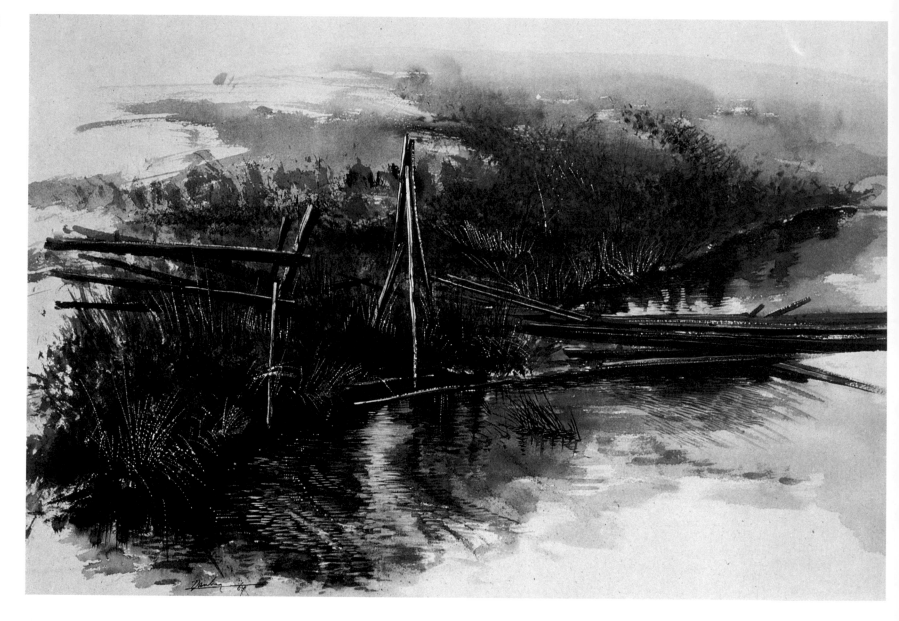

*Two Tree River*; 1964 Watercolour 18¹/₂ x 27¹/₂; Private Collection, Toronto, Ontario

*Brown Abstract*; 1962 Collage on Masonite 16 x 19$^1$/$_2$; Collection the Artist

through fidelity of observation and honesty of execution has variously brought down upon the realist jail terms, poverty, social excommunication, and critical charges varying from banality, vulgarity, social agitation, and slavish imitation to pandering to the masses.

Despite the common misconception that realism represents a ready path to the mother lode of artistic popularity, the facts show that the route has often been rocky and, at least initially, unrewarding. Artists who later enjoyed fame and popularity were early condemned for their fidelity to pictorial fact as they conceived it. Their utter integrity and individualism of realist approach were taken as a challenge to the easy, accepted salon standards of the day. Gustave Flaubert eloquently summed up the determined individuality of the true realist when he wrote: "Why should one need to hitch oneself to the same shaft as other people and join a bus company when one can go on pulling a gig?"

Realist victims of critical ignorance or misunderstanding included Courbet, Rodin, Degas, Manet and Eakins. Occasionally, like the brilliant nineteenth-century American still-life painter, William Harnett, they were even the victims of an overzealous judiciary. Harnett rendered the U.S. treasury bills with such fidelity in his *trompe l'oeil* pictures that he was arrested in the winter of 1886 for counterfeiting, a charge that dissuaded him from ever including paper money in any of his still-life compositions from then on.

When Auguste Rodin exhibited his early masterpiece *The Age of Bronze* in the Paris Salon of 1877, his lifelike nude figure of a young man was immediately assumed to have been cast directly from a living model. Outraged commentators called the now famous sculpture a "fake" and one critic dismissed it as "an astonishingly exact copy of a low type."

Thomas Eakins, the great nineteenth-century American realist, was called a "butcher" for the fidelity of his 1875 painting *The Gross Clinic* which represented a Philadelphia hospital's operating theatre. Today, that same painting occupies a place of honour in the Jefferson Medical College, Philadelphia, perhaps reflecting the wisdom of the great poet, Walt Whitman, who commented: "I never knew of but one artist, and that's Tom Eakins, who could resist the temptation to see what they thought ought to be rather than what is."

Gustave Courbet received little but abuse for his realism which now seems to us the most straightforward and honest painting of its period. For his integrity and refusal to go along with the neo-classic and romantic art ideals of the time, he was accused by such an influential contemporary critic as Theophile Gautier of painting pictures which belonged "in that extravagant category to which the artist owes his notoriety — a deafening tattoo

*After the Rain*; 1964 Watercolour 15¹/₂ x 21¹/₂; Dr. R.F. Billings, Willowdale, Ontario

*Red Abstract*; 1962 Collage on Cardboard 13¹/₂ x 16; Collection the Artist

on the drum of publicity to attract the attention of the unheeding mob."

It took another great painter — and a romantic at that — Eugène Delacroix, to recognize his fellow artist's greatness. After one of Courbet's paintings, *The Painter's Studio*, was rejected for inclusion in the 1855 Exposition Universelle at Paris, Delacroix wrote: "They have refused one of the most singular paintings of our time; but a strapping lad like Courbet is not going to be discouraged by so small a thing as that."

How different is Delacroix's vital approach to that of those arch-academics who possess no gut experience with painting and barrenly assume that art appreciation is done by degrees. They collect the droppings of the horse long after the animal itself has disappeared from view, put them in a deep freeze and then, with a sterilized scalpel, dissect them straw by straw. These academics may think that such an analysis, and polysyllabic incantations, will recreate the horse, but all they have when they are finished, of course, is still a pile of droppings. The vitality and material structure of the horse itself has escaped them completely.

Emile Zola said it for the misunderstood realists of all time when he commented on the hostile critical reception to Manet's nude *Olympia*: "Our fathers laughed at M. Courbet and now we go into raptures over him. We laugh at M. Manet and our sons will go into raptures over his canvases."

Significant realist painters generally have been loners. They have not gathered together to form "movements" for mutual protection and propaganda, nor sent forth group advertizements in the form of manifestos. Most often, realists have chosen to live in semi-solitude, away from the major metropolitan centres, in smaller communities or even on farms. Usually they have not pursued, nor accepted, membership in official art bodies.

Courbet, one of the true heroes of realism, spoke in the spirit of many of his fellows when he refused the Legion of Honour in 1870, with the words: "I am fifty years old and I have always lived in freedom; let me end my life free. When I am dead, let it be said of me: 'He belonged to no school, to no church, to no institution, to no academy, least of all to any regime except the regime of liberty.'"

*So much of art is simply a matter of common sense*

HENRY MOORE

Contemporary realists often have the same official art establishment opposition as their colleagues of the past. They are confronted by museum officials, special interest groups and reviewers who are more attuned to promotion and fashion than to the broad substance of art. Many of these parties view pictures through their ears, rather than their eyes. They listen intently for the latest guidance from foreign art magazines, which are controlled in great part by dealers, and which concentrate on the currently promoted painters and styles, to the exclusion of others. Anyone who glances back through copies of such magazines from the last twenty-five years will be readily convinced of the ephemeral, and sometimes sudden, changes of critical emphasis to satisfy a commercial market demand. It serves neither artists nor the public that a particular "style" is lionized for a few brief, profitable seasons while virtually all others are ignored.

Much of the art bias offered to the general public is due to the nature of some major contemporary art institutions. They are often too nervous to admit realism to their hallowed halls for fear that they might be labelled passé, so they opt more readily for the fashionable or novel, often regardless of special merit. The continued importance or vitality of art which might be described as traditional is overlooked or ignored. Surely the fact that artists continue to explore an already open, but rich, creative vein should not disqualify them or their work from consideration by public galleries. After all, even in the often ephemeral world of the theatre, the classics continue to make their successful appearance. It is how those classics are reinvested with vitality and a fresh approach that is the measure of acceptability by succeeding generations.

Regrettably, the staff member of a museum all too often has little or no deep involvement with art or any considerable understanding of the materials or techniques of the artist. Too rarely does he possess any expert knowledge of what is involved in making a painting or sculpture. Rarely do you find one who comprehends that the art of pictorial creation is, in great part, a physical labour, or that a painter may stand for six or more hours at an easel or over a drawing board, getting a backache in the process.

In the midst of the pale politics, the committee machinations, the infighting that takes place within our art institutions the subject of living artists and their art gets lost. Dependence upon outside guidance, meaning art fashion magazines and dusty catalogues, takes the place of original research. What passes for art scholarship usually remains a matter of degrees, books read and required papers written, with an immediate basic experience of art itself sidestepped altogether. It is ignored that painting is a *material* occupation in which the artist spreads earth and minerals, in the form of such paints as

20  ochres, umbers, siennas, cobalts, cadmiums and leads—all made from soil and metal—upon a canvas or board. A purely academic approach to painting is rather like a surgeon learning his art without contact with the human body. I am convinced that many academics and officials involved in art really dislike the subject, but it represents for them a "nice-nelly" livelihood. For them, a painting only becomes a work of art when it is safely removed from the sweat and labour of the studio, and is properly divested of physical reality by a wide gold frame and a place on an institutional wall.

It is, regrettably, the ill-informed snobbery of such museum keepers and lymphatic academics that has persisted in neglecting and demeaning the realism of today as it was abused in the past. There is something about an art form which communicates directly to most people that is an anathema for those who would rather deal in esoterica which they can "explain" to the populace in polysyllabic, if meaningless, phrases which completely obscure the actual work of art from view. It is very difficult, however, for them to play this academic game when confronted by a painting by Courbet or Eakins, Wyeth or Danby. They would appear the pretentious poseurs they often are if they attempted to erect a verbal screen to obscure the clarity of statement and execution represented in such artists' works.

In Canada, in recent years, realism could be described as an "underground" movement (though it is a movement in no other way). Many of the individuals who have been quietly painting some of the more notable works of the period have been ignored or treated derogatorily by a good number of museum officials and reviewers. Significant painters such as Ken Danby, Hugh Mackenzie, D.P. Brown, Jeremy Smith, Christiane Pflug and Eric Freifeld are rarely represented even in the galleries of their native Ontario, although a number of them are represented in the collections of foreign institutions. Remarkably, the Province's artistic flagship, the Art Gallery of Ontario, has still to purchase works by some of these prominent realists. This fact underlines the Gallery's long-standing refusal to recognize such realist artists, while making multiple purchases from non-figurative painters—a blatant bias towards a more highly-organized pitch in the marketplace. Realist painters, working quietly in relative solitude, do not engage in the social performances and publicity stunts which catch the eye of the press, nor pursue the sort of personal contacts which appear to guide so many decisions of gallery committees.

The growing attention given to such a realist as Ken Danby by American and European museums (including New York's Museum of Modern Art and England's

*Fur and Bricks*; 1963 Egg Tempera 21 x 27; Private Collection, Toronto, Ontario

*Kimbo*; 1964 Pencil Drawing 9¹/₄ x 12; Private Collection, Toronto, Ontario

Bradford City Art Gallery) only underlines the Art Gallery of Ontario's refusal to recognize special realist talent when it exists in its own backyard.

Ironically, the more widespread the appreciation of contemporary realism becomes, the more stubborn grows the resistance to it in esoteric art circles. There is almost a neurotic resentment that art so carefully crafted and easy of access to a wide audience should also, finally, bring public prestige and financial reward to its practitioners. This seemingly troubles and makes insecure those who propose that art should be divorced from the everyday world and, at the present time, be almost certainly abstract.

The paranoia caused in some United States art circles by the enormous success and popular prestige of Andrew Wyeth is mirrored here. For some abstract artists riding high in the marketplace, and their supporters, high realism obviously may present a challenge, particularly as the Canadian art market is still fairly limited. Dealers almost exclusively engaged in representing abstract painters may be heard readily offering scornful opinions of rising realist stars. One hears oblique damning such as: "Well, *technically* he is very good," or, "What does realism offer you can't get in a colour photograph?" Another favourite critical gambit is that high realism is "old-fashioned"—as though re-runs of the New York abstract expressionist or minimal schools are fresh discoveries.

Further aggravation is found by the anti-realists in the fact that realist works such as Ken Danby's reproduce very well, and thus reach a potential audience measured in the millions. The incredible sale of Wyeth reproductions in the United States and elsewhere has had the non-representational dealers and their investment coteries seething for years. Artists who one finds generally tolerant feel an obligation to decry Wyeth, Danby, and the whole band of contemporary realist painters. Such success as realists may now enjoy is looked upon as a non-art event by painters whose audience is necessarily limited. It is not so much envy, or even professional jealousy, that causes this hyper-reaction against fellow artists, but a belief that somehow realists have broken the rules of the creative game by commanding such enthusiasm from a mass audience.

The intensity of the anti-realist faction is underlined by liberal critic Brian O'Doherty in his book *American Artists,* where he writes: "Wyeth is attacked with a violence far beyond the usual etiquette of critical disagreement." The same statement could be made about some reactions to the art of Ken Danby.

In Canada, Danby presents a classic example of a realist who has found repeated neglect or abuse at the hands of commentators who seem to have been totally unaware of any quality in either his aims or achievements. Danby has been the whipping boy for a

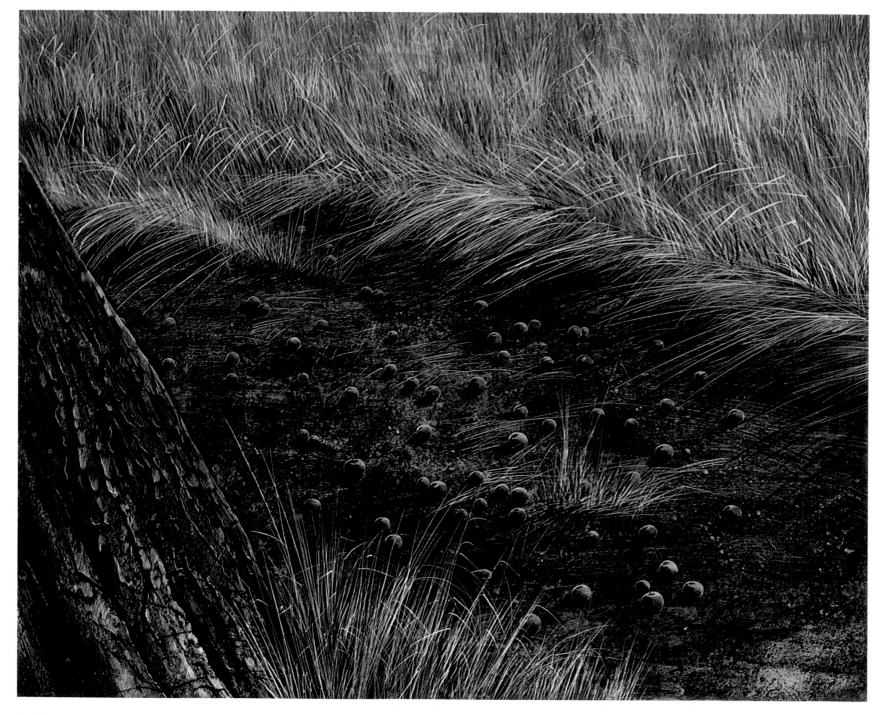

*Crab Apples*; 1964 Egg Tempera 24 x 30; Professor H. Olnick, Toronto, Ontario

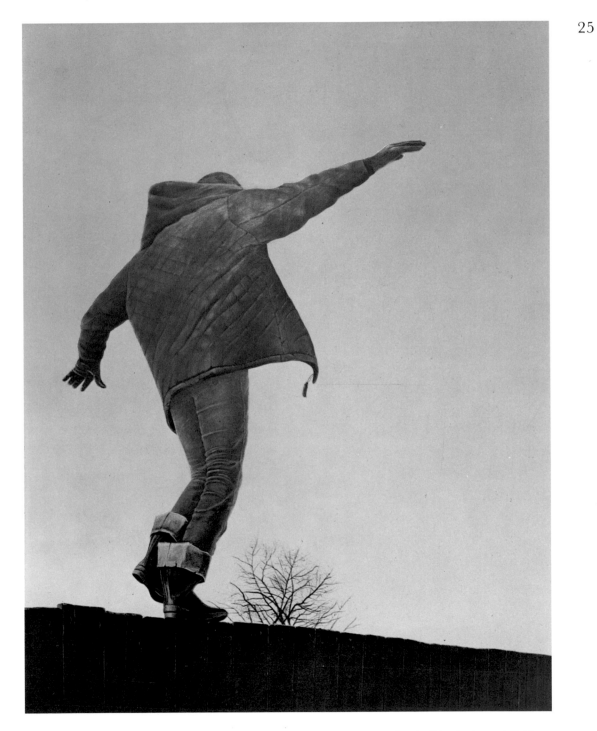

*Boy on Fence*; 1965 Egg Tempera 36 x 28; Mr. and Mrs. Daniel M. Clark, Birmingham, Michigan

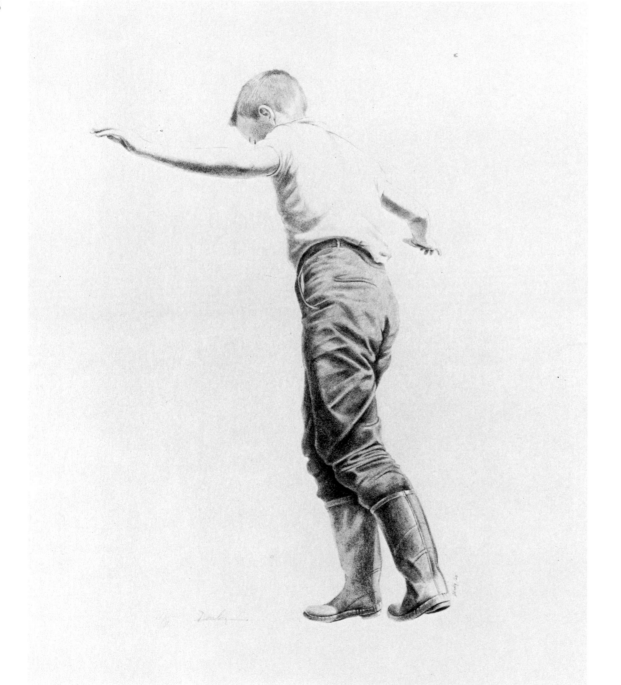

*Boy on Fence*; 1965 Lithograph 23 x 18; Edition of 50

series of reviewers who wanted to make it clear that they were sophisticates who understood the abtruse beauties of geometric art, but who were certainly not going to be taken in by achievements that invited no profound analyses.

"Danby's art," one of them (in the Toronto *Telegram*) wrote in 1970, "is of the calendar variety: sentimental, slick and cloying to the point of nausea. Unlike most calendar art it is poorly drawn, has no feel for composition or texture other than the most obvious, and has absolutely no sense of the properties of mass and line. As for colour it is solidly uniform and washed out. . . . This is art for people who prefer Muzak to music. It is an opiate that dulls rather than a stimulant that increases your awareness of the world as it really is."

Another reviewer (in the *Toronto Star*) joined in: "This is superficial painting in the literal sense of the word. Danby carefully describes his surface but never conveys the underlying structure of his objects . . . " and then went on to complain of Danby's treatment of light: "This is not the Ontario sunshine the Group of Seven and other artists have studied and painted." Danby, curiously, is thus even blamed for not being a copyist.

Presumably, the writers of such nonsense could not see in Danby's paintings a progressive individuality of vision and dedication to a style of pictorial communication that renews itself in the hands of succeeding generations, that has not dated and need never date. Such reviewers fail to notice that all structured painting is basically abstract, in that it grows out of a common palette of nature, comprising space, shape, colour, tone, pattern and texture. Whether the painter elicits from these elements compositions which relate intimately to objects as we see them, or designs which are spun from his logic or imagination (although the forms of these inevitably emerge subconsciously from the physical world he has known), is basically inconsequential. What does matter is the true originality, authority and executive aptness with which the artist conveys his pictorial message, naturalistic, non-figurative or surreal.

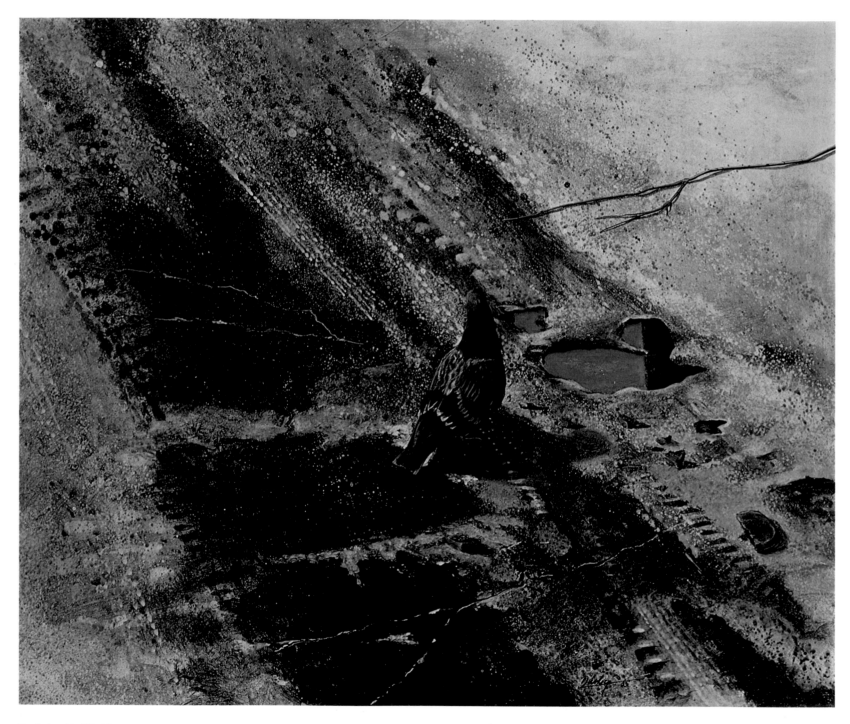

*Exploring his World*; 1965 Egg Tempera 20 x 24; Mr. Paul Becker, Toronto, Ontario

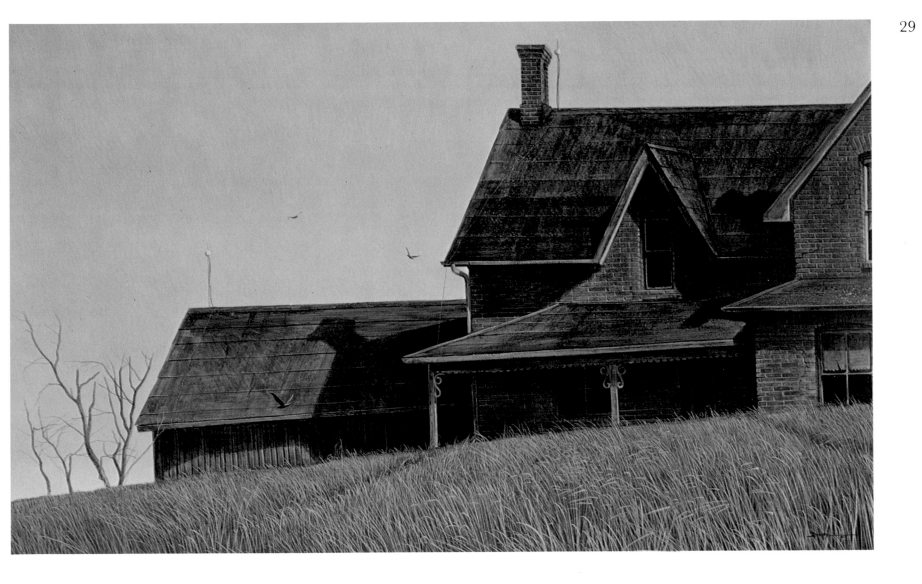

*Early Morning*; 1965 Egg Tempera 23 x 37; The National Gallery of Canada, Ottawa, Ontario

*Certainly the landscape forms I knew as a boy affected*

*my painting in later years*

A.Y. JACKSON

The early physical and social horizons of any painter unquestionably affect his future art.
The forms he finds about him in childhood condition to some degree the shapes of his future compositions and attitudes to theme.

Ken Danby's celebration of the Ontario scene is rooted in generations of Canadian ancestors, measuring more than a century-and-a-quarter.

Robert Marshall, Danby's great-great-grandfather on his grandmother's side, landed at Quebec City from England on July 29, 1845, and his first son George, Ken's great-grandfather, was born in Quebec, on August 1 of the same year. Robert Marshall first worked briefly at his trade of carpenter for a Quebec shipyard and later bought a section of land in Megantic County, Lower Quebec, where he farmed for thirteen years. In 1858, hearing of better farming opportunities in Upper Canada, Marshall took his wife Mary and six children to York (Toronto), by the Grand Trunk Railway. Leaving them behind at York, he continued to the railroad's end at Royal City (Guelph). He then travelled by stagecoach to Goderich and rented a farm at nearby Clinton, where his family joined him. Finally, in 1862, he settled for the last time on a hundred acres in Korah near a little Indian town called Sault Ste. Marie, buying a second eighty acres not far away. Both farms are still owned by Marshalls. Robert Marshall lived to be 94, and his descendants included 71 grandchildren, 68 great-grandchildren and six great-great-grandchildren.

Robert's oldest son, George, married Mary Ann Kelly in 1866, and they made their home at West Korah. When Confederation was declared on July 1, 1867, Mary made a flag which flew at their farm on that date each year. George and Mary Marshall worked their farm for sixty years, and had four boys and six girls. Their second youngest daughter, Clara, married Milton Danby, youngest son of James Danby and his wife, Mary Whitmore, daughter of a Mennonite family. James Danby first farmed in Stanley Township in the County of Huron and later at Petrolia, Lambton County. Milton Danby left home at a very early age, worked on Manitoulin Island, and by age sixteen, in 1900, was living at Sault Ste. Marie. Their son Edison Danby, Ken's father, was born at Sault Ste. Marie on July 9, 1909. Edison Danby married Ken's mother, Gertrude Buckley, the daughter of English immigrants to the Sault, on September 12, 1934. Edison Danby later became Assessment Commissioner for Sault Ste. Marie, a position he held for thirty-five years. He retired in 1974.

This almost undiluted Canadian background, with its solid attachment to an early settled area of Ontario has unquestionably conditioned the unaffected and direct

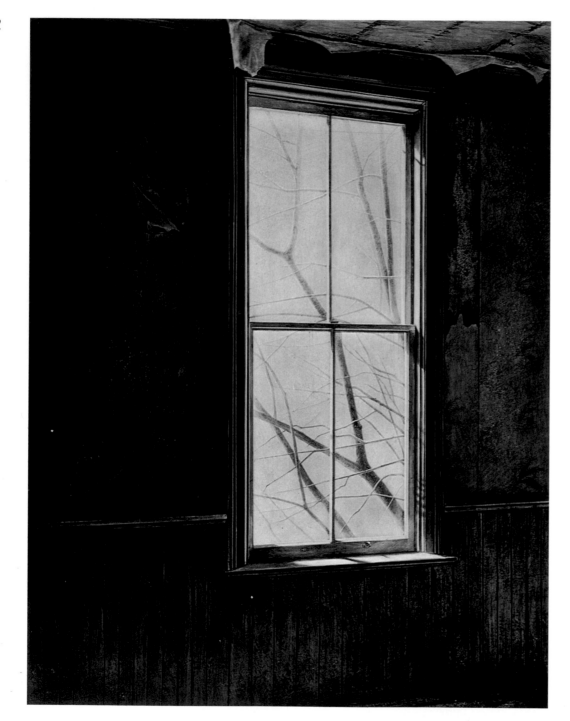

*Maples in the Winter Sun*; 1966 Egg Tempera 32 x 24; Montreal Museum of Fine Arts, Montreal, Quebec

approach revealed in Danby's art, and lends to his work a peculiarly strong sense of place. Recent arrivals to Canada may paint the material it offers in a novel, powerful, or even exotic way, but they can never have the complete ease with the material commanded by a native-born artist who has been immersed in its light and forms since infancy. It is, in fact, this very regionalism (in the best sense of that ill-used word) found in Danby's work that disturbs commentators who demand of Canadian painting some mirroring of a prevailing foreign style, who insist on searching for the *fleur de lis* where trillium bloom.

Ken Danby was born on March 6, 1940 at the General Hospital in Sault Ste. Marie, four years after the birth of his brother Marvin. Unaffected by the World War II atmosphere in which he grew up, Ken's early childhood was typical for a Canadian boy, except for his special interest in making drawings. His first serious sketches were mostly copies from art books borrowed from the library. In those early years, both parents encouraged their children's leanings towards art. Their mother frequently acted in amateur theatricals, and the walls of the Danby home were hung with a number of modest original paintings. (One of Ken's favourites among these was a two-sided sea-and-landscape which his father, while working as a gasoline attendant during the Depression, had received as a gift from an indigent amateur painter he had befriended.)

Edison Danby frequently took his sons on hikes into the woods around Sault Ste. Marie, and many of Ken's earliest landscape watercolours resulted from such trips. These have been preserved by his parents, along with other early drawings, and already hint at the future painter's abilities. His skills had an opportunity to expand during Ken's elementary years at the local Cody Public School, where he soon became known as the school artist. He painted murals, created *papier mâché* sculptures for special events, entered hobby shows and, at the age of ten, won a prize for a portrait of his father. Perhaps the most important piece of information Ken received at Cody Public School came when his guidance teacher told him about Toronto's Ontario College of Art. Then and there, at age eleven, he decided that one day he would go there.

Before that ambition was to be realized, Ken went through five checkered academic years. His ambition to be a professional painter was then only mildly approved by his parents, who preferred that he adopt a more economically secure occupation. A temporary compromise was found in architecture and, at the age of twelve, Ken enrolled at the Sault Technical and Commercial High School, spending much of his time after the initial ground course years taking architectural draughting.

Ken's ambition to be a painter was still nagging at him when he finally transferred to

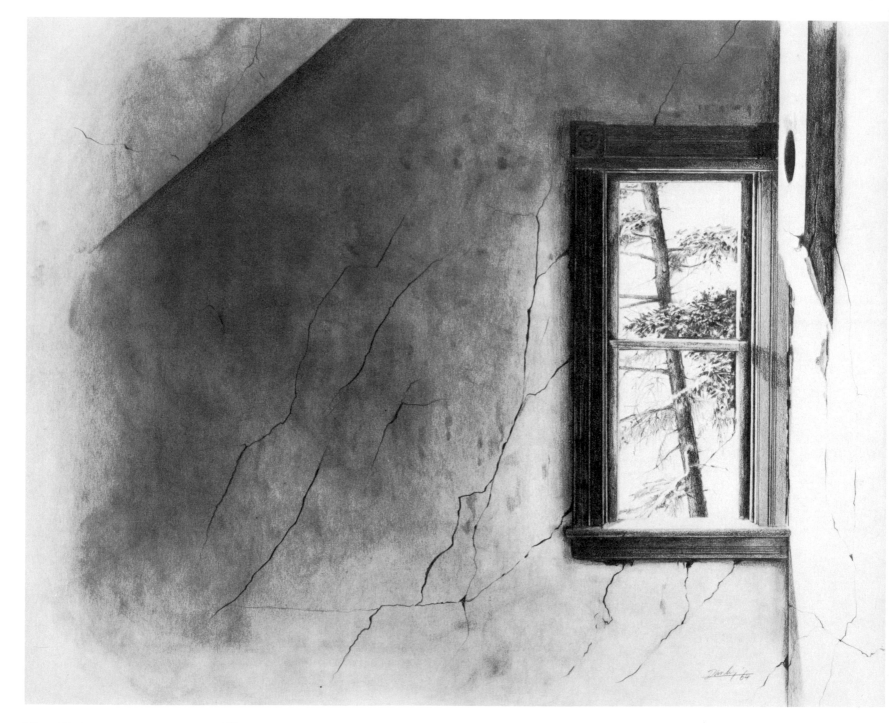

*Winter Window*; 1964 Pencil Drawing 17¹/₈ x 23; The National Gallery of Canada, Ottawa, Ontario

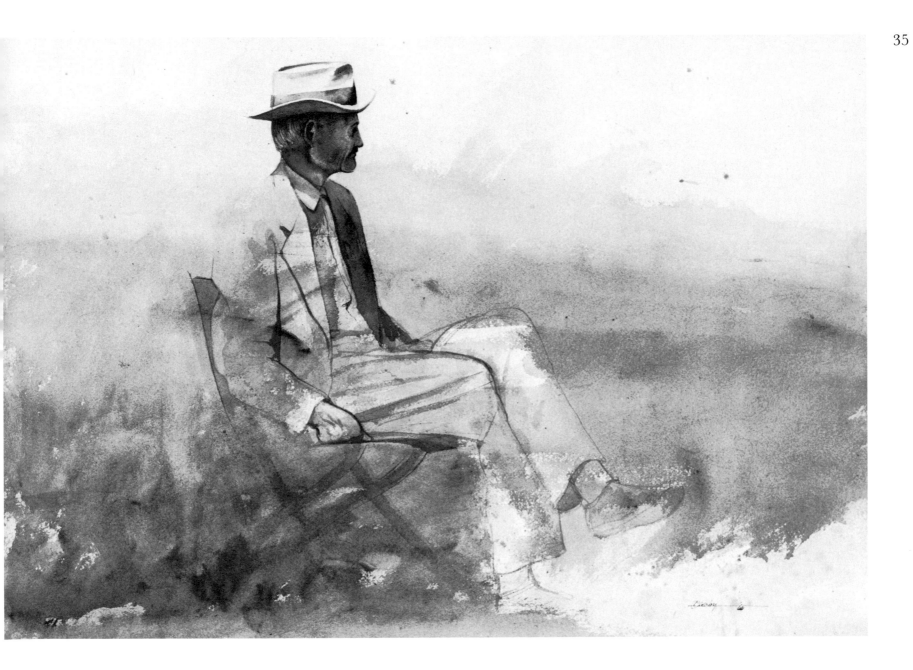

*Old Timer at Hilton;* 1966 Watercolour 20 x 29¹/₂; Mrs. Judith Danby, Guelph, Ontario

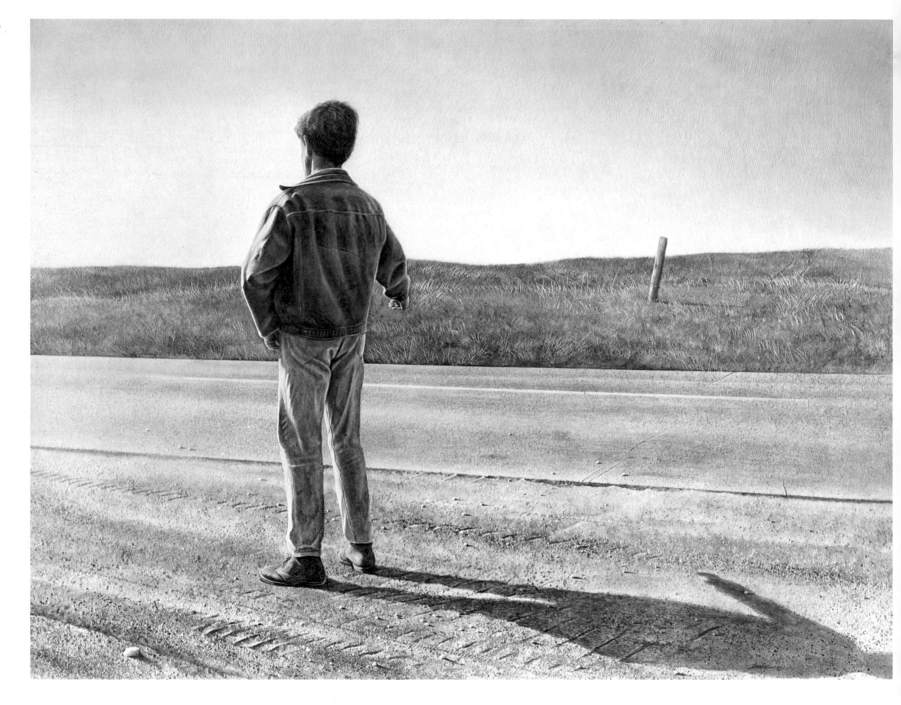

*On His Way*; 1966 Egg Tempera 32 x 42; Private Collection, Toronto, Ontario

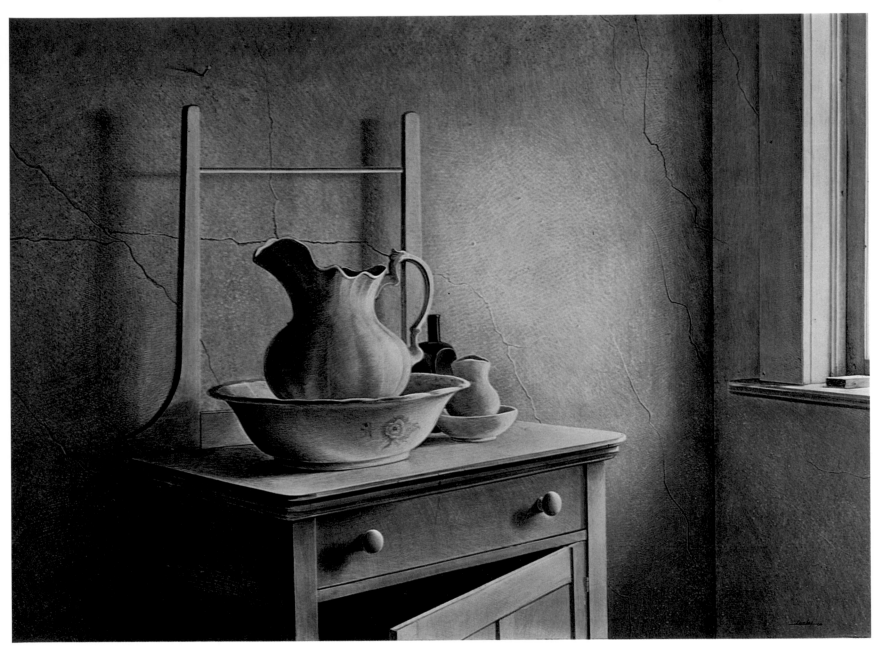

*The Rose Bowl*; 1966 Egg Tempera 20 x 28; Mr. and Mrs. E.L. Stringer, Toronto, Ontario

38  the Sault Collegiate to take his matriculation that was to prepare him for his projected future studies in architecture. He continued always to draw and paint in his spare time, and was especially encouraged, at the age of fourteen, when one of his Cody Public School teachers, Glen McEachern, purchased two of his paintings for five dollars each.

Especially helpful in Danby's early years were the drawing and painting classes given at the Sault Collegiate by Charles Carrington, a teacher who was instrumental in keeping his interest in art alive. A further encouragement was permission to occasionally attend sketching sessions with the local Algoma Art Society. All of these activities joined to confirm young Danby's decision to attend the Ontario College of Art, and after much discussion with his parents, he left for Toronto in September 1958, at the age of eighteen, to enrol officially at the famous school on Toronto's McCaul Street.

*From the Shed*; 1965 Egg Tempera 24 x 20; Private Collection, Toronto, Ontario

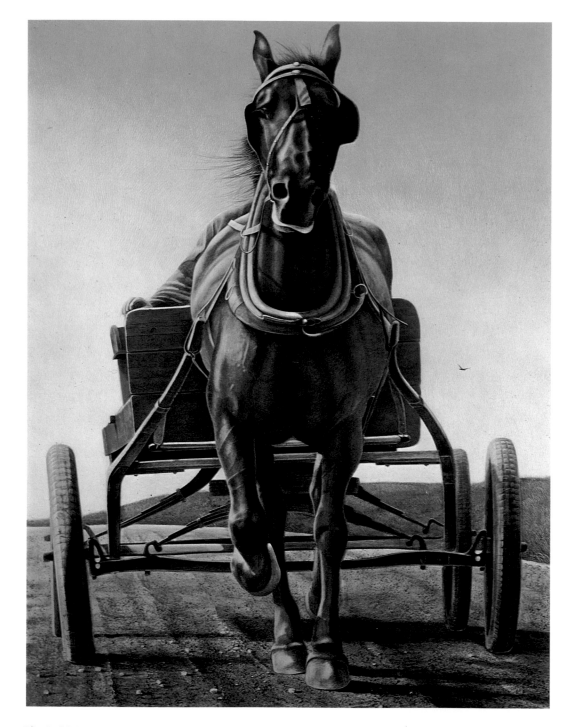

*The Red Wagon*; 1966 Egg Tempera 42 x 32; The Art Gallery of Hamilton, Hamilton, Ontario

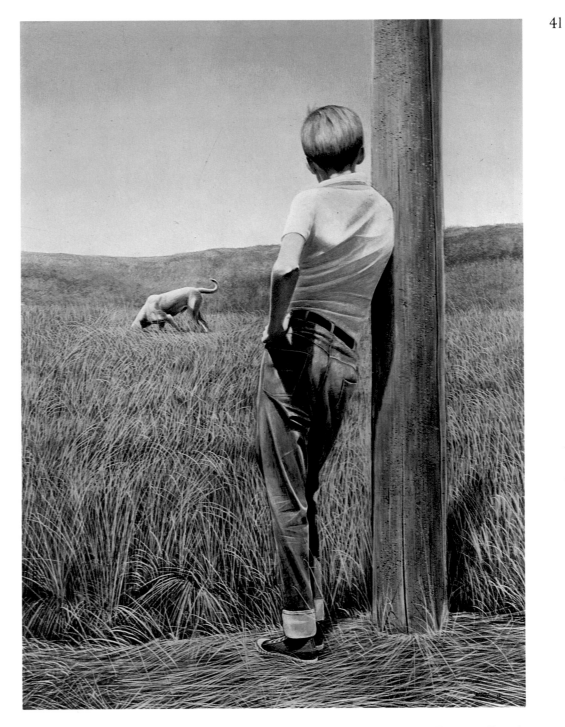

*Young Master*; 1966 Egg Tempera 32 x 24; Private Collection, Toronto, Ontario

*Abstraction is the best thing that has happened to realism*

ANDREW WYETH

Danby's first year at the Ontario College of Art in 1958 – 59 went smoothly enough. Like most beginning students he concentrated on academic drawing—at school, in the Royal Ontario Museum, and in his rooming house quarters on downtown Willcocks Street. He especially enjoyed sketching with a rapidograph pen in black ink, a medium which allowed both concision and vigour of execution. He carried out the school's first year programme and on his own drew portraits of his friends and himself, still-lifes, animals— virtually anything that caught his eye.

"At Art College I was nicknamed Vincent," recalls Danby, "partly because I wore a beard, but mainly because I was a loner and never stopped drawing. I also had a genuine admiration for Van Gogh and read all of his letters. I was intense and almost fanatical about drawing and did hundreds of studies, mostly in pen, during my first year."

The summer following his first Art College year was an emotionally trying time for Danby. His teenage "growing pains" made him restless, and his year away from home had brought about an inner conflict concerning what art was to mean for him in the future. His early interest in realism had been challenged at the College by teaching that emphasized pure design rather than drawing and this caused for Danby a period of confusion. During the summer he even questioned whether or not he would continue to pursue a career in painting, and destroyed a number of his canvases done at the Art College.

To try to get some perspective on his problems, Danby decided to get away on his own for a period of reflection. He obtained a job in the northern Ontario town of Wawa with a construction firm engaged in replacing the metal siding of mining towers. This involved working on a suspended swing stage, something he had already done during previous summers back at the Sault. Danby enjoyed his break at hard physical labour for six days a week, but still spent his spare evenings and Sundays drawing and painting. Many of the rapidograph pen sketches of this period portray the bunkhouse life shared by the construction crews. These closely-observed studies are the forerunners of his later realist drawings of the 1960s. The watercolours he did at Wawa are of the local landscape, executed in a straightforward and fairly traditional style. Danby himself confesses that at times he was consciously "playing at Group of Seven." Despite these continued creative activities, Danby had virtually decided in the summer of 1959 not to return to the Ontario College of Art. Only after several talks with his parents did he agree to give it another try.

Danby's restlessness persisted into his second year at the Art College. He specialized in drawing and painting, but was dissatisfied with the school programme in general. It was

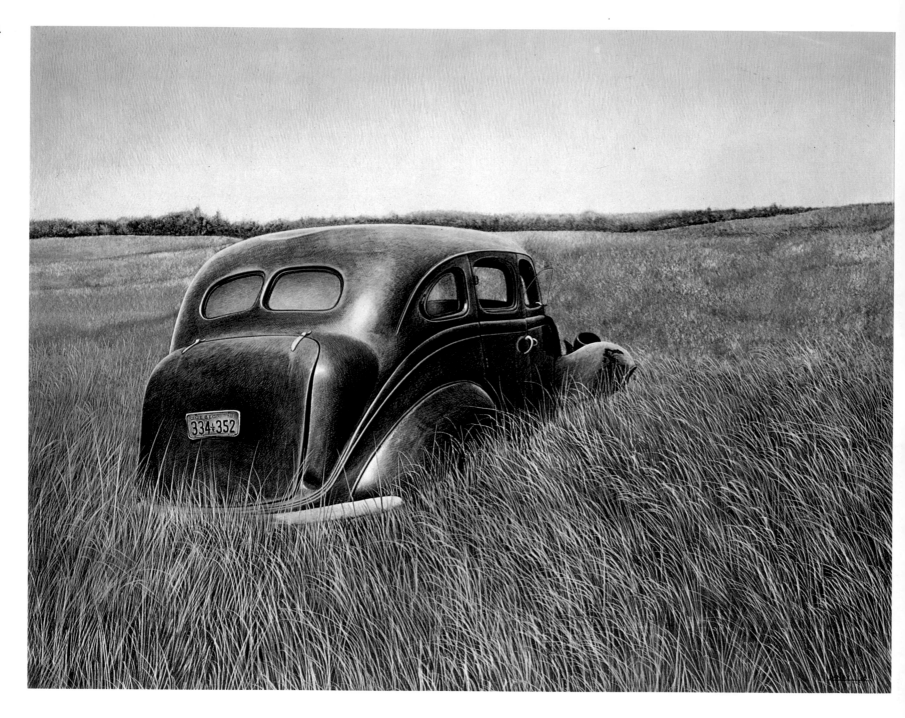

*From the Summer of '38*; 1966 Egg Tempera 22 x 28; Mr. and Mrs. N. Weisman, King City, Ontario

*Beside the Fireplace*; 1966 Watercolour 20 x 29; Mrs. Judith Danby, Guelph, Ontario

a period of disenchantment. Despite encouragement and sound advice from some of his teachers (particularly John Alfsen, Eric Freifeld and Fred Hagan), he now found the school confines too restricting. The main thing that kept him at College was the presence of the late J.W.G. (Jock) Macdonald, who Danby remembers as an inspiring and understanding teacher. Macdonald had joined the Ontario College of Art in 1947, and has been credited by many of Canada's most prominent artists and former students as being a guiding spirit in their careers.

Ken Danby could not have met a more valuable teacher during a period when he was threshing about for some creative direction. Macdonald pointed out that masterpieces and inspiration could be found in all styles of painting. In the year when Danby came under his influence, Jock Macdonald was entering into the very peak of his creative powers and was facing a period of indecision about continuing teaching, just as his student was questioning continuing his formal studies. "I enjoy my classes but I feel that I should cut them out soon and be absolutely free after my four days at the College," Macdonald wrote in November 1958. There is no question that Macdonald must have sympathized with Danby's growing feelings that he should leave school and work on his own.

Macdonald's guidance to Danby gave the young artist a full appreciation of abstract design as well as a respect for natural form. In a short period of one school year, Macdonald was able to inject a liberal attitude to art, past and present, that has persisted with Danby ever since. Danby speaks with almost as much admiration of Kandinsky as he does of Albrecht Dürer, he praises Georges Braque as readily as Andrew Wyeth. Most of all, Jock Macdonald instilled in Danby the necessity of keeping in touch with nature and not falling back solely upon the limited creative sources of the imagination. As Macdonald himself wrote: "Never have I entirely deserted objective painting. I believe it absolutely necessary to associate myself with the visual world. It is from the visual world that an artist derives his vocabulary of form and colour. It is necessary to observe continually to memorize and attune oneself to the forces of nature."

With Jock Macdonald's blessing, Danby decided to leave the Ontario College of Art permanently in April 1960, at the end of his second year. He felt a need to test his abilities in the outside world, and to search out the wide creative road which Macdonald's teaching had left so open. Danby returned home to Sault Ste. Marie and obtained employment for the summer as a set designer for a local television station. It was work that left him with time at night and on weekends to paint, in a storage shack behind the station that the management allowed him to use as a studio. There Danby began the series of abstract

*Guidepost*; 1965 Egg Tempera 20 x 24; Vancouver Art Gallery, Vancouver, B.C.

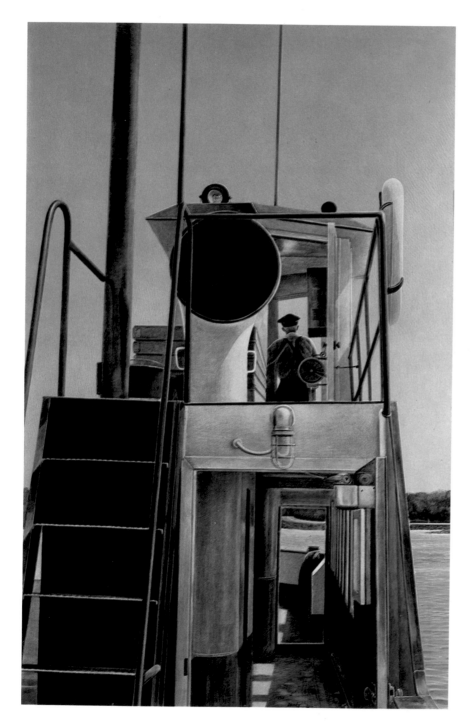

*St. Joseph Islander*; 1966 Egg Tempera 28 x 18; Mr. and Mrs. I. Waltman, Willowdale, Ontario

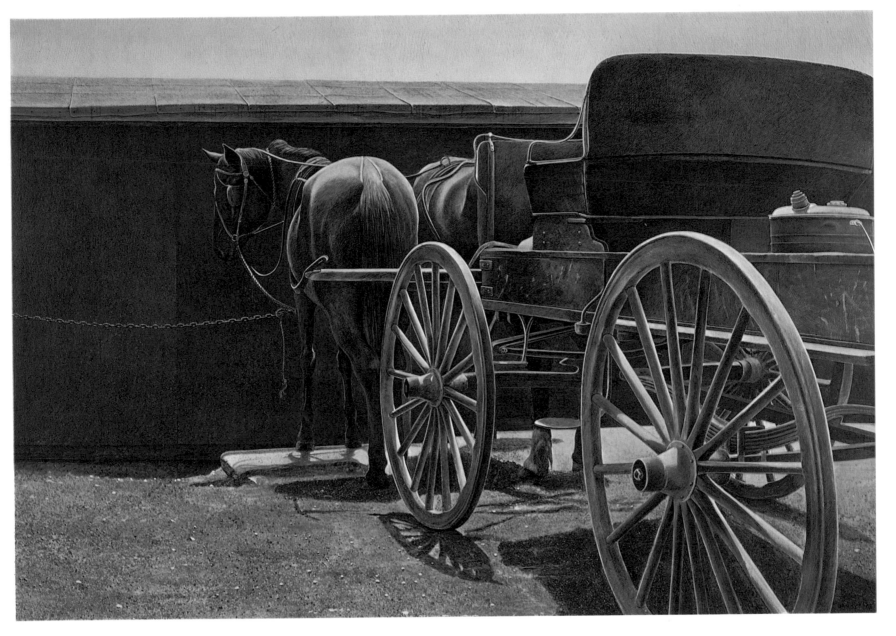

*The Elmira Democrat*; 1967 Egg Tempera 26 x 38; Private Collection, Edmonton, Alberta

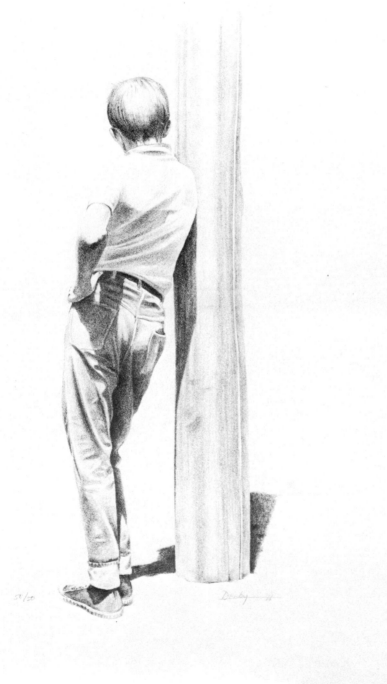

*Young Boy in Thought*; 1966 Lithograph 23 x 15¹/₂; Edition of 50

expressionist paintings which were to occupy him for much of the next two years. Most of these abstracts were painted in Toronto, following Danby's return there in the fall of 1960. The paintings were to be the one thread of unity during a period which saw him change employment and abodes with an almost gypsy abandon. Danby lived successively above Benny's Cigar Store on Yonge Street near College (with a menagerie of one dog, one cat, four kittens, several hamsters and a goldfish), at the Gate of Cleve, a folk club and coffee shop on Dupont Street, and the Fifth Peg, another folk music place where he lived with an ocelot named Tawny. (Danby exchanged the ocelot for a black cat named Kimbo after several visits to the emergency ward as a result of Tawny's attentions.)

To sustain himself and his pets and to pay for art supplies, Ken embarked on a succession of jobs. For two months, in November and December 1960, he painted sets for the CFTO television studios at the village of Kleinburg, just north of Toronto. He later worked at D'Allaird's Women's Wear shops setting up window displays, an occupation which included dressing the store's display dummies. He lasted at D'Allaird's only two weeks. "I never," Danby says, "got the hang of putting brassieres on the dummies." Employment as a designer for Bradshaw's Packaging Company lasted considerably longer, a full two months, March and April 1961. For Bradshaw's, he executed the finished art for chocolate bar wrappers and other ornate labels.

In May 1961, Danby finally found a job that interested him and rewarded him enough to remain for a year-and-a-half, as a layout and illustrating artist for the promotion department of the now defunct Toronto *Telegram*. (During that period, the author of this book was writing a column of criticism for the same newspaper, but we were not to meet one another until early in 1964, when Danby had completed his first egg tempera, *Fur and Bricks*.) Danby left the *Telegram* on November 2, 1962 to freelance.

In his spare time from his various employments, Ken steeped himself in the local folk-singing scene and in 1962–63 was art director for the famed Mariposa Festival at Orillia, succeeding singer Ian Tyson. For Mariposa, Danby designed all posters, advertizements and brochures.

"I look back at the early sixties," recalls Danby, "when the coffee-house era was just beginning in Toronto on downtown Gerrard Street, as one of the most enjoyable periods of my life. It was fun being a part of the birth of what became a great Canadian folk music movement. Later, at Mariposa and in Toronto's Yorkville district, I came to meet already famous singers like Pete Seeger and Ed McCurdy and many of those yet to come to fame such as Ian and Sylvia and Gordon Lightfoot." (Music has always been an integral part of

Danby's life. Back in his Sault Ste. Marie boyhood he had played the bass drum in the local air cadet corps band. He still enjoys plunking on an old banjo he keeps in his studio and almost always works with music from his studio record player or radio.)

In November 1961, Danby held his first one-man exhibition of paintings done in his free time away from his various employments. All of the thirteen works displayed in that show, at Toronto's Pollock Gallery on Elizabeth Street, were either abstract or non-objective. Nine of the exhibits were in oils on canvas, bearing such titles as *Dream, Transition, Figure in Orange, Reminisce, An Inner Thought,* and *Ponytail.* Five of the canvases at Pollock's were sold, and the next year, in the summer of 1962, a Danby abstract won the local Four Seasons Award for painting.

Abstraction represented a valuable phase in Danby's development. "It gave me an opportunity to work myself into and through what has been a vital part of contemporary painting," he says. "Jock Macdonald had told me to try everything pictorial in order to find my personal direction." Danby has been a keen student of abstract painting. Without prejudice, he can admire equally the physical vigour of Franz Kline's black and white explosions and the cerebral deliberations of Piet Mondrian. Although he does not use the conscious geometric framework favoured by such a fellow-realist as Alex Colville, Danby carefully composes the elements of each of his compositions in a classic formal sense. Only when he is happy with the balance and variety of his theme as pure design does he pursue the final execution of his temperas.

For Danby, abstract painting as such was eventually unfulfilling. Like such realists as Hopper or such modern pioneers as Cézanne, he needed to relate to natural forms. He did not feel at home working in a thematic vacuum nor merely adapting trends spawned abroad, as so many Canadian painters of the early 1960s were doing. Danby would have agreed with a statement by the distinguished American historian Lloyd Goodrich that: "Many of the strongest, most vital contributions have been made by native artists with no relation to trends abroad." In the United States, this would have included such great figures as Albert Pinkham Ryder, Winslow Homer, Charles Bingham. In Canada, it includes painters such as Alex Colville, Ken Danby and E. J. Hughes.

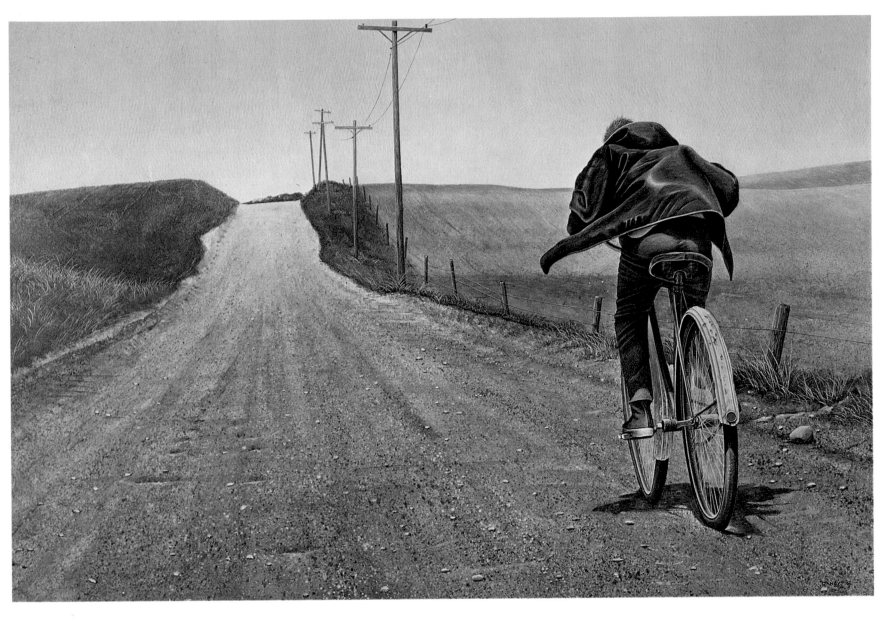

*Towards the Hill*; 1967 Egg Tempera 24 x 36; Mrs. J.D. Eaton, Toronto, Ontario

*My aim in painting has always been the most exact transcription possible*

*of my most intimate impressions of nature*

EDWARD HOPPER

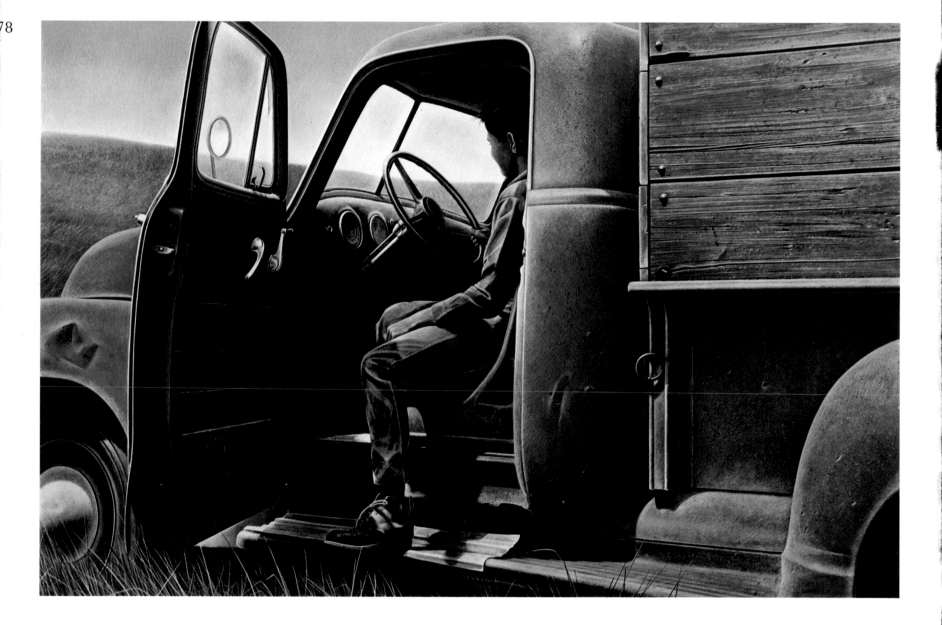

*Still Running*; 1969 Egg Tempera 24 x 36; Mr. and Mrs. Dan Rowan, Hollywood, California

dramatically centre with a rectangular panel of light, a shadowed, dilapidated interior.

The walls of the empty room, with their peeling paper and old wood panelling, provide a vivid illustration of Danby's early concentration upon textural and chiaroscuro effects and his determination to master them with the egg tempera medium. In the simplicity of *Winter Sun*'s design we can see his continuing concern for the abstract elements in composition. A side note to this painting is the fact that, after a corner of it had been nibbled by mice in the basement of the Art Gallery of Ontario, the repaired work was eventually purchased by the Montreal Museum of Fine Arts for its permanent collection.

Such a theme as *Harvest Morning*, with its sense of warm autumn air entering through an open door, has a special symbolic meaning for an artist or viewer raised in the long northern Ontario winters. An open door usually means mild weather and the freedom of outdoor life it allows, and Danby was not unaware of that symbolism when creating *Harvest Morning*.

The physical energy and dedication to his profession possessed by Danby were reflected in the fact that his 1966 exhibition at Gallery Moos offered twenty-three paintings, twelve of them egg temperas, a slow medium in which he had been working for less than three years. It was not only the quantity of the 1966 show that made it memorable; hung in it were two of the finest paintings of Danby's career, *The Red Wagon* and *The Rose Bowl*.

*The Red Wagon* is one of Danby's most ambitious paintings, in concept, size and execution. At the age of 28, he here has the nerve to tackle one of the most difficult feats of draughtsmanship, a head-on portrayal of a moving horse. To compound his problem, Danby decided to place his subject in the dead centre of his composition, a design challenge he has regularly given himself throughout his career.

*The Red Wagon* is a *tour de force* by an ambitious young artist, and its degree of success is noteworthy. The deep perspective demanded by the low angle of vision adopted is handled simply and without too much emphasis. The modelling of the horse itself has been done meticulously, but with full realization of its larger volumes, and does not dissipate into a mere collation of anatomical facts. There is a sense of power and movement conveyed in *The Red Wagon* without sacrifice of solidity and formal control. If there is a weakness in the picture, it is in the rendering of the driver's hand emerging at the left of the animal. *The Red Wagon* could easily have been a piece of *trompe l'oeil* trickery, but it emerges as much more than an example of artistic sleight-of-hand. It is a compelling and honest work of art, patiently and expertly realized.

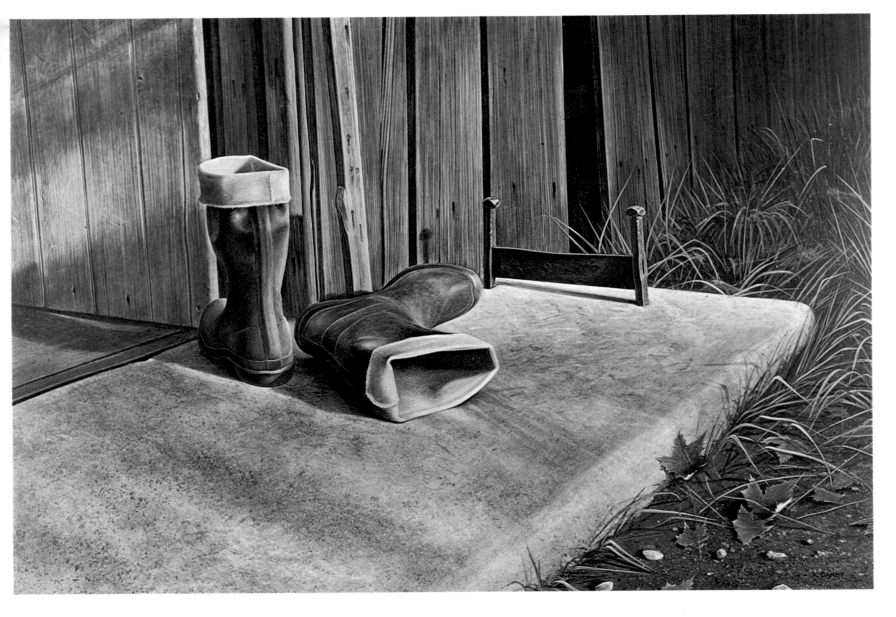

*Boots*; 1969 Egg Tempera 16 x 24; Mr. and Mrs. John Hanson, Holidaysberg, Pennsylvania

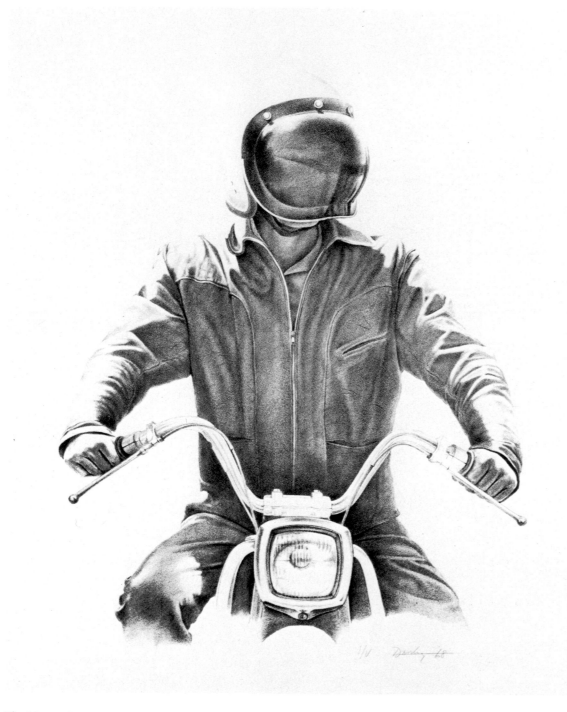

*The Motorcyclist*; 1968 Lithograph 23 x 18; Edition of 50

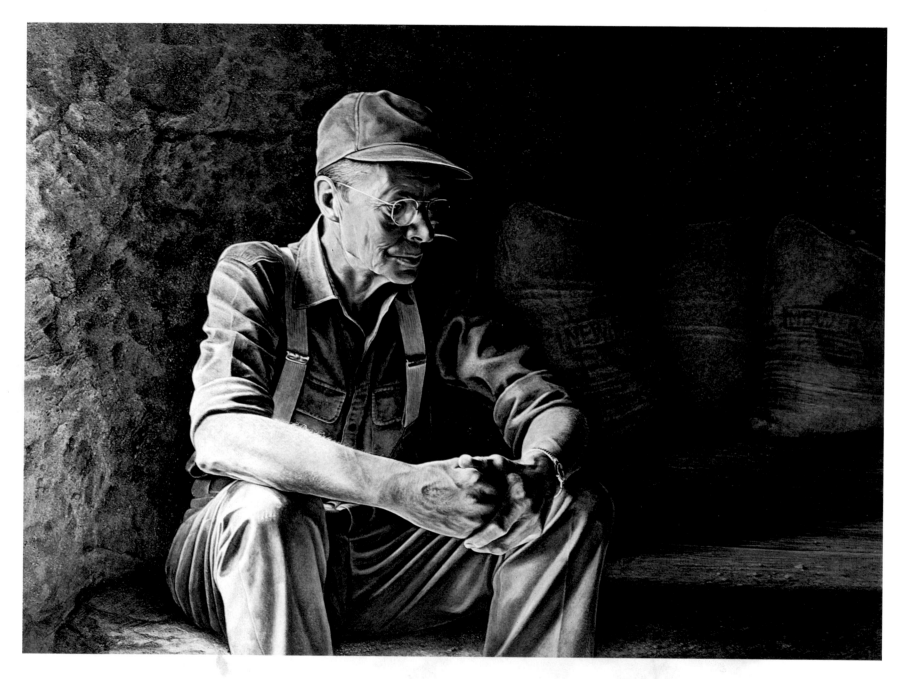

*The Armstrong Miller*; 1970-71 Egg Tempera 38 x 52; Mr. and Mrs. Julie Hanson, Toronto, Ontario

Danby's interest in machinery and local activities came together in a major 1968 tempera *Pulling Out,* an image as contemporary as the Armstrong Mill is ancient. The creative commuting between old and new themes, or the surprising juxtaposition of them in the same composition, has a fascination for Danby. "A motorcycle or sportscar and a millstone or butter churn have the same validity as subject matter as far as I am concerned," says Danby. "They both bear a close relationship to humanity and as objects they share an equal timelessness." Certainly, no Canadian artist has painted machinery with more accuracy or interest than Danby. The rendering of the motorcycle in *Pulling Out* has the same vitality as the depicting of the rider. The two are part of the same steed, and the featureless bubble over the model's face only adds to the impression of this unity of power. *Pulling Out* is another example of Danby's carefully plotted division of a picture space to obtain a dramatic effect. The open left half of this painting is the important space in the mind of the rider as well as an effective pictorial device. Since the machine is about to pull out to the right, it is from the open left half of the frame that danger might appear. The full and familiar tension of "pulling out" into traffic is captured here in the turn of the wheel, the shift of the head, and the flat foot about which the entire action pivots.

Once again, as in *At the Corner,* the subject is bathed in the hot, harsh, full midday light of summer, with all the problems of cast shadows and glaring reflections it offers the painter. It says something for the integrity of the artist that he has not avoided the harshness of midday, with its demands for full attention to detail, texture and chiaroscuro. "I decided early," Danby admits, "that if I was going to learn to control the full range of treatment available to egg tempera, I had better begin with the subjects that offered the toughest problems." *Pulling Out* presented Danby with plenty of problems in draughtsmanship, presentation and technique. His success in solving them and the technical finesse evident in it and in *The Mill Cat* of the same year prove how far his problem-seeking had taken him in a mere five years of tempera painting.

The fact that Danby now possessed a mill of his own did not stop him from continuing his exploration of other mills. Thus he happened upon the theme for *The Mill Cat* at a mill in Bruce Peninsula, while on a brief sketching trip in 1968. (Danby usually took a few weeks each spring to travel and relax after a heavy schedule in the studio during the winter and before he settles back into the studio for the summer.) There are always cats around a mill due to the problem of mice, and the young cat in Danby's painting is one of a pair he found playing around feed bags waiting to be removed from a loading dock. (Another mill cat from the same trip appears in the winning dry brush watercolour *Grooming*.)

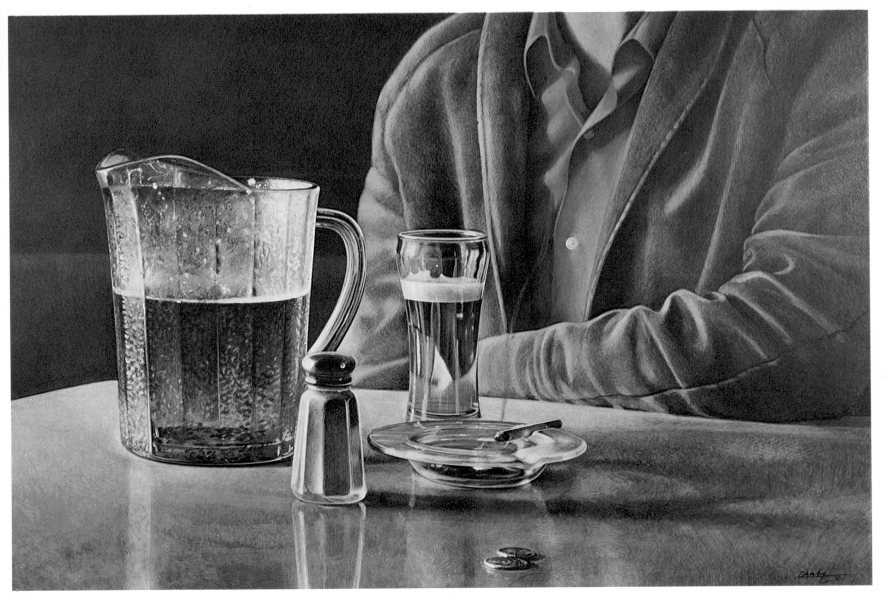

*Draft*; 1971 Egg Tempera 16 x 24; Mr. Armand Ornstein, Paris, France

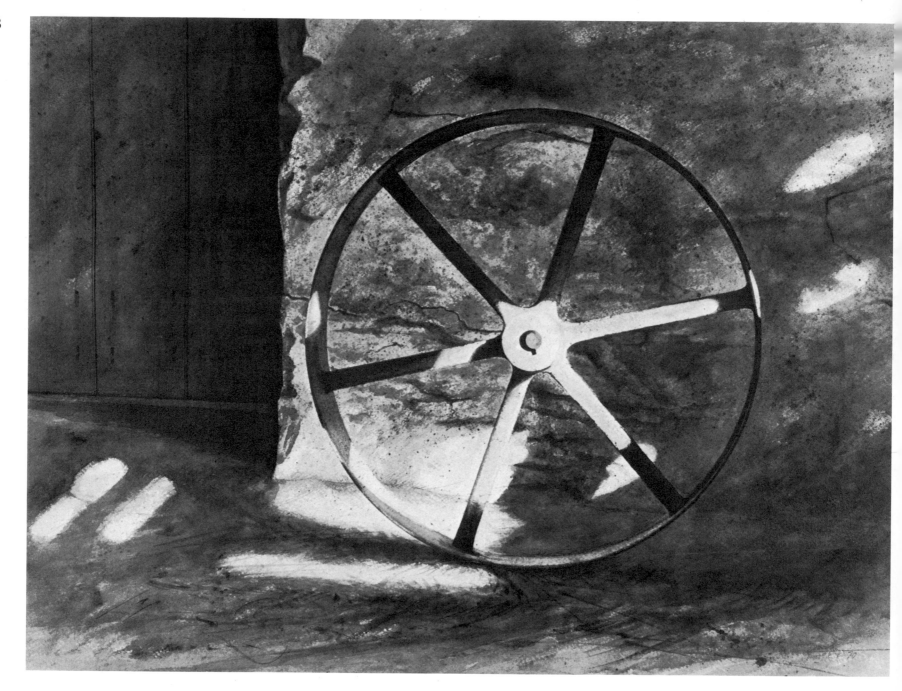

*Pulley Wheel*; 1970 Watercolour 20 x 28; University of Guelph, Guelph, Ontario

When I first met Ken Danby, he lived in a bachelor apartment on the sixth floor of an eight-storey apartment building on Toronto's Park Road, a few hundred yards from the Studio Building where the Group of Seven was founded and which once housed J.E.H. Macdonald, Tom Thomson, A.Y. Jackson and other major Canadian painters. Danby lived on Park Road from November 1963 to May 1964. Sharing his apartment was the black cat, Kimbo, who was the model for Danby's first egg tempera painting *Fur and Bricks*, started at the Fifth Peg and completed in late November 1963 at Park Road. (Danby painted five other temperas in his Park Road apartment — *Old Will, Dorothea, Kristine, The Old Farm House,* and *Swallow's Haven*, plus nine drawings.)

*Fur and Bricks* was a significant work for its creator. It introduced him for the first time to the classic egg tempera medium which he was to continue to use from then on, exploring and expanding its creative possibilities with a growing mastery. *Fur and Bricks* also first brought Danby's work to wide public and critical attention. Submitted to the Montreal Museum of Fine Arts Eighty-first Annual Spring Exhibition (April 7 to May 3, 1964), the painting won a prestigious Jessie Dow Prize. Much more significant than the cash award of $250 was the importance of the recognition by a prize which had formerly been won by such celebrated Canadian painters as A.Y. Jackson, Maurice Cullen, J.W. Morrice, Clarence Gagnon and William Brymner.

*Fur and Bricks* lacks the technical assurance and finesse of Danby's later egg temperas, but it is a remarkable performance for a first essay in a difficult medium. Its paste-like opacity in certain areas is compensated for by the overall directness of handling. It is a successful portrait of a pet which meant much to its artist-master. The painting also introduces the plate-like clear blue sky which serves as a backdrop for almost every picture by Danby through the middle 1960s.

The opacity found in the sky of *Fur and Bricks*, however, is quickly replaced by a translucent luminosity as Danby gained greater ease with the egg tempera medium. Applying large areas of gradated tone is one of the most difficult achievements in tempera painting. As Daniel V. Thompson, the leading authority on the techniques and materials of tempera, wrote: "Nothing is a harsher test of a tempera painter's skill in his medium than this very problem, a graded blue. Even competent painters often make broad, light gradations chalky or streaky for want of a thoughtful handling."

Danby's early use of open, cloudless skies has been a subject of considerable criticism, including references to its being "artificial" or "formula". However, anyone who has lived in Canada for any time must have observed that our skies possess just such bald, cloudless

complexion much of the time. The light which dominates the Ontario landscape is frequently a hard, metallic light and Danby's paintings have recorded this, however naked it may appear to romantics in search of thunderheads, mist or cumuli.

For Danby, *Fur and Bricks* was the fruit of two things coming together: his rapidly growing dissatisfaction with abstract styles as a means of personal expression, and a visit to a major Andrew Wyeth retrospective exhibition staged by Buffalo's Albright-Knox Art Gallery in November 1962. Danby's return to the representational style that had preoccupied his youth was confirmed by that Wyeth exhibition of 148 works.

"The Wyeth show was both a revelation and an affirmation," says Danby, and well it might have been, since it included such realist masterpieces as *Christina's World, Miss Olson, Brown Swiss, Ground Hog Day* and *Wind from the Sea.*

Danby also was impressed at the Buffalo exhibition by Wyeth's use of egg tempera as a painting medium (which Wyeth had learned from his brother-in-law, Peter Hurd). From then on, Danby made the tempera medium his own, but utilized completely different technical methods from those used by the American master.

Ever since *Fur and Bricks* Danby has been charged, from time to time, with being a "Canadian Wyeth," as though the facts that he paints in egg tempera and uses themes from the country region in which he lives justify such a description. There is no close relationship between Wyeth and Danby in the way they use colour or tonality. Nor is there any close similarity in their actual technique and the resulting textural surfaces of their paintings. Wyeth, for the most part, confines himself to earth colours using a low-keyed palette; Danby, from the very beginning of his realist career, has favoured a much more chromatic, high-keyed approach.

While discussing the Wyeth comparisons which so readily spring to less subtle minds, another simplistic accusation brought against Danby and other Canadian (and American) realists is that "they only paint barns." Danby, it is true, painted his share of rural architecture in the first years of his realist development, but we can only wonder why this should be surprising. Any inclination to record Ontario regional life inevitably entails some proportion of farm life, and such minutiae as pumps, millstones or fenceposts. After all, the barn and farmyard have supplied vital pictorial themes for North American painters since Winslow Homer and Eastman Johnson, through William Harnett and Grant Wood to Charles Sheeler, Georgia O'Keeffe, Charles Burchfield and Stuart Davis. Criticizing artists for painting rural themes in agriculturally dominant countries such as Canada and the United States is as footless as berating Toulouse-Lautrec for confining

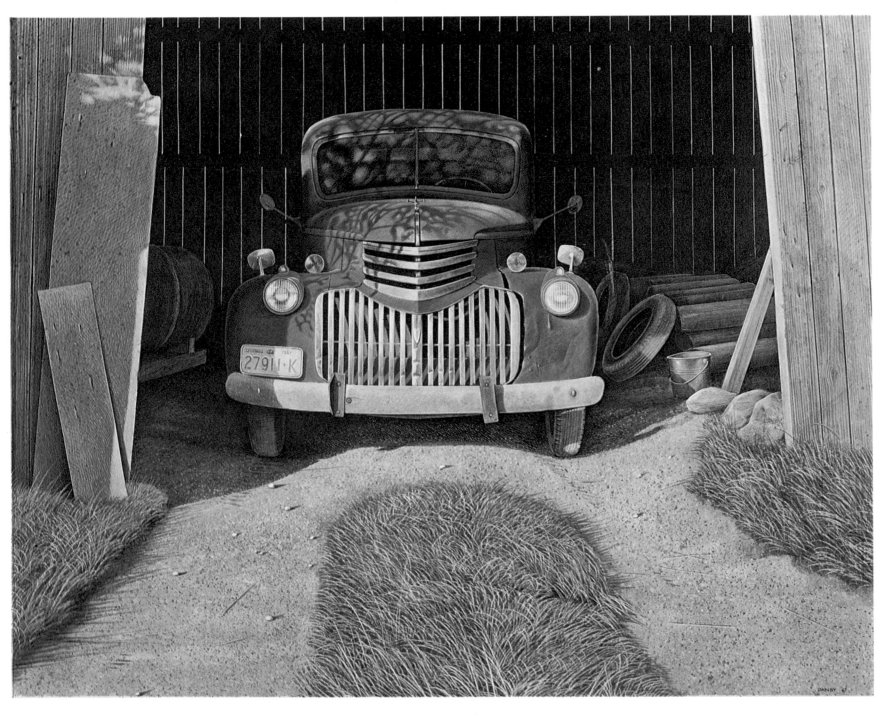

*The Pickup*; 1967 Egg Tempera 22 x 28; Mr. and Mrs. Julie Hanson, Toronto, Ontario

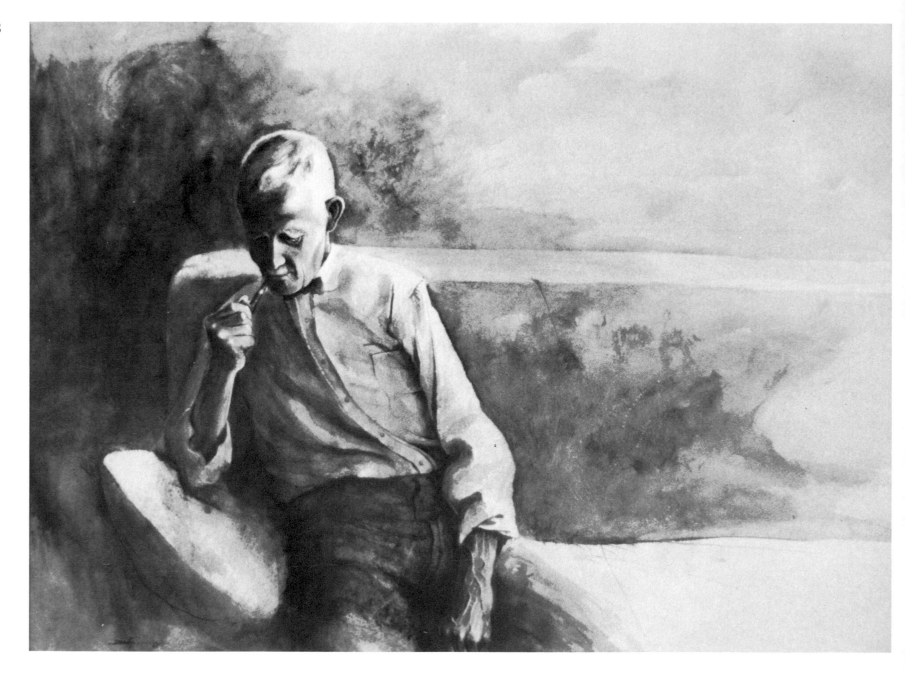

*Mr. Buckley*; 1965 Watercolour 20 x 28; Mr. and Mrs. E. Danby, Sault Ste. Marie, Ontario

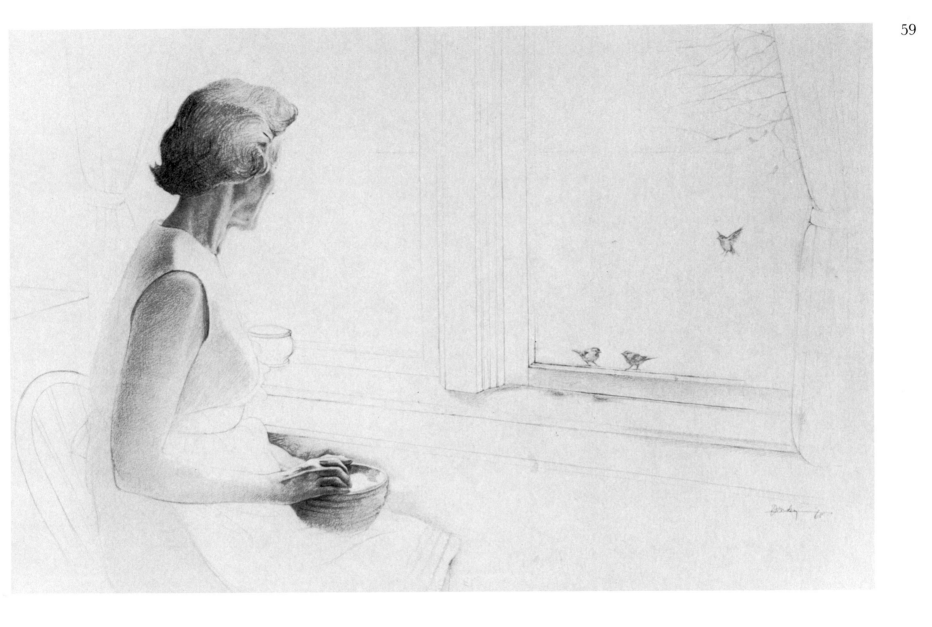

*Study for At the Window*; 1968 Pencil Drawing 16¹/₄ x 23; Mr. and Mrs. I. Waltman, Willowdale, Ontario

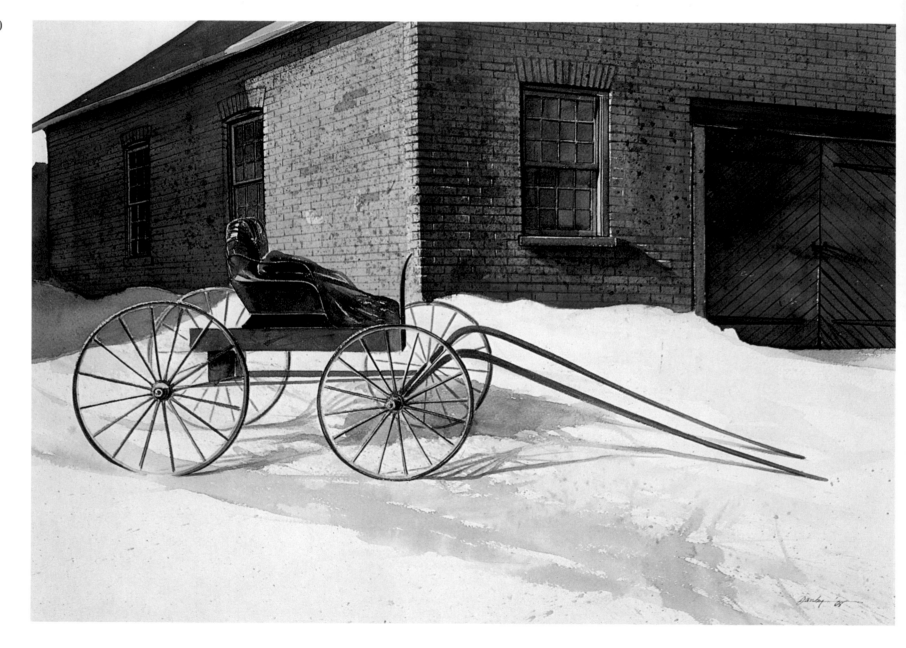

*Martin's Shop*; 1968 Watercolour 22 x 28; Private Collection, Toronto, Ontario

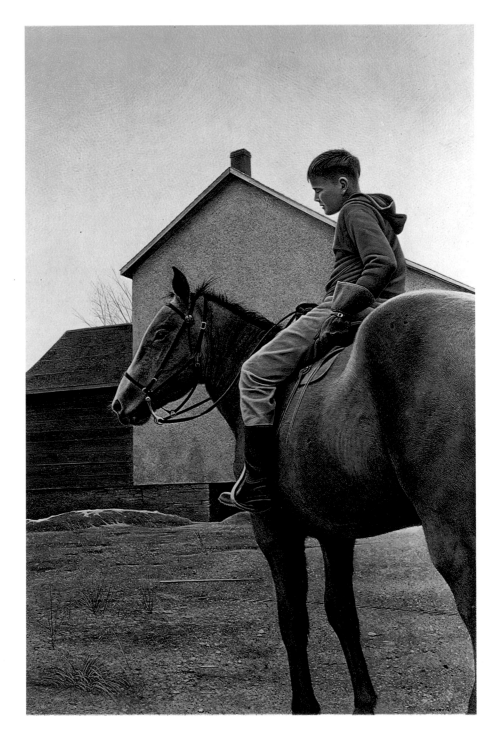

*Pony Rider*; 1967 Egg Tempera 36 x 24; Mr. F.M. Rolph, Montreal, Quebec

much of his art to Parisian café life, or condemning Mondrian for painting squares. The fact that many untalented, part-time painters also depict barns means no more than that equal thousands of similar people enjoy doing portraits of their friends or flowers. The thematic preference of any artist is a weak basis for critical attack.

The Wyeth exhibition at Buffalo only fortified Danby's decision to concentrate on a realist approach. At the time he had already left abstraction and was in the midst of completing a representational composition in oil. The first paintings he did after his return from the Wyeth show were three oils: a portrait of a wicker chair in an empty room, a view of the mooring dock on St. Joseph Island and a still-life, *Fish and Rocks*, the most successful of the three. An almost monochrome composition, this last painting represents a single dead and decaying fish against a background of small stones, pebbles, and strands of dry sea grass. It is stark, unprepossessing in theme, and reminds us that Danby has always painted what interests him, whether it is a hanging side of beef, a rusting car or a patch of trilliums, regardless of what might please anyone else.

Technically, *Fish and Rocks* represents a bridge between the artist's abstracts and egg temperas. It is executed in a lean, thin oil colour, with a draughtsman's precision. Each pebble is modelled with individual precision within a pattern that lies flat to the canvas plane in an almost abstract way. The textural treatment relates closely to the early temperas that followed, including the use of a spray texture achieved by slapping a brush against the hand.

*Fish and Rocks* was the last oil painting by Danby. It was followed by *Fur and Bricks*, and henceforth all of his work was executed exclusively in egg tempera, apart from drawings and watercolours. During his time at the Park Road apartment Danby did a number of closely rendered HB graphite pencil drawings. Among these was a memorable small study of his cat Kimbo and the earliest of his many window compositions *Winter Window* (National Gallery of Canada collection), drawn on a New Year's trip to St. Joseph Island. In each of these drawings, Danby has searched out the forms in a deliberate, almost cautious way.

Danby's adoption of egg tempera as a medium proved a crucial decision for his creative career. Here was a medium Danby was immediately at home with, which met his requirements of a painting method wherein he could emphasize his skills and inclinations as a draughtsman in a way he could not in oil. Tempera allows a crisp delineation of form, a luminosity and a control of texture denied modern oil techniques, while allowing the same wide range of pigments. (Realist painters who choose to paint in acrylic colours are,

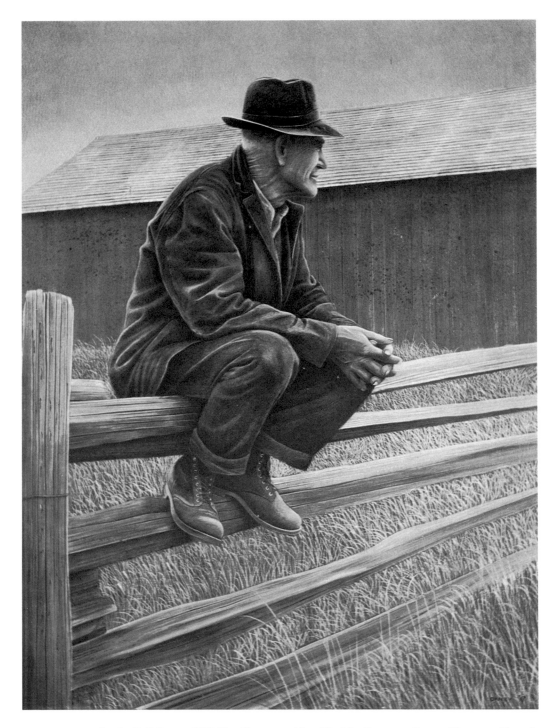

*On the Rail Fence* ; 1967 Egg Tempera 36 x 28; Mr. Seymour Baum, Toronto, Ontario

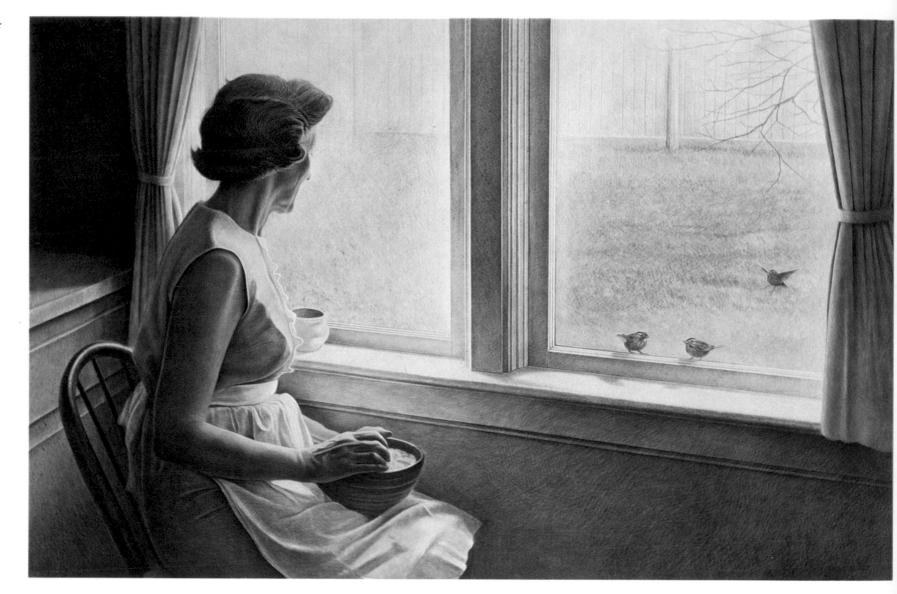

*At the Window*; 1968 Egg Tempera 24 x 36; Mr. and Mrs. I. Waltman, Willowdale, Ontario

in contrast, limited in the choice of pigments available to them.)

With the coming of spring in 1964, Danby felt the urge to relate his realist convictions in painting to the scenes of his boyhood summers at St. Joseph Island, located in the North Channel which links Lake Huron and Lake Superior.

An hour's drive from Sault Ste. Marie, St. Joseph Island is about twenty-five miles long and fifteen miles wide. Recorded since 1650, the island in its early years was a British trading post and the site of a stone fort, the ruins of which are now one of its main tourist attractions. Towards its centre, the island rises to an elevation known to the inhabitants as "the mountain." From the mountain outward are located the farms which export cattle, butter, garden produce and maple syrup to the mainland. Much of St. Joseph's 99,000 acres is covered by the forest stands which have supported its thriving lumber business for a century. The island abounds in points and bays bearing such names as Whiskey Bay, Gravel Point, Mosquito Bay and Canoe Point. Its two main settlements are Richard's Landing and Hilton Beach.

Danby settled from May to October 1964 on the main street of Richard's Landing. There, in a log cabin rented for forty dollars a month, he painted all of the temperas and watercolours for his first one-man show held at Toronto's Gallery Moos from November 5 to 18, 1964.

Danby had first met Walter Moos in February 1963, when he showed the dealer three oil paintings done at the Fifth Peg, plus a number of drawings. Moos had immediately agreed to show Danby's work and has remained his exclusive dealer and agent since, arranging shows in other Canadian cities, as well as representation in the United States and Europe.

That first Gallery Moos exhibition revealed the creative impetus Danby had received at St. Joseph Island, with its abundance of rural subject matter so familiar from his boyhood. In the show were nine temperas, ten watercolours, and four drawings — all of them affectionate, if still tentative, portrayals of his youthful haunts.

Throughout that first realist summer on St. Joseph, Danby had been working his way through experimental technical variations — in brushwork, spatter and a somewhat excessive use of textural pattern. Danby admittedly did strive to represent each blade of grass, each knothole and pebble in the landscape before him, so that at times the proliferation of detail detracts from the overall design and dramatic impact of his compositions. But though their show of skill seems sometimes evident for its own sake, the 1964 paintings laid the groundwork for the increased selectivity and authority to be found in the works that were to follow.

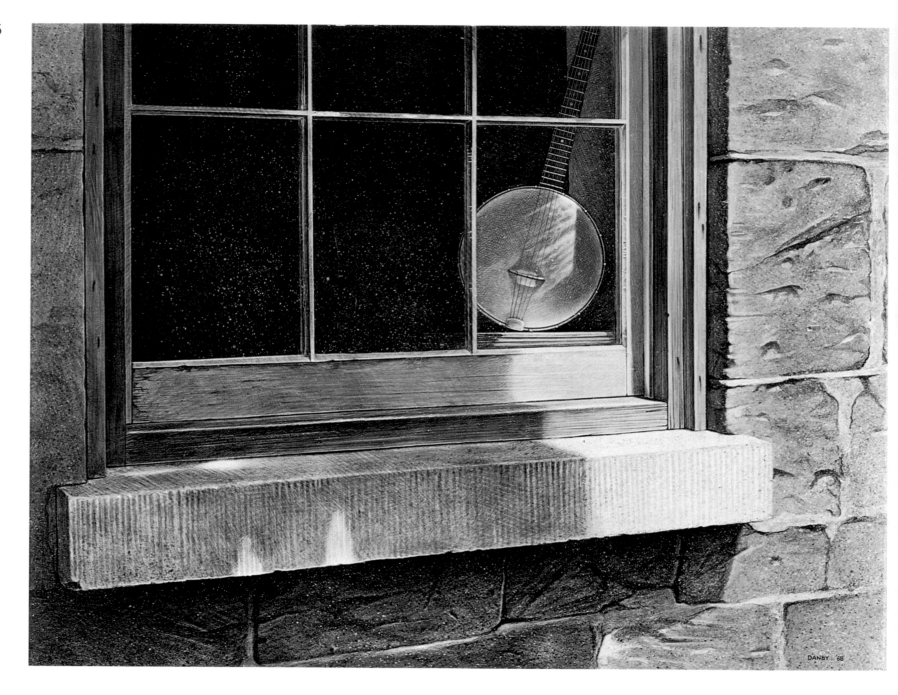

*Banjo Window*; 1968 Egg Tempera 18 x 24; Dr. John E. Morch, Toronto, Ontario

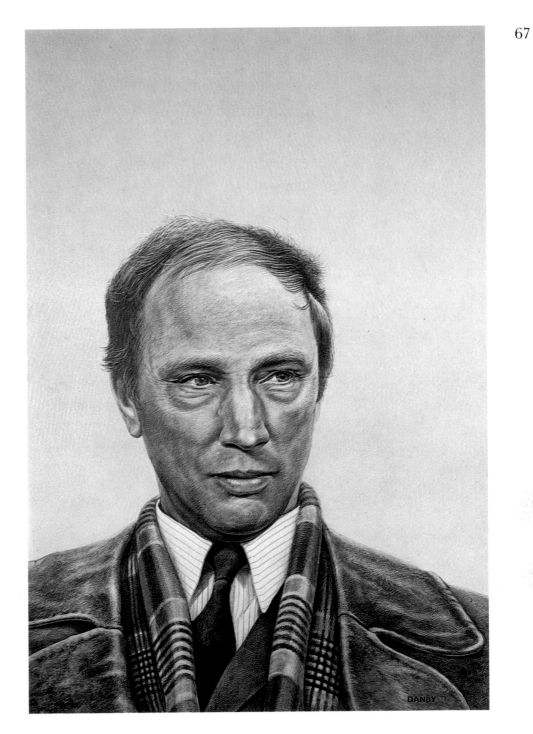

*Pierre Elliott Trudeau*; 1968 Egg Tempera 20 x 14; Time Inc., New York, N.Y.

*Crab Apples* presents an ideal example of the painting problems that preoccupied Danby during that St. Joseph summer. In it, he has engaged in the maximum play of light and texture, applied to the sort of gentle rural theme he was most attracted to. It is not a pretentious painting but, within the limited technical vocabulary Danby then possessed, it conveys its eternal seasonal message in a warm and evocative way.

*On the Prowl,* another ambitious 1964 composition, was the last portrait Danby painted of his cat before it disappeared on New Year's Day, 1965. In it, Danby portrays Kimbo from behind as the pet poises, expectantly, before a dark crevice beneath some cast-off barn beams. The boulders among which Kimbo stands represent Danby's use of spatter, first seen in *Fur and Bricks,* at its maximum. In fact, *On the Prowl* is almost optimum in textural treatment, using engraved scratchings and horizontal streaks as well as spatter. The picture possesses a compelling chiaroscuro, but suffers from a somewhat static rendering.

Although critical response to that first Moos exhibition in 1964 was tardy, the exhibition was a public success. Both *Crab Apples* and *On the Prowl* were immediately sold, along with a number of other temperas, drawings and watercolours. The watercolours, like the temperas, were still tightly rendered and lack the selectivity of detail and fluid brushwork which is so characteristic of the paintings executed a few years later.

It was while on St. Joseph in July 1964 that Danby met his future wife, Judy Harcourt, while attending the Community Parade Night at Richard's Landing. Judy was then an outpost nurse at the northern town of Thessalon. They were married the following year, on March 20, 1965, in the United Church of Judy's hometown, Sundridge, Ontario. The Danbys made their first home in an apartment at 115 Hazelton Street, in the Yorkville area of downtown Toronto. While Ken painted, Judy worked as a psychiatric nurse at the Wellesley Hospital, before the birth of their first child, Sean, on December 15, 1965.

Danby and his family moved from the Hazelton Avenue apartment to a coach house on Warren Road in March 1966. There he was able to organize a small room into a working studio. The coach house delighted Danby's affection for Canadian lore. Its lower floor had once been a stabling area for horses, and the trap door for feed still ornamented the living-room ceiling. Upstairs in the former coachman's quarters, the Danbys had their bedroom, which still had its original wooden walls and flooring. Although located downtown in a big city, the Warren Road home had all of the intimacy of a rustic setting.

It was also the setting, in November 1966, for one of the merriest and most successful post-opening celebrations this writer has ever attended.

Danby's 1965 exhibition at Gallery Moos (Oct. 7 to 20) continued to feature paintings related to St. Joseph Island. It included twelve egg tempera paintings, eight watercolours and three drawings. In this show Danby was already staking out his own landscape territory with such compositions as *Early Morning* (National Gallery of Canada collection) with its hard, clear light, its unremittingly sharp delineation of edge and shadow, and its close concern for the play of texture, whether of brick, wood, roofing or glass. Here it is still too early for people, even in the country, and the only signs of life are in the two birds that cut their way into the distant sky, and another in the middle ground poised to land. *Early Morning* has its antecedents as a theme in such unpeopled canvases as Edward Hopper's *House on Pamet River*, but it is entirely personal in its execution (partly dictated by its different medium) and its objectivity of concept. It also reveals the individual, caramel-like colour which Danby favoured for most of his landscapes of the 1960s.

Apart from *Early Morning*, Danby's 1965 production was dominated by the temperas *Exploring His World*, *Boy on Fence* and *Letting Go*.

*Exploring His World* is one of the most engaging and effortless-seeming of all Danby's paintings. Rendered with surprising freedom for this period, the picture's almost casual composition perfectly suits the pertness of its subject matter — a pigeon strolling confidently midst an oily mess of snow and tire tracks. It is a painting that represents an unaffected, and wholly successful, merging of style and concept.

*Boy on Fence* was the first of many major compositions representing Ontario boyhood that Danby was to paint between 1965 and 1974, ranging from *On His Way* (1966), *Young Master* (1966) and *Towards the Hill* (1967) to *The Runner* of 1969 and *Snooker* and *Sharpshooter* of 1971.

Most Canadian paintings of youth have been limited to static portraiture; rarely have our artists attempted to record our young people at study, work or play. Such canvases as Charlotte Schreiber's *Sleighing on the Credit* (c. 1875, collection Mr. and Mrs. Fred Schaeffer), F.M. Bell Smith's *Return To School* (1884, London Public Library and Art Museum), and Jean Charles Faucher's *Cour d'Ecole* (1941, Musée de la Province de Québec), are rare enough to be remarkable. Danby's candid and perceptive gallery of boys running, bicycling, hitchhiking, and playing games of skill provides an

70

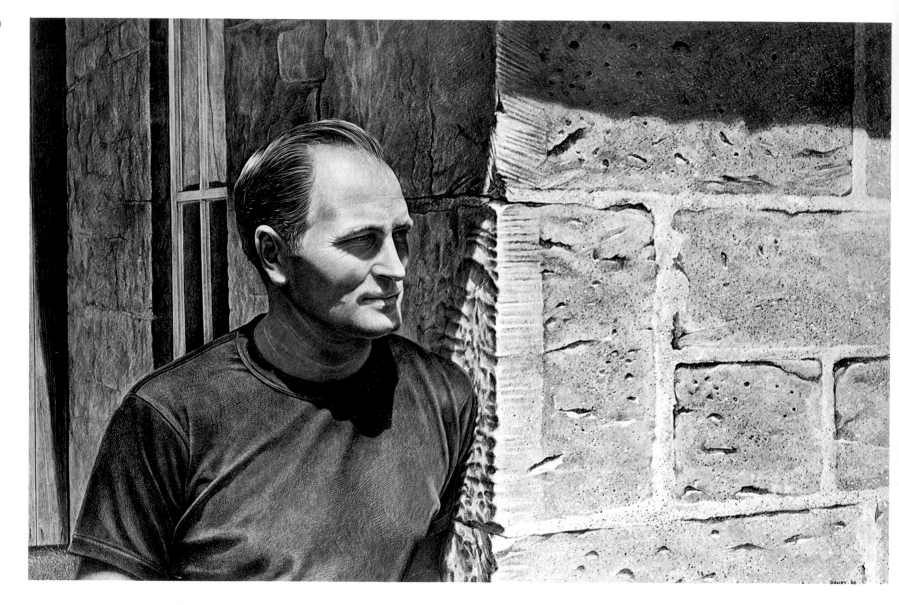

*At the Corner*; 1968 Egg Tempera 24 x 36; Mr. and Mrs. D.B. Cowie, Toronto, Ontario

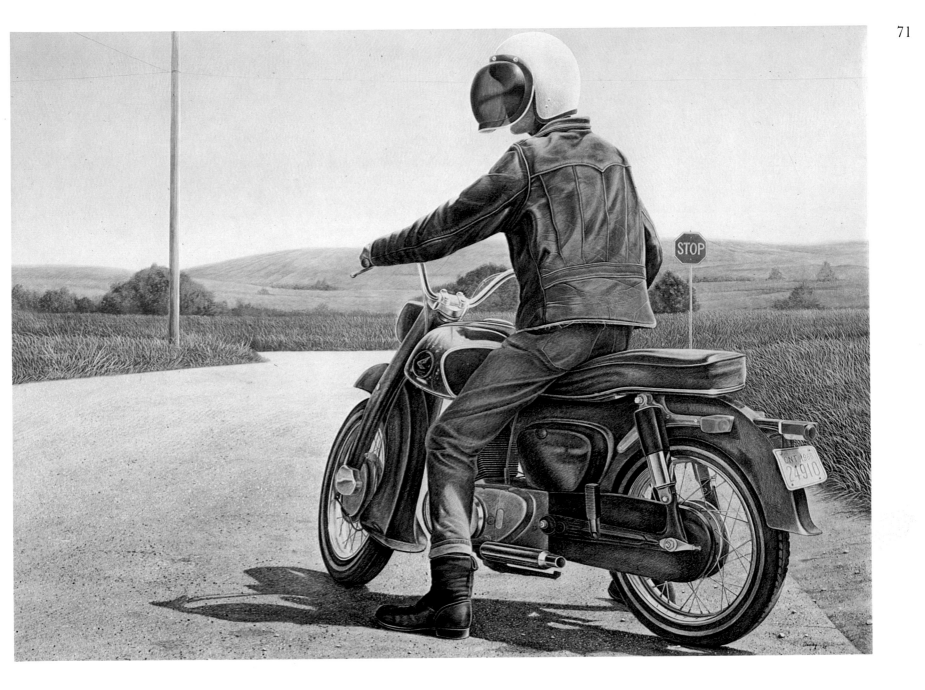

*Pulling Out*; 1968 Egg Tempera 32 x 44; Private Collection, Vancouver, B.C.

unprecedented and evocative record of contemporary Canadian youth. Though they are painted in what might be described as the "constricting" medium of tempera, there is a sense of burgeoning adolescent vitality in the best of these works.

*Boy on Fence* typifies the isolated, single full-length figure composition Danby has favoured through much of his early career. In it the suspended motion of the subject sets up its own abstract tensions of asymmetry within the picture, just as the frozen action and the challenge of the feat of balance holds the viewer subjectively. As in all of his early figure paintings, the figure in *Boy on Fence* is shown in the full light of day, to maximize the dramatic modelling of each part of the subject. At times, in the beginning, Danby's desire to accent every part of an arm, a leg or torso volume becomes dissipated in an abundance of over-accented folds and creases. This desire to reveal *everything* visually is a fault of over-application which has affected the early work of most masters. Only with time do they learn what to subdue, or lose visually, in order to lend a maximum plastic unity to the whole.

The concept for *Boy on Fence* — like so many of Danby's themes — was germinated some time before it was actually put into paint. While attending a showing of the film *Mary Poppins* with Judy, Ken had memories of his childhood activated by the sight of actor Dick Van Dyke doing a pretend tightrope act along a crack in a sidewalk. "That part of the film took me back to my boyhood when I would walk railroad tracks or balance on fences," recalls Danby. "The memory stayed with me and gradually took form as a composition in my mind. I had our local paper boy pose for me until I had what I wanted down on paper. Many of my best pictures have come about long after the initial impact of an idea. Sometimes, it takes years for it to jell into a painting. An image just keeps on recurring until finally I am forced to the conclusion that it must be recorded. Then the problem is to recapture the spontaneity of that earlier impression."

Among the other temperas of 1965 were three that continued Danby's pursuit of the door or window as a theme which had begun the previous year with the St. Joseph Island pencil drawing *Winter Window* (National Gallery of Canada collection) and the egg tempera *Open Window*. The three 1965 variations were *Cellar Window*, *Harvest Morning* and *Under the Loft*.

In a northern climate, the window or door takes on a special significance. In a region where so much of the year is spent indoors behind the protective shield of solid walls, any clear aperture is a reassuring visual link to the outside world. *Winter Sun* is one of the finest of Danby's versions of a window composition looking outwards. In it, four panes of glass

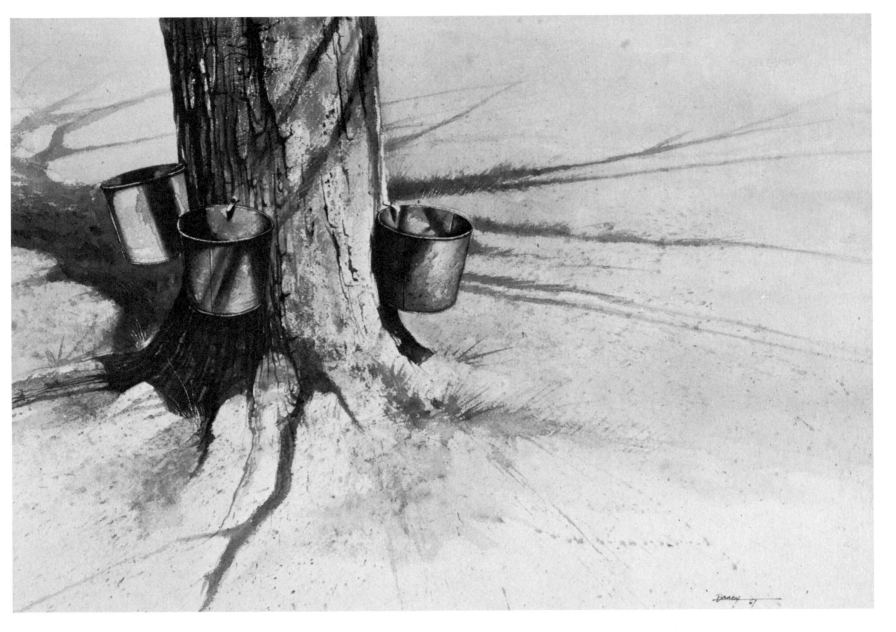

*The Bucket Tree*; 1967 Watercolour 18¹/₂ x 27; Mrs. Judith Danby, Guelph, Ontario

*The Bucket*; 1968 Egg Tempera 18 x 24; Dr. Michael Braudo, Toronto, Ontario

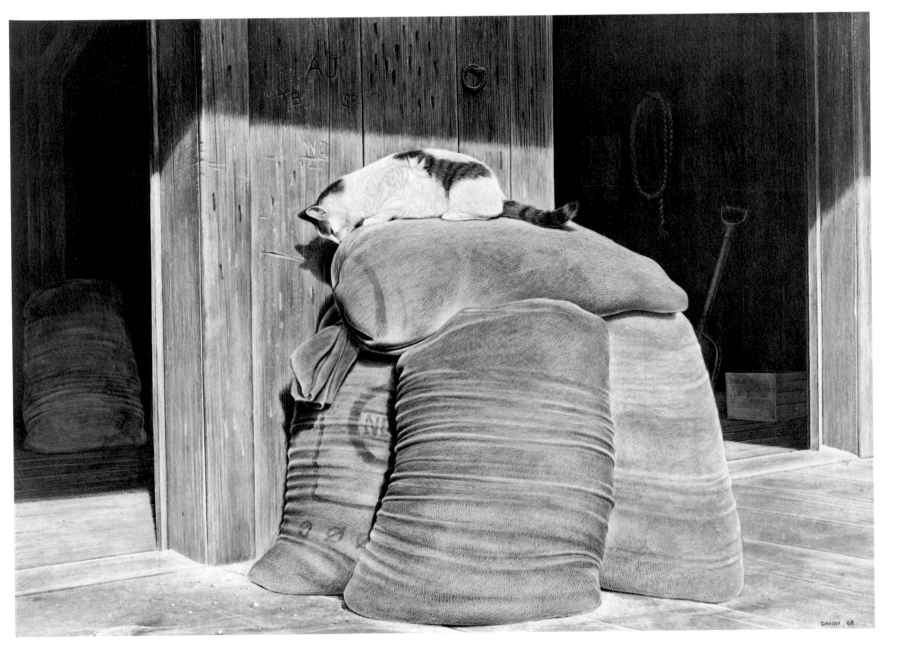

*The Mill Cat*; 1968 Egg Tempera 18 x 25; Mr. and Mrs. A. Green, Willowdale, Ontario

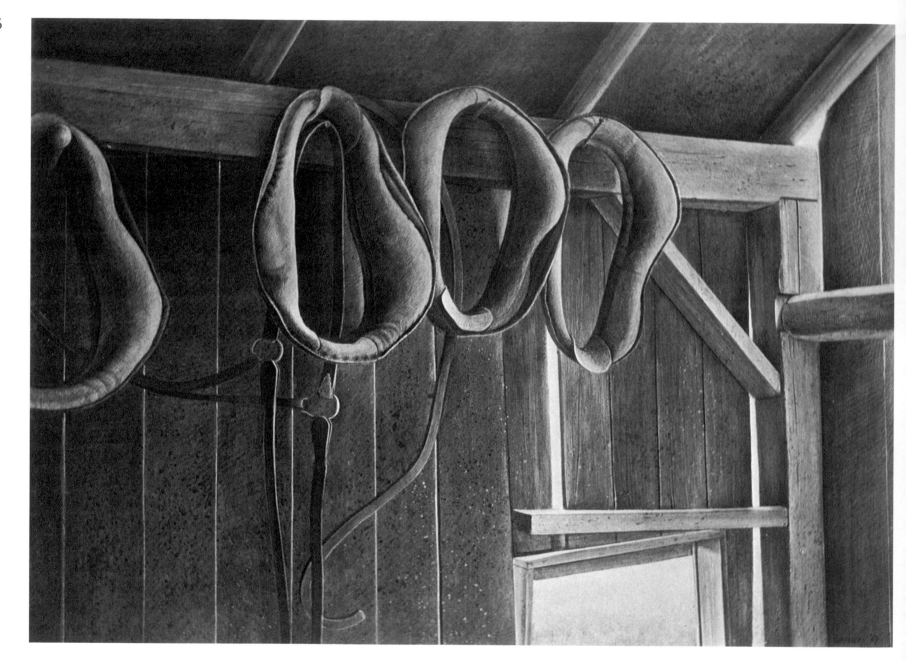

*Horse Collars*; 1967 Egg Tempera 18 x 24; Power Corporation of Canada Ltd., Montreal, Quebec

Inevitably, comparisons are made between *The Red Wagon* of 1966 and Alex Col-
ville's famous dark vision of 1954, *Horse and Train* (The Art Gallery of Hamilton
collection). It is a comparison which is hard to sustain, between artists whose aims, skills
and personalities are very different. However, despite a difference in their ages (Colville is
twenty years older), Danby and the New Brunswick artist do bring a common dedication
and sincerity to their work. Colville, an undoubted pioneer of high realism in Canada
(despite his self-styled role of "primitive"), is involved in a much more conscious sym-
bolism than Danby, and seems less concerned with evidence of technique and
draughtsmanship. In contrast, with every passing year, Danby reveals a remarkable
growth in his skill as a painter, yet his concern with abstract design, apparent from the
beginning, has remained as a formal support of his continuing interest in close and telling
detail. Colville generally foregoes a maximum of sharp-focus detail (with a few remarka-
ble exceptions, such as *Hound in Field*) to achieve an overall air of mystery, but it remains a
fact that in his treatment of the human figure he has not revealed the facility of
consummate draughtsman. His figures have remained simplified and conventionalized,
sometimes even awkward. Colville also takes more ready liberties with natural colour
than does Danby. The accusation of "illustrator" sometimes levelled at Danby could just
as easily, and wrongly, be applied to Alex Colville's *Dog, Boy and the Saint John River*.
Colville deserves the international reputation he has earned during a long career. To use
that success and his greater age to demean other Canadian realists such as Danby
represents a trap into which many ill-informed commentators have fallen. Canada's
younger realists themselves pay ready and fulsome respect to Colville, but they are not
prepared to admit that greater public attention and seniority in time necessarily means
that he will forever remain more than equal. Painters like Danby are now at an age where
Colville virtually began his apprenticeship in tempera. It will take more than a few
decades, and the perspective of time, before comparisons of their total careers in contem-
porary Canadian realism may fairly be made. Danby himself has said: "I would rather my
work be appraised over a period of twenty years, than from one year to the next. I want my
art judged over a period of time, so that transitions may be seen."

The 1966 still-life, *The Rose Bowl*, is a serene and gentle contrast to *The Red Wagon*. It
is pervaded by the quiet light of morning softly illuminating the commonplaces of a
farmhouse bedroom. Despite its pristine aura of tidiness, *The Rose Bowl* is not a rigid
composition. Its tonal changes and flow of light lend it a unity and radiant strength. It is a
painting which pleasantly weds intimacy of concept to formalism of design.

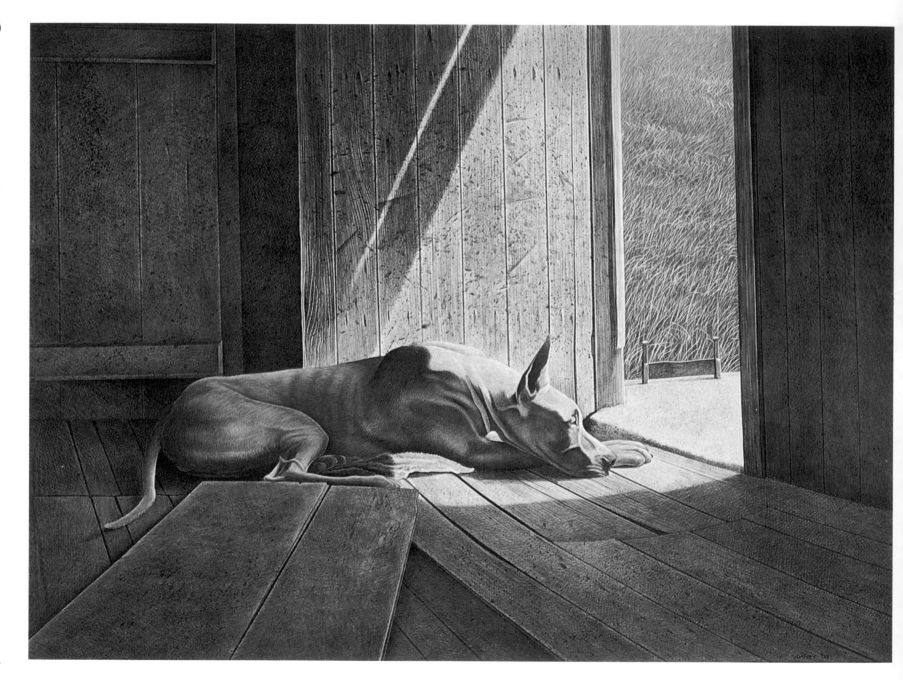

*Timber*; 1968 Egg Tempera 24 x 32; Mr. and Mrs. A. Green, Willowdale, Ontario

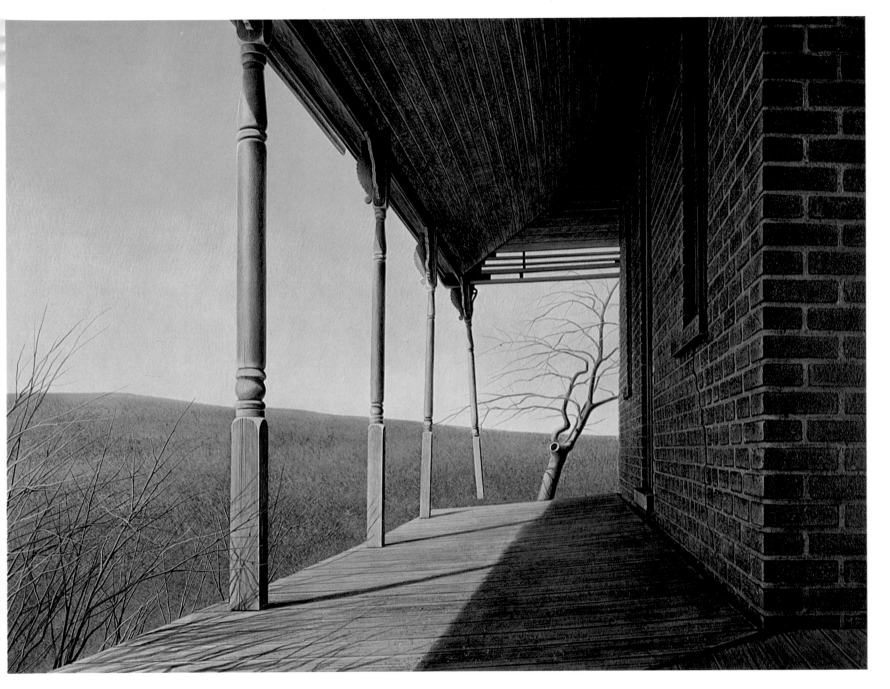

*Along the Porch*; 1969 Egg Tempera 24 x 32; Mr. and Mrs. R.D. Wadds, Stowe, Vermont

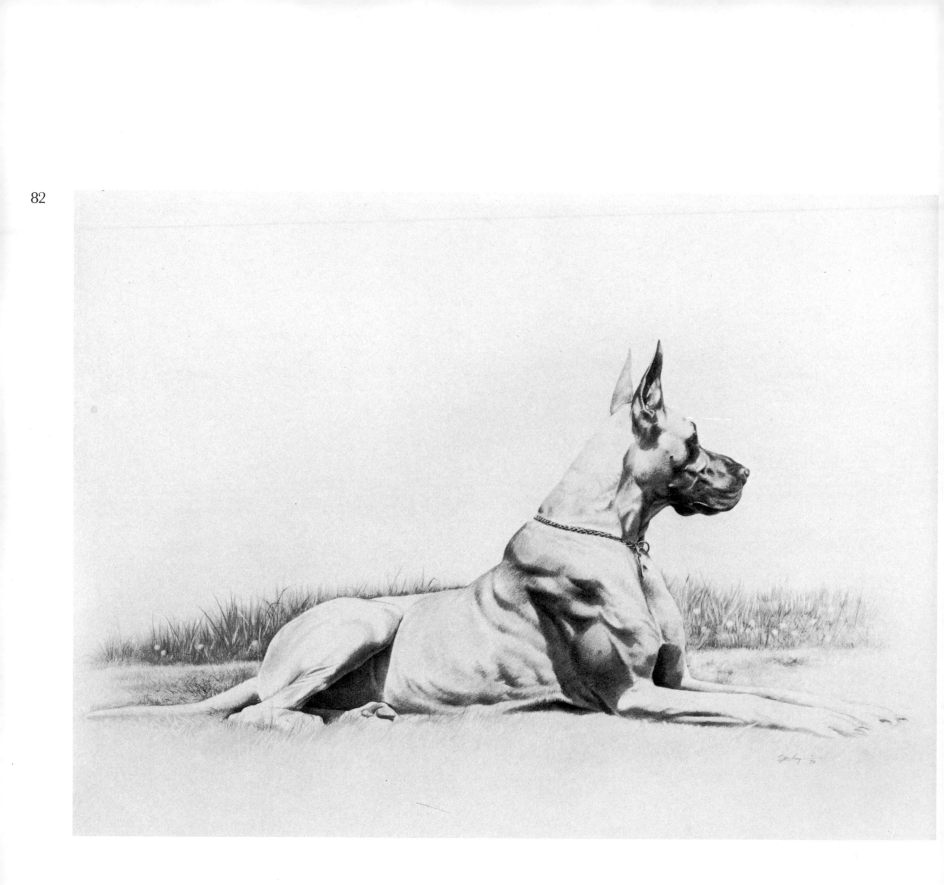

*The Great Dane*; 1970 Pencil Drawing 20 x 28; Mr. and Mrs. Julie Hanson, Toronto, Ontario

Travel and its human dimensions have always interested Danby as an artist. In a country of vast distances, the romance and reality of going from one place to another is culturally omnipresent. Danby has often caught in his paintings the traveller on the move, in mid-passage, and at rest, in a series of paintings involving motorcycles, cars, horse-drawn vehicles, boats, and hikers.

*On His Way* and *St. Joseph Islander* are two such paintings from 1966. The young, windbreaker-clad hitchhiker in *On His Way* is caught at a point of pause, with the compositional emphasis directed leftward to the space beyond the picture frame, towards where the possible and unseen traffic would approach. In the foreground the long cast shadows of early morning cut across the tire tracks on the shoulder of the highway. The sense of adventure involved in solo travel for the young boy has not changed since Huckleberry Finn, and in *On His Way* Danby has captured a romantic commonplace of the mechanized twentieth century, where the automobile has replaced the riverboat and black streams of asphalt take precedence over water. The gradual phasing out of modern water travel is symbolized in Danby's *St. Joseph Islander*. Still running when he painted it in 1966, the ferry it portrays has since been discontinued and replaced by a bridge. The reality of plying back and forth between the mainland and the island docks which Danby had enjoyed since childhood has now become a memory retained in this small painting. *St. Joseph Islander,* with its crisp, geometric design and carefully honed finish, is as close as Danby ever came to the cool art of such American realists as Charles Sheeler, except for the fact that Sheeler painted his trains and factories devoid of people, while Danby, with his abiding interest in humanity, includes in his painting a figure intent on the horizon ahead.

*Young Master* of 1966 represents a definite pause in time. Certainly its subject, a young neighbour, seems to be perfectly satisfied lounging where he is, just gazing out at his dog. One of Danby's most restrained compositions, it is a straightforward report of boyhood. The vertical pole and the simple horizontals stressed in the foreground and horizon emphasize the stillness of the moment.

The symbolism and drama of communications have played a special part in the art of the New World where, unlike in Europe, the distances are readily measured in hundreds and thousands of miles, and where the automobile, train or bus means the difference between staying in the city or visiting the cottage, or remaining in the country unable to visit the city. In the minds of most North Americans, the automobile, in particular, has become a virtual necessity and a mark of social status. It has also become a part of our

84

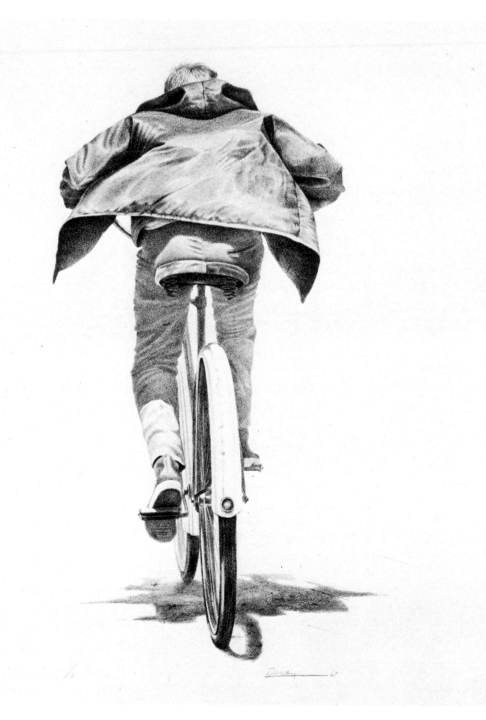

*The Cyclist*; 1967 Lithograph 23 x 18; Edition of 50

cultural legend, in folk song, motion picture, literature and painting. The automobile appears in the canvases of such diverse twentieth-century American painters as John Sloan, Childe Hassam, William Glackens, Charles Burchfield, Thomas Benton and Edward Hopper. (The latter was even more attracted by the gas station itself and the capsulated world of the railroad.) In Canada, the Model T made fleeting appearances in the work of such artists as Adrien Hébert, Carl Schaefer and George Pepper, while Montreal's Philip Surrey can be described as our visual bard of the contemporary four-wheeled chariot, complete with its satellite world of highways, crosswalks, stop lights and pedestrians.

Cars have played an important role in a significant number of Danby's paintings executed over a period of years, beginning with the abandoned hulk portrayed in *From the Summer of '38*. Danby was clearly compelled in part by the formal and technical problems posed in depicting man's favourite piece of machinery. Its hard-edged torso and incessant mirrored reflections of chrome and glossy paint are a world away from the stock themes of painting. The automobile's very banality and social omnipresence is a challenge to evocative picture making for Danby. Such works as *The Pickup* (1967), *Still Running* (1969), *His MGB* (1971), *On the Hood* (1972) and *Summer Driver* (1973), are concepts which, by their freshness of vision, must overcome the stereotypes of the advertizing agency renderings and photographic versions which make their daily appearances in newspapers and on television screens. Automobiles have a mythical and philosophical significance for Danby. Whether abandoned or manifest with their masters, he sees them as important icons of contemporary pride (*His MGB*), power (*The Pickup*), or communion (*The Special*).

The blue-black hulk in *From the Summer of '38* has been abandoned in the same long, tawny, late summer grass which appears in the majority of Danby's landscape settings throughout the 1960s and it is backed by the same wavy horizon line which is found in such other works of 1965 and 1966 as *The Sentinel* (C.I.L. collection), *Young Master*, and *The Red Wagon*. About *From the Summer of '38* Danby says: "The automobile as an image was something I was reluctant at first to tackle. I didn't know whether I could turn such a commonplace object into a painting, but then I thought that the cutters and wagons and horse fittings I had already painted were once commonplace. For me, *From the Summer of '38* is just one more tragic object of modern man's wasteful culture of disposables. It is simply the corpse of a convenience, but also, I feel, very much a pictorial sign of our times."

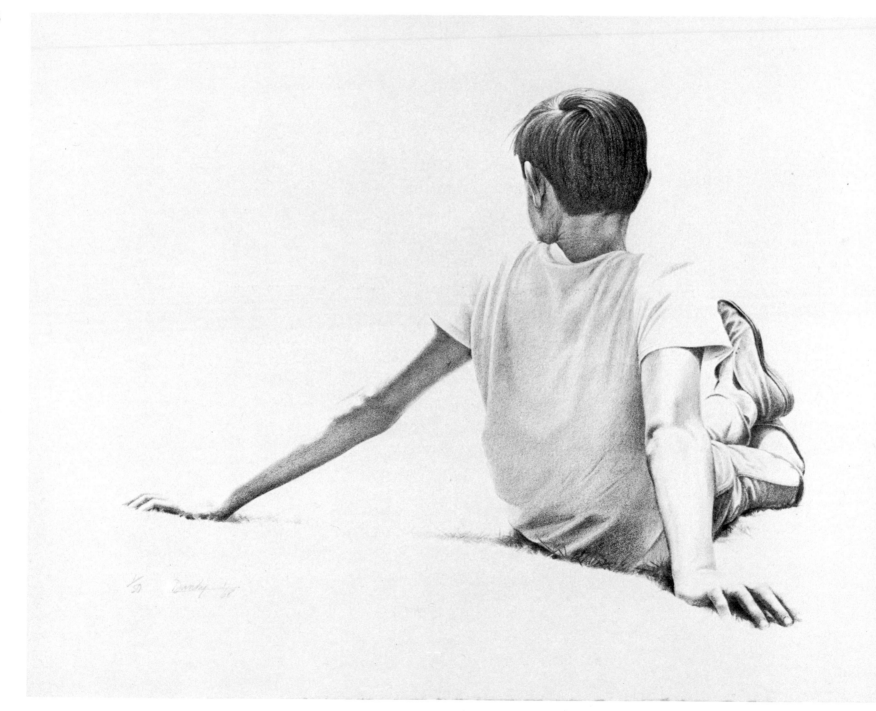

*Looking Off*; 1968 Lithograph 18 x 23; Edition of 50

By 1967, Danby's one-man show at the Gallery Moos had become an annual event. The 1967 exhibition, held from December 7 to 19, presented a collection of thirteen temperas, six watercolours and three drawings, all of them depicting rural themes. The featured works were the temperas *Towards the Hill* and *The Elmira Democrat*.

For several years Danby had planned to paint a memento of his own youthful exploits with a bicycle, but the right concept for it escaped him until he saw a boy soaring down a country road on a bike with his windbreaker billowing out behind him, suggesting the heady sense of speed which overtakes youth on such occasions. Danby had earlier attempted to compose a bicycle picture, using local youngsters at Toronto's Churchill Park, near his home. "But somehow," he found, "try as I might, I just couldn't get the sense of action I needed. It wasn't until much later, on a sketching trip near Stratford, that I came upon the boy who is represented in *Towards the Hill*—which only shows, I suppose, that the answer to a pictorial problem comes best when you are relaxed about it. Although I think all the earlier deliberate effort must have recalled to me what I *didn't* want, and helped me to identify the answer when I found it." *Towards the Hill,* which continued Danby's interest in the interrelationship of humanity and its machinery, is one of the most subtly designed and executed of his early paintings. It suggests a triumphant sense of space.

Compositionally, as in so many of his other pictures (such as *On His Way*, 1966, and the later, 1968, *Pulling Out*), the emphasis of the pictorial action in *Towards the Hill* is to the right. The empty left area of the picture sets up a tension against the weighted right side— a compositional device as popular with Danby as splitting the painting geometrically down the middle, as with the telephone pole in *Towards the Hill*.

Danby's fondness for portraying the functional marriage of the old and the new is well illustrated by *The Elmira Democrat*, where the ancient horse-drawn vehicle is loaded at the back with a modern red can of gasoline. Danby found this pictorial contrast at one of the hitching posts which are placed behind the stores on the main street of Elmira, one of the artist's favourite sketching areas. There are many Mennonites in the neighbourhood of Elmira, and Danby has always admired their way of making the most of their simple conveniences. Bonnets and buggies are still much a part of the Mennonite community's life, and Danby, who labours at his craft more than most modern painters, has a great enthusiasm for its tradition of thrift and hard work. The starkly-lit forms in *The Elmira Democrat* are slightly more simplified than most of his works of this period. The horses, with their rounded forms, are more conventionalized than the animal in *The Red Wagon*.

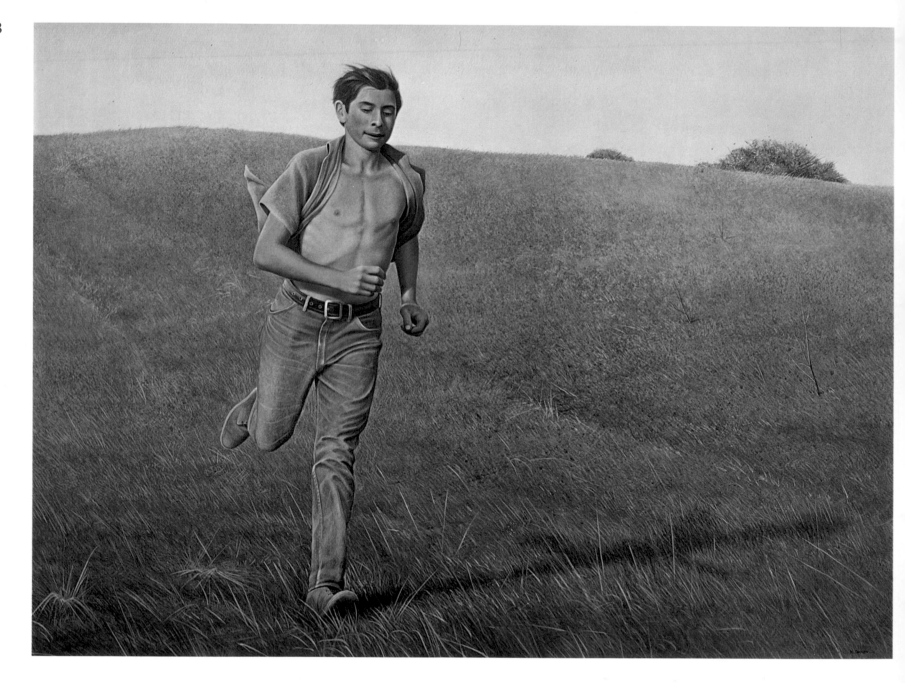

*The Runner*; 1969 Egg Tempera 32 x 44; Mr. and Mrs. I. Waltman, Willowdale, Ontario

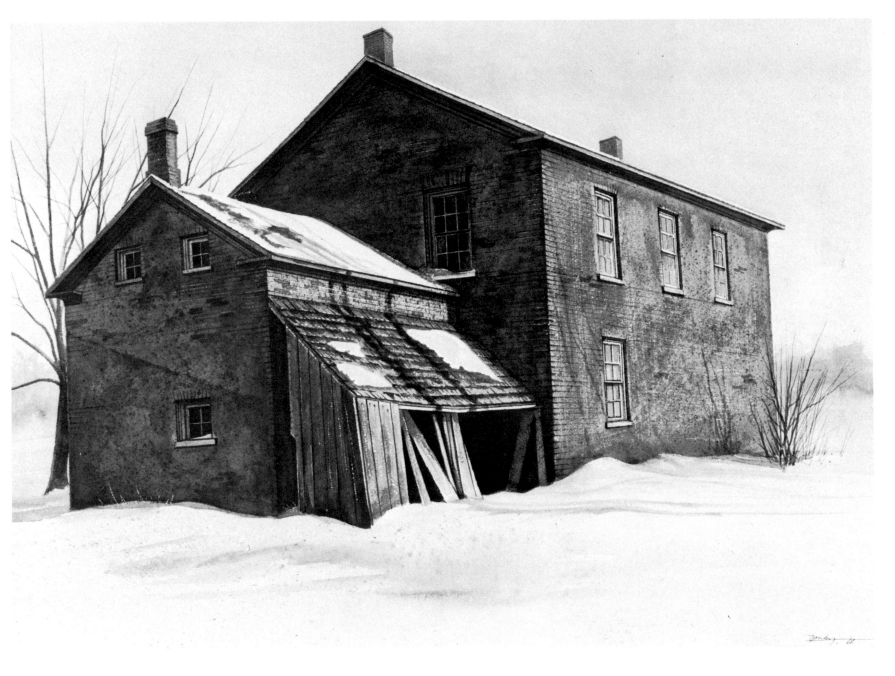

*Winter Brick*; 1968 Watercolour 22 x 28; Mr. and Mrs. John H. Daniels, Willowdale, Ontario

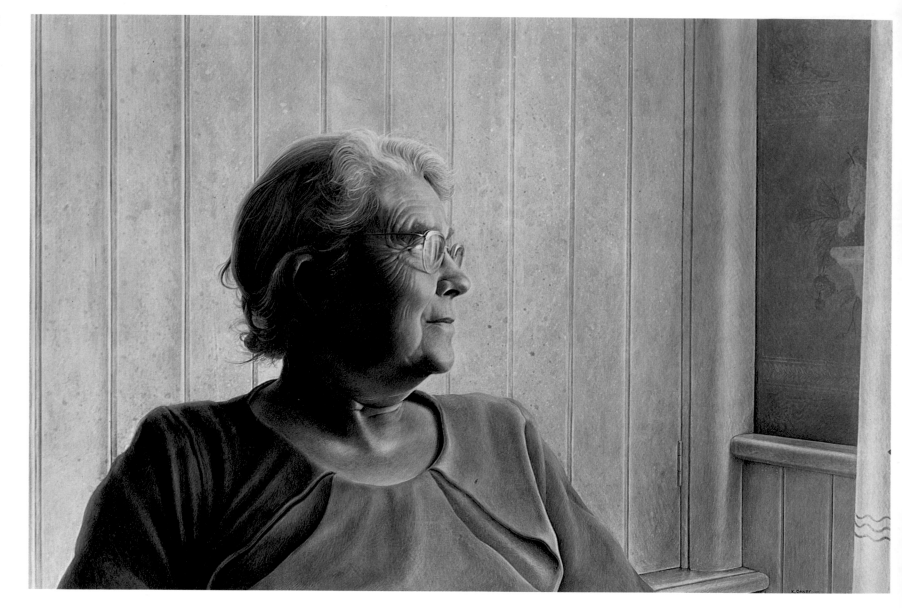

*Auntie May*; 1969 Egg Tempera 20 x 30; Mr. and Mrs. Julie Hanson, Toronto, Ontario

Although its receding linear movement is shut off by the dark mass of shed in the middleground, the deep perspective in this painting has the same graphic impact as in *Towards the Hill.* This compositional device is one that Danby comes to rely on much less in his later paintings of the 1970s.

In *Pony Rider* (1967), the emphasis upon deep recession becomes almost too evident, with the haunches of the horse looming in an almost startling way. Although executed with skill and appealing as a theme, there is a static, snapshot quality about this painting which removes it from such a carefully prepared presentation as *Towards the Hill. Pony Rider* lacks the sense of personal discovery and intensity to be found in most of Danby's major works.

Two 1967 paintings which might be described as contrasting rural still-lifes are *Horse Collars* and *The Pickup.* The subject of *Horse Collars* attracted Danby by its abstract design elements, and the painting is as close to a pure geometric arrangement of forms as anything he had attempted since his non-figurative efforts of the early 1960s. The theme of *The Pickup* had the same formal attraction for him. He had noticed the truck parked inside a drive shed near Guelph. "It was the colour of the thing that first caught my attention," Danby recalls. "The bright red highlight of the metal against the wide expanse of dark interior; the cast shadow thrown by a tree unseen in the picture added a further design element. It was one of those rare cases when the subject presented itself complete. I guess *The Pickup* is the most brilliantly chromatic painting I had done up until that time. It was an enjoyable picture to do, and I used all of my crosshatch, scratching and spatter techniques to compose it."

*Will my work really be worse because, by staying in the same place,*

*I shall see the seasons pass and repass over the same subjects,*

*seeing again the same orchards in the spring, the same fields of wheat in summer?*

VINCENT VAN GOGH

Despite the popular image of artists as wandering Bohemians, most major painters of history have lived in, or longed for, a stable physical and social background. Rubens resided in a virtual palace; Rembrandt, when he could afford it, existed in an atmosphere of finery and treasures; Cézanne enjoyed his Provence bourgeois home; Corot rarely left the comfort of his parents' house; and Renoir was proud of his prosperity.

The comic opera version of the dissolute, starving artist presents the exception, rather than the rule. For every Modigliani, there have been countless others like Renoir or Rodin whose lives were lived, complete with maids, in domestic comfort. The members of Canada's Group of Seven, synonymous in the public mind with the exploration of the wilderness, were, with the exception of Fred Varley, well settled in homes or large studios, to which they returned to paint their canvases after completing sketching trips.

The painter, more than the author or composer, needs a physical base, a place where he can carry on his creative trade with a knowledge of some material stability. He cannot carry around all the instruments of his craft in his pocket like a diary or a sheet of music. The artist needs somewhere to stand his easel, store his paints, pose his models and work in relative quiet. If he does not have such a settled base he is working under a great handicap.

After his marriage in 1965 Ken Danby began to search for a place where he could settle permanently to bring up his family and paint. Although living in Toronto at the time, he preferred a property in a rural setting large enough to provide him with plenty of privacy, but within easy commuting distance of the city. Ideally, his choice would provide an environment with some water and a varied gradation of terrain. The answer to all of these requirements, Danby decided, could be found in the location of an old mill. He had already used mills as central points for sketching trips throughout southern Ontario and so, armed with an Ontario government list, he began a serious and detailed search for available mills.

In the late summer of 1965 Danby came upon a mill site that met all his demands, located four-and-a-half miles northeast of the city of Guelph, the place that his great-great-grandfather Robert Marshall had travelled to in 1858. After exploring the site, called Armstrong Mill, Danby decided one day he would attempt to buy it, and in the spring of 1966 he and Judy approached the mill's owners, George and Violet Parkinson. The Parkinsons rejected their approach, as they had previously done the offers of hundreds of other would-be buyers. Disappointed, but not dissuaded, Danby asked a local real estate agent to pursue his interest in the mill. Despite several early disappointments,

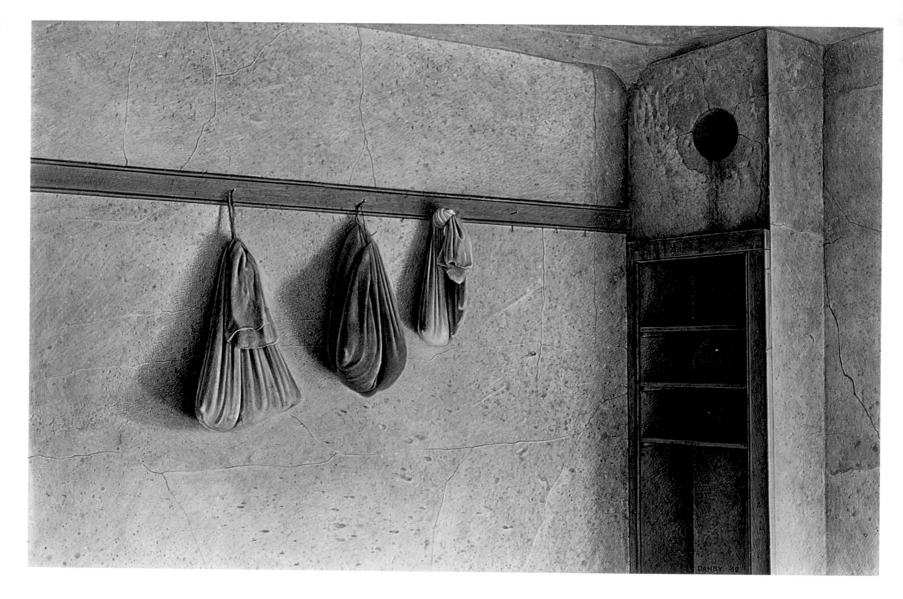

*Seed Bags*; 1969 Egg Tempera 16 x 24; Galerie Claude Bernard, Paris, France

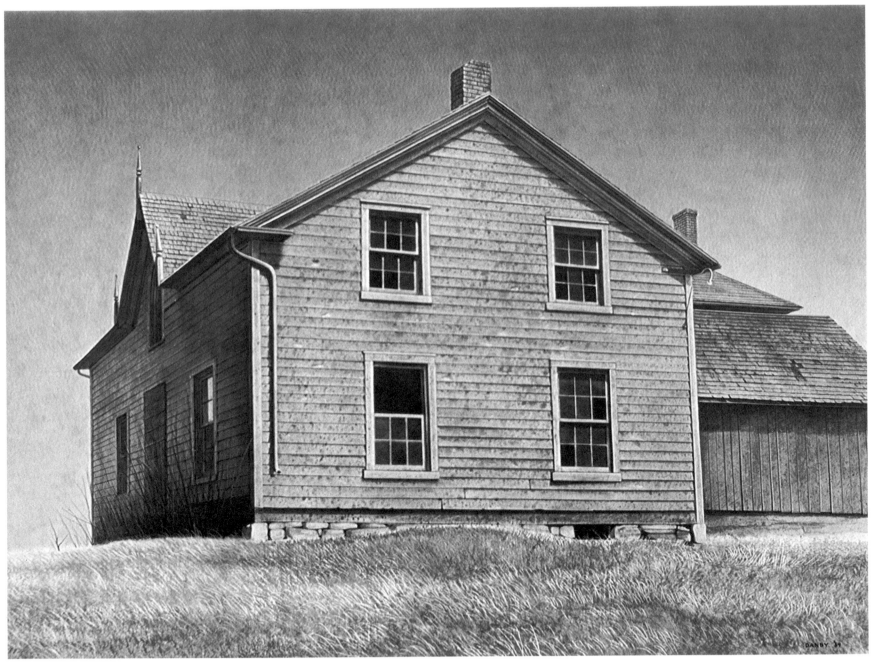

*The Frame House*; 1969 Egg Tempera 18 x 24; Galerie Springer, Berlin, Germany

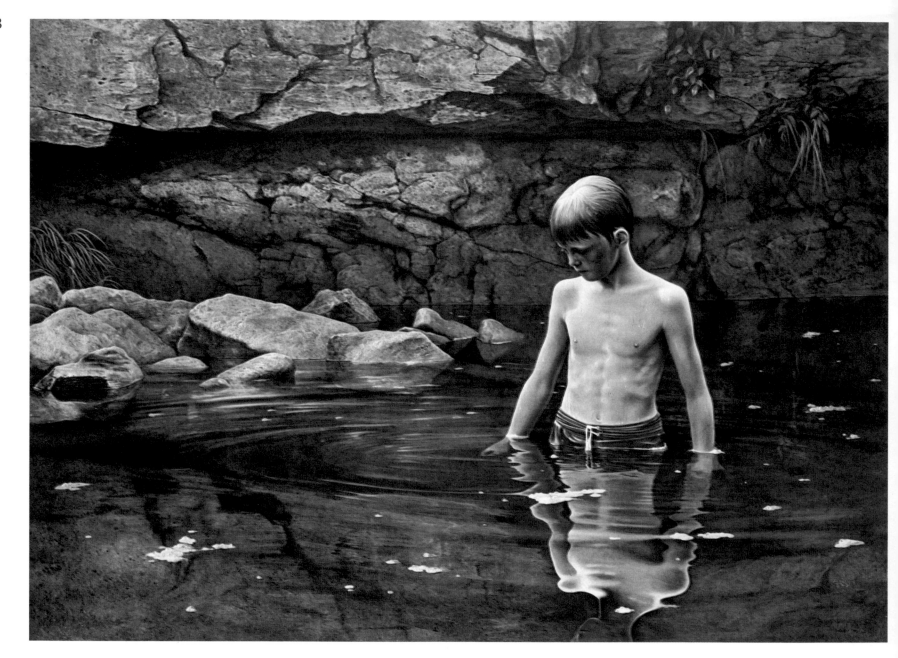

*Reflections*; 1970 Egg Tempera 38 x 52; Mr. and Mrs. Norman Webster, Oakville, Ontario

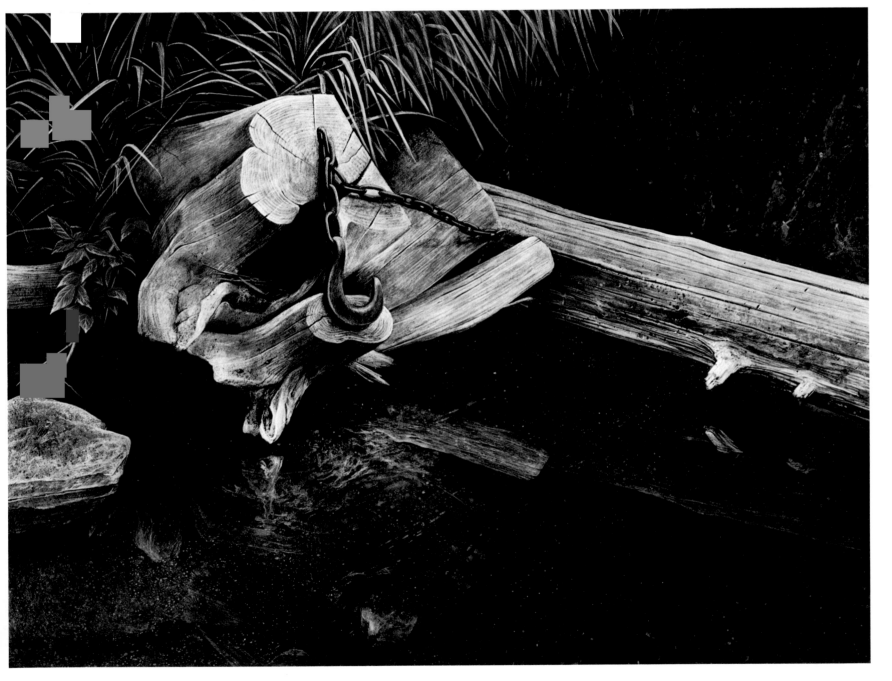

*The Boom Hook*; 1970 Egg Tempera 18 x 24; Private Collection, Edmonton, Alberta

this persistence finally paid off in the late spring of 1967, when an offer to purchase was accepted. The transaction was closed on September 26, 1967.

That September day was a vital one in the history of Danby as a painter and a man. Armstrong Mill, with its eleven-and-a-half rolling acres, provided him with what he considers a perfect environment for both his family and his art. The large mill building and the Speed River which courses through it have provided him with settings for many of his paintings. The mill, which Danby is gradually restoring for a future residence, and the miller's house in which he and his family now live, were both built in 1856. The studio in which he paints was erected in 1969 on the stone foundations of an ancient barn.

The Danbys, with their young son Sean, moved into their 1856 home in December 1967. It is a one-and-a-half-storey structure built from local stone, and contains five rooms on the first floor and four on the second. In an attached shed, swallows return to nest each year and the prevailing feeling of the setting suggests that the house has not only been there for more than a century, but forever.

One of the noblest structures of its kind in Ontario, the Armstrong Mill was built by John S. Armstrong who came to the area in 1824. His nearby agricultural property was called Cranberry Farm, after a cranberry bog which was on it. The mill, originally a four-and-a-half-storey structure, had three pairs of flour stones and a pair of millstones for feed. An overshot waterwheel, with a head of eighteen feet, supplied the grinding power.

Armstrong Mill is the only one in Ontario with a drive-in Roman arch, an architectural feature which occurs in several Danby paintings, prints and drawings. George Parkinson, who owned the mill from 1931 until he sold it to the Danbys, continued to live nearby, and posed for the painting *The Armstrong Miller* in the winter of 1970 – 71.

A little more than three months after Danby had settled at his new mill home, he received a major portrait commission to paint Pierre Elliott Trudeau. Generally, Danby has refused commission projects, particularly for portraits, with their inevitable limitations upon the painter's creative freedom. The only portraits carried out professionally by him previously had been for Mr. and Mrs. Henri Kolin of Toronto, of their children Pamela, Mary and Michael. Even here, Danby had insisted on selecting the poses and backgrounds and the results have none of the static formality of usual commissioned works. Pamela is shown against a tree in the Kolin backyard with the family Golden Retriever. Mary is standing in front of a window displaying a collection of blue glassware. Both portraits have a background of snow and were executed in the winter of 1965; the portrait of Michael against a tree was done the following year.

Danby accepted the Trudeau commission from *Time* magazine because the subject had a fascination for him. "Trudeau," Danby says, "has a truly subtle and difficult face to portray. I couldn't refuse the challenge, although the demands of this particular commission were much more than those of straight portraiture."

Those demands, in fact, came close to impossible to fulfil. The portrait was done during Trudeau's bid for leadership of the Liberal party, and arrangements were made for Danby to join the candidate's entourage and work directly from life. By the time this proved impossible, only four days were left to meet the magazine's cover deadline. On the morning of March 24, Danby drove from Guelph to Toronto's *Time* offices where he was provided with a file of two dozen photographs, most of them useless for his purposes. (Ironically, *Time* colour photographs taken in Newfoundland especially for Danby's use arrived too late, after the painting was almost finished.) Supplemented by his observations of Trudeau television footage and biographical summaries, Danby began his portrait on the morning of March 24, with only a four-day delivery deadline of March 28.

To realize the presentation and composition, he did two complete pencil studies the first day, finishing the painting on the three following days. For four days and nights, Danby worked with virtually no sleep, but the final result was worth the unusual effort. The portrait that appeared on *Time*'s cover of April 12, 1968 is one of the best that the magazine has ever published—and *Time* has commissioned some of the greatest names in world art for its designs. Danby's Trudeau portrait is not only a distinguished painting, it is also a penetrating pictorial analysis of the complex personality of a famous Canadian politician. No single photograph could ever have captured so completely the mobility, sensibility, calculation, and toughness that are combined in Trudeau's features.

The simplicity and totality of the composition and rendering revealed in the portrait despite the urgency of an immediate deadline suggest the new command of his art that Danby had found at Armstrong Mill.

"I consider it one of the very best cover portraits I've seen in nearly twenty-four years at *Time* magazine," said a letter to Danby from the magazine's executive offices. "You did a superb job under a very tight deadline. I was surprised at how well you captured the man's elusive qualities and how extraordinarily alive the portrait is."

A second commission done by Danby, in July 1968, was of a subject for which he needed no photographs and whom he knew well. When the *Ladies Home Journal* requested him to do a two-page spread painting for them, Ken chose his mother as his model. Instead of a rushed four days, he was able to spend four weeks on the painting of *At the Window*.

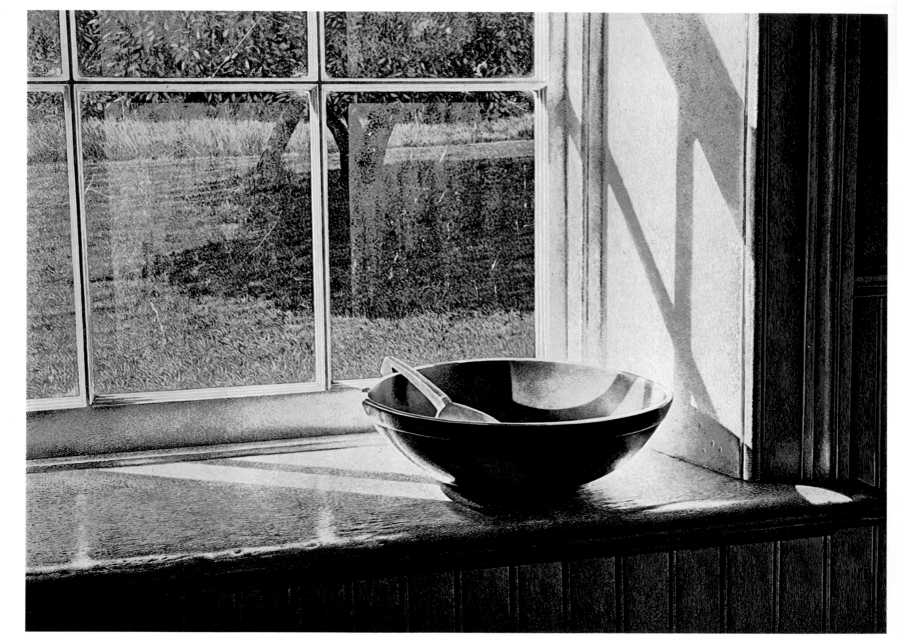

*Butterbowl*; 1970 Colour Serigraph 18 x 24, 21 Colours; Edition of 75

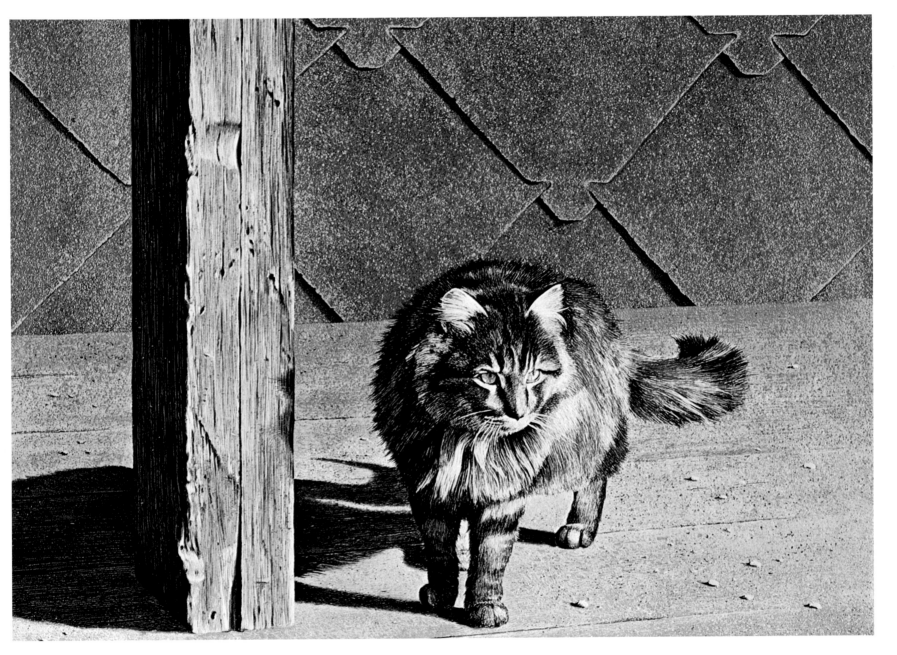

*The Prowler*; 1970 Colour Serigraph 18 x 24, 14 Colours; Edition of 75

Both the artist and his mother enjoyed the experience, and Danby still looks back at it as one of his favourite creative periods.

In *At the Window*, Mrs. Danby is portrayed looking out of a window in her Sault Ste. Marie home at a pair of sparrows resting on an outer ledge. Her aproned figure is dramatically sidelit and the strength of its definition is in strong contrast to the soft rendering of the backyard and fence seen beyond. This is a frank and affectionate study, far from the chocolate box banalities one might expect in a portrait of an artist's mother. The figure is rendered with care, honesty and unquestionable regard. Though the face is partly turned away, one does not question the validity of the portrayal. In its full range of tone from black to white, it represents a further major step by the artist away from the accepted view of egg tempera as a high-key pastel medium, and towards the powerful lighting of such paintings as *Reflections* and *The Armstrong Miller* of a few years later.

The purchase of the Armstrong Mill not only brought rich landscape and still-life material to Danby's door, it also provided him with human subjects in the form of his new neighbours. They are featured in the majority of his figure subjects henceforth. One of them, Les Foote, posed for the painting *At the Corner*. Les Foote lives across the river from Danby and his portrait is a step in what the artist describes as his 1968 desire to "get away from artifacts and paint more of the local people." Danby was impressed by the strong masculinity of Les Foote's features, and after making initial studies of his model sitting in a captain's chair, finally decided to paint a close-up, using the rugged stone wall of the house as a background. The result is one of Danby's simplest and most powerful portrayals. The subject and the setting are flooded with an almost translucent luminosity. Despite the hard contrast impact of high noon light and shade, there is no opacity to be found anywhere in the picture. The cast shadows are kept full of reflected light, and the high whites of the mortar between the stones are subtly held back. As he so often does, Danby has decided to split his picture space almost evenly geometrically, giving it a tension, in this case, of two contrasting halves, one in almost total shade, the other bathed in light. No abstract could possess a simpler basic design. Les Foote usually wore a black T-shirt when around his property, and Danby asked him to wear it for his sittings since it was characteristic and also because the dark monochrome material would keep the picture in the basically low-chromatic scheme the artist desired for the final painting. The fact that his sitter unexpectedly turned up for the sittings with a shining new T-shirt and a fresh haircut did not deter Danby too much. *At the Corner* was one of the first of many portraits the artist has done of his neighbours, and it remains one of the finest.

*The Mill Cat* is probably the most delicately rendered of all of Danby's egg temperas using the patient crosshatch technique, wherein thousands of short fine brush strokes are interwoven and laid across one another. The subtle, consistent modelling of the animal, bags and surrounding textures help make *The Mill Cat* a work of technical perfection. It is no less subtle in its colour and tonality. The composition, with the cat placed almost midway in the picture and the simple vertical divisions flanking it, is typical of Danby's emphasis upon geometry. The telling drawing of the cat only underlines the artist's attraction to the species, as exhibited in a long succession of works leading from *Fur and Bricks* (1963), *On the Prowl* (1964), *Grooming* (1968), to *The Prowler* (1970) and *Partners* (1973).

An animal with a very special place in Ken Danby's life was his Great Dane, Timber. Bought as a six-week-old pup shortly after the Danbys moved into Armstrong Mill in December 1967, Timber died on June 10, 1972. In 1968, Ken painted the portrait of the young Timber, one of his best animal pictures. A few weeks after Timber's death, Danby purchased his Great Dane, Taller, who is portrayed standing in the snow in a March 1974 watercolour.

*Banjo Window* recalls Danby's earlier footloose days as a folk music enthusiast and amateur minstrel. It depicts the window of the room in the original Armstrong Mill house that he used as a temporary studio before his permanent studio was completed in January of 1970. That room is now a playroom for his children, and the banjo which he still occasionally strums hangs on the wall of his new *atelier*.

The Gallery Moos exhibition of 1969 (December 16 to 29) displayed eleven temperas and sixteen watercolours, all painted during that year. The most outstanding of these were probably *The Runner, Still Running, Auntie May,* and *Seed Bags.*

Auntie May is the familiar name for Mrs. May Grieve, an elderly widowed neighbour of the Danbys. She lives alone in a small brick house where she plays the piano and tends her own garden. She is a favourite citizen of the Armstrong Mill area of Wellington County, where she has made her home for many years. Auntie May is an avid baseball fan as well as adopted grandmother to all of the children in her valley. Her portrait is one of Danby's favourite paintings. "I didn't have to sweat at it," he says. "My subject was full of warmth and character, and she was a pleasure to paint. Auntie May came through more easily than almost any sitter I ever had."

Another favourite Danby model, Robert Gray, posed for both *The Runner* and *Still Running. The Runner* originated while the artist and his young neighbour were playing one

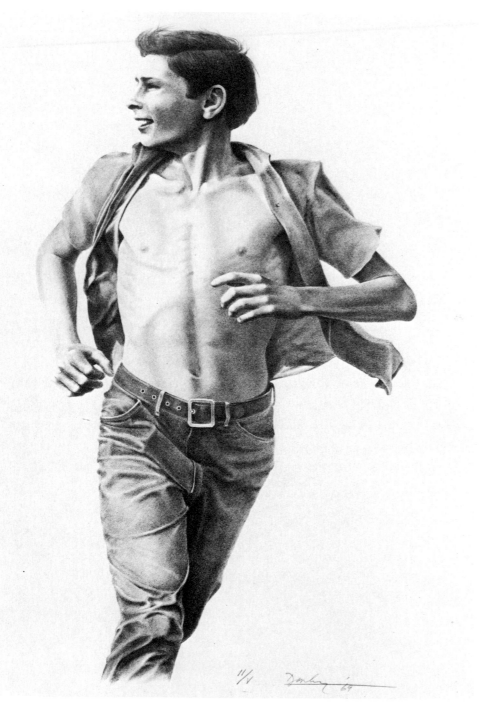

*The Runner*; 1969 Lithograph 23 x 18; Edition of 50

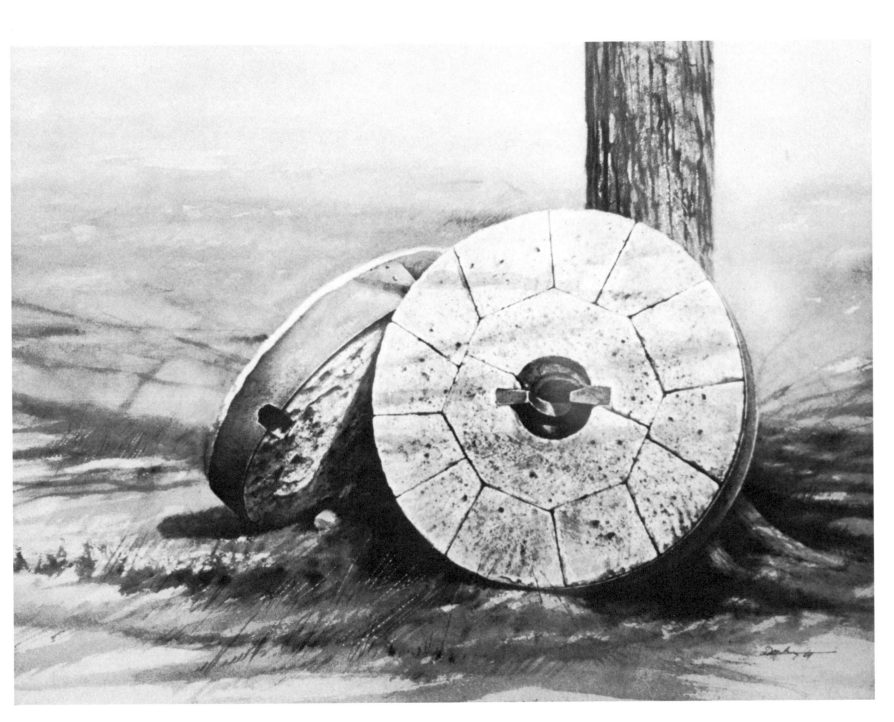

*The Millstones*; 1969 Watercolour 20 x 28; Mr. and Mrs. Dan Rowan, Hollywood, California

*Door Handle*; 1969 Drybrush 13 x 22; Mr. and Mrs. D. Armstrong, Toronto, Ontario

*Sean*; 1970 Drybrush 21 x 21; Mrs. Judith Danby, Guelph, Ontario

112    day with Frisbees. During the preliminary sessions for the painting, Danby says, "Robert did a lot of running." In its sense of movement, quality of paint and high-key delicacy, *The Runner* recalls *Towards the Hill* of 1967. *Still Running* is one of Danby's most powerful colour compositions, its contrasting deep shadows and brilliant reds orchestrated to a high chromatic pitch. The painting was inspired when Danby attended a local farm auction and watched a number of youths testing out the trucks that were being offered for sale. He made a series of on-the-spot notes, later eliminating all extraneous background forms to isolate the boy sitting in the cab of the semi-retired vehicle.

"I was interested in creating an abstract with subject matter," Danby says of *Seed Bags,* the interior of an abandoned frame house he discovered during a sketching trip to Ontario's Bruce Peninsula. Danby was fascinated by this particular house and did a number of paintings of it including an almost architectural rendering of its exterior. In *Seed Bags* he was as concerned with conveying the weight of the bags as he was in developing a design or capturing what he describes as the "spooky atmosphere of the place." The painting's resonant tonalities give it a special place among the painter's portrayals of interiors.

*Flatbottom*; 1971 Egg Tempera 14 x 20; Mrs. Audrey Miller, New York, N.Y.

*Nothing is ugly or beautiful except that light should make it so*

---

J.M.W. TURNER

1970 was a triumphant year for Ken Danby. The previous years of struggle and experiment to command the difficult egg tempera medium and make it a thing of his own came to realization in *Reflections*, one of his masterpieces, and one of the most brilliant tempera works ever achieved in this country. *Reflections*, and such works to follow as *The Armstrong Miller* (1970), *At the Crease* (1972), and *Pancho* (1973), place Danby among the leading contemporary realists anywhere.

*Reflections* achieves that orchestration of light and shade which had been a challenge since the beginning of Danby's career. Even before he began painting in egg tempera, he had been compelled by the study of chiaroscuro as is evident in innumerable early drawings of animals, portraits and anatomical details. At a time when the use of the modelling of form for creative expression had reached its lowest point in the history of western painting, Danby looked back to such earlier masters as Caravaggio, Rembrandt and Georges de la Tour to find sustenance for his own future style. Surrounded as a student by fashionable styles which denied the naturalistic use of light and shade, he often found himself a maverick in a world of flat planes and colour fields where the roundness and depth of volumes were consciously obliterated.

As a contemporary painter prepared to utilize all of the creative vocabulary available to him, Danby is a relative rarity. The success of his patient search for the fullest expression of light and form becomes fully evident only after a comparison between his temperas of the early 1960s and a 1970 work such as *Reflections*, with its remarkable subtleties of texture, luminosity and surface. The large fomat (38 × 52 inches) would intimidate most tempera painters by its demands of industry, consistency and intense concentration over a period of months.

Danby contemplated the theme of *Reflections* for more than a year before beginning even the roughest preliminary pencil notes. Its setting, a stretch of the Speed River which runs through his property, is a scene he had contemplated every day, through all seasons, for more than three years. It had become even more familiar than his own face in the mirror. The contrast between the permanence of its limestone rock wall and the flowing water represented a graphic image which assumed an increasingly demanding place in his imagination. "I knew I would one day have to do something with it," he says, "but didn't know what until I happened upon a neighbour's boy, Neil Foote, playing in that water hole where the mill dam used to be. I had looked so long at that natural stone background which had once been the anchor dam for the Armstrong Mill. I had looked at it from above and below, and at the play of light on the river surface and its reflections on the

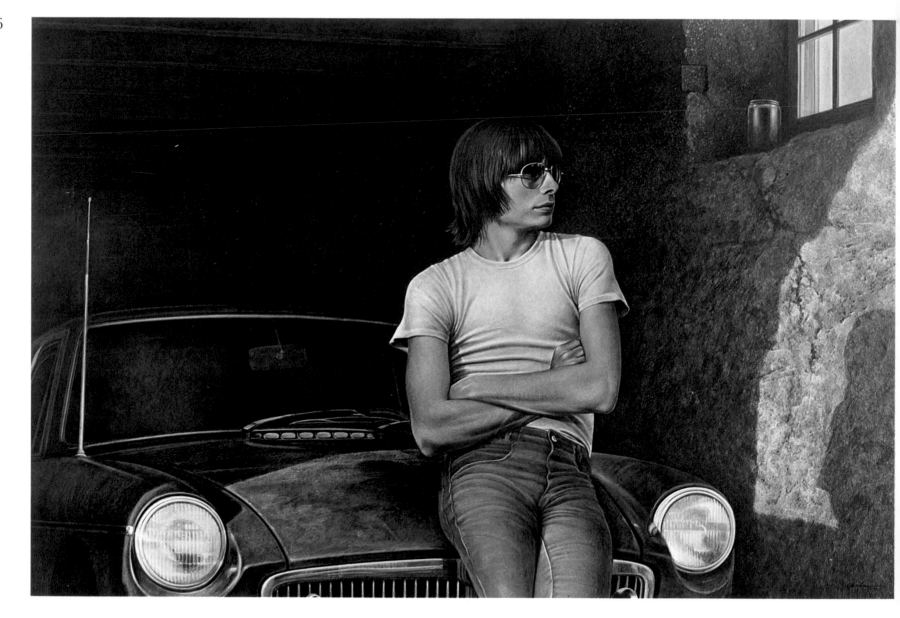

*His MGB*; 1971 Egg Tempera 24 x 36; Mr. and Mrs. Julie Hanson, Toronto, Ontario

rock. When I saw young Neil in the water, I knew that here was a subject of a figure in an environment which could offer a challenge to all of my abilities. To hold all of that complex play of light and form in a strong design, and yet keep the painting from becoming a technical trick piece, I knew would be a real test."

When completed, *Reflections* was a masterpiece of tempera technique, and represented a pivotal point in Danby's creative evolution. The remarkable tonal and textural effects realized in this picture affected every work he was to do in the future. In it, the paint is used in the thinnest films of glaze, where earlier the pigment surfaces were opaque and semi-opaque. Gone is the persistent crosshatching of before, replaced by luminous washes and a subtle calligraphy. The inner light that emanates from this composition is truly magical. The figure of the bathing boy is like the mystical presence of a faun poised in the shining semi-darkness of a grotto.

The drawing and subtle modelling of the boy's wet figure in *Reflections* surpasses anything achieved earlier by Danby. The painting as a whole is relentless in its exploration of every nook and cranny of form, although it rarely dwells on detail for its own sake. The rendering of the plane of water, full of delicate variations of light, reflections and depths, represents a *tour de force* of tonal perspective. Yet what easily could have been a mere example of technical mastery emerges here as a triumphant use of technique in the service of a haunting pictorial image.

In the beginning, Danby had conceived of *Reflections* as a relatively modestly-sized work, but the concept grew in dimension as he did his preliminary studies. The final preparatory cartoon was a full-scale study in HB graphite pencil. After transferring this drawing to a gessoed panel, he did a tonal underpainting for the final painting in India ink and distilled water, carried to a completeness beyond that of any underpaintings for his previous pictures. Such an underpainting records all of the range of tone from white to black to be found in the finished painting, but in broad, generalized forms which are later softened and refined under layers of tempera. Danby began *Reflections* in early summer of 1970 and completed it in mid fall, four months later.

What might be termed a companion picture to *Reflections* is *The Armstrong Miller*, painted between late October 1970, and March 1971. It is identical in size to *Reflections* and shares the same richness of chiaroscuro, which, by now, has become a connecting thread throughout Danby's style as an artist. (Unlike such earlier chiaroscuro masters as Georges de la Tour, who artificially arranged their light and shade schema by use of candles, lanterns, or small windows concentrating luminosity, Danby almost always uses

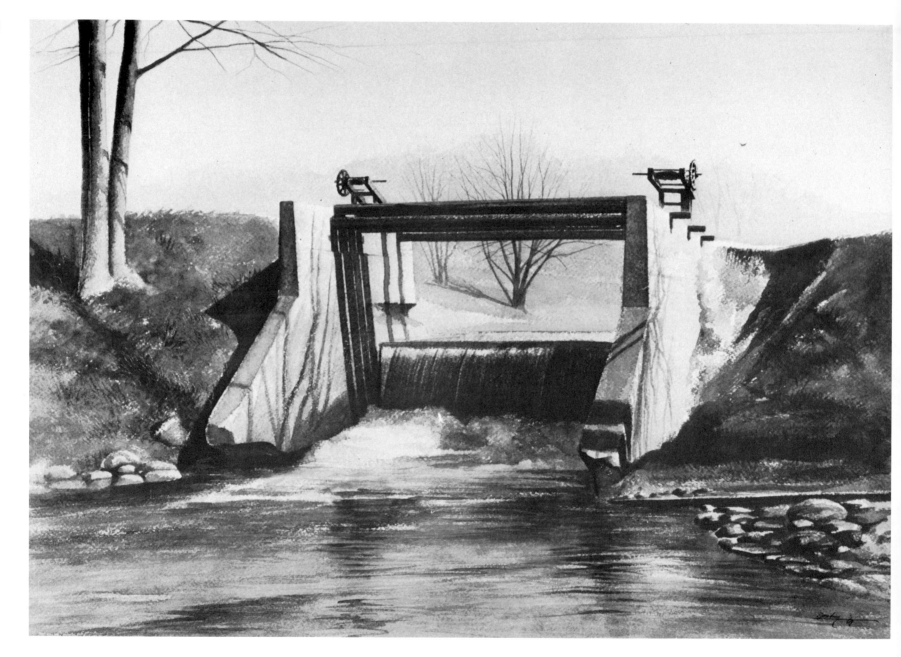

*The Dam*; 1969 Watercolour 20 x 28; Mr. and Mrs. D. Caswell, Sundridge, Ontario

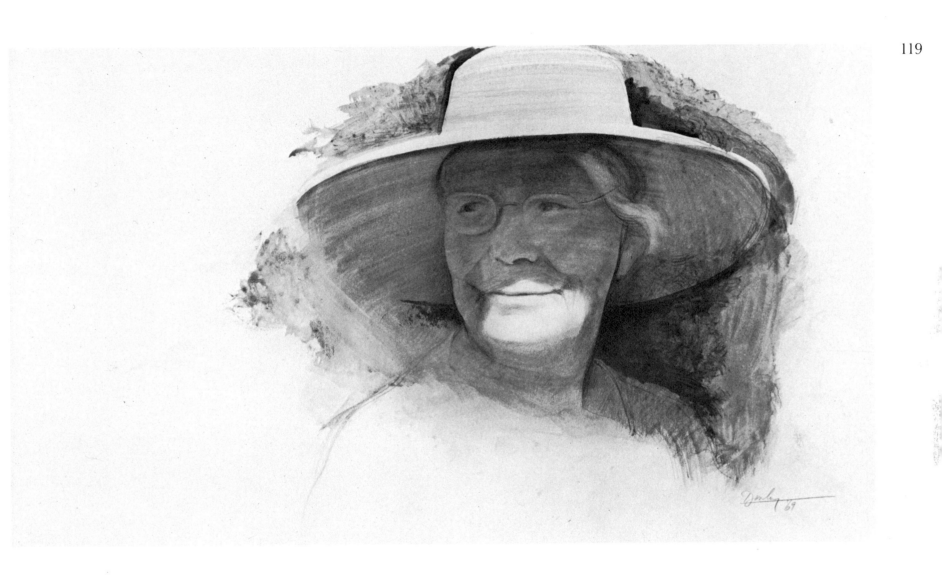

*Straw Hat*; 1969 Drybrush 11 x 19; Mr. and Mrs. Martin Onrot, Toronto, Ontario

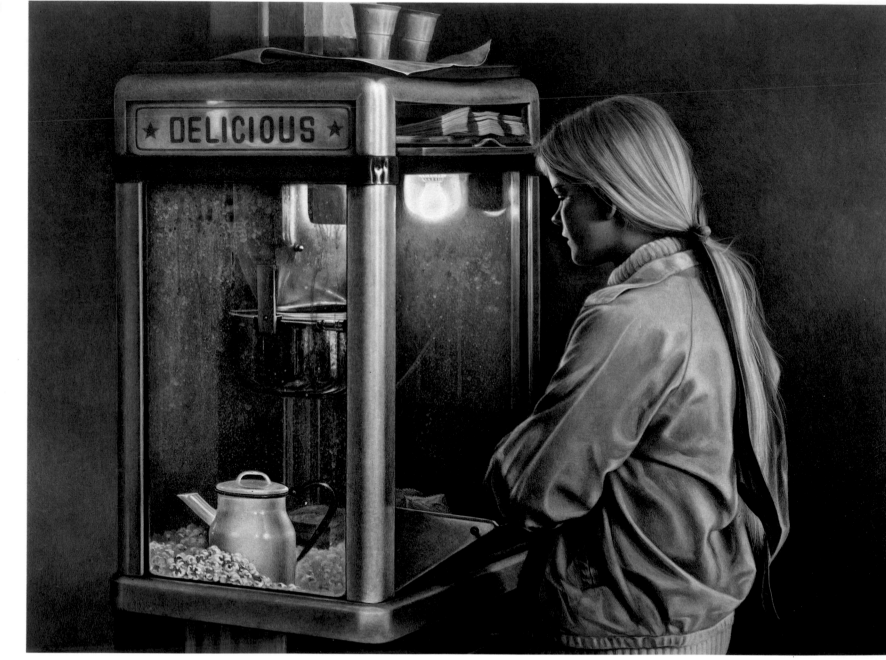

*Delicious*; 1971 Egg Tempera 24 x 32; Private Collection, Toronto, Ontario

natural available daylight, filling even the deepest shadows with some half-light.)

*The Armstrong Miller* exhibits a favourite Danby compositional device—the division of his picture space into a light and a dark half; the seed bags in the right shaded area forming a pictorial and thematic *leitmotif* for the figure of the miller himself. The pivotal centre of interest of the picture is formed by the miller's hands, locking the design together like the keystone of an arch, powerful and omnipresent. When Danby first began the studies for this portrait of George Parkinson, the former owner and miller of Armstrong Mill, he was struck by the character of the sitter's hands. "George is a slight person," observes the artist, "but he has tremendous and powerful hands. I have never shaken a hand which possessed such obvious strength as his."

Much of Parkinson's strength resulted from his years of operating the mill for grinding feed from 1930 until the late 1940s. When the west wall of the mill collapsed, he personally rebuilt it by removing a storey-and-a-half of limestone from the top of the mill and using it to replace the wall. For his portrait, Parkinson was posed within the mill, the gentle humour of his face belying the elemental power of his hands. It is a face full of memories, looking out from a background where many of those memories were born. "Painting George drew me a little closer to the Mill," Danby observes, "and established a creative link with it."

*The Armstrong Miller* is a telling and indelible image of a rural way of life now past. It was an existence with ethical and work standards which appeal to Danby who, as an artist, gives all of his talent and energy to each work of art. George Parkinson is still a neighbour and friend, living in a bungalow on an adjoining property.

*The Boom Hook,* the earliest tempera of 1970, is primarily a still-life composition with water. The presence of man is suggested only by the mechanical nature of the hook. "It is more of an abstract painting than anything else," says Danby, for whom *The Boom Hook* is a favourite painting. "It was one of those things that went so well and quickly. I like the simplicity and formal pictorial life within it. It was also an important experiment in painting light—and light, I guess, is what my work of 1970 was all about." *The Boom Hook* is also important as a preliminary to the execution of *Reflections*.

A very different kind of illumination from that used in his three major 1970 temperas is found in Danby's affectionate watercolour dry-brush study of his son, Sean, one of his few family portraits. The figure of Sean seated on a tricycle is backlit in silhouette against a pure white background. The colour scheme of the subject is restrained almost to the point of being minimal, with Sean in a Prussian blue sweater and jeans with a diamond-

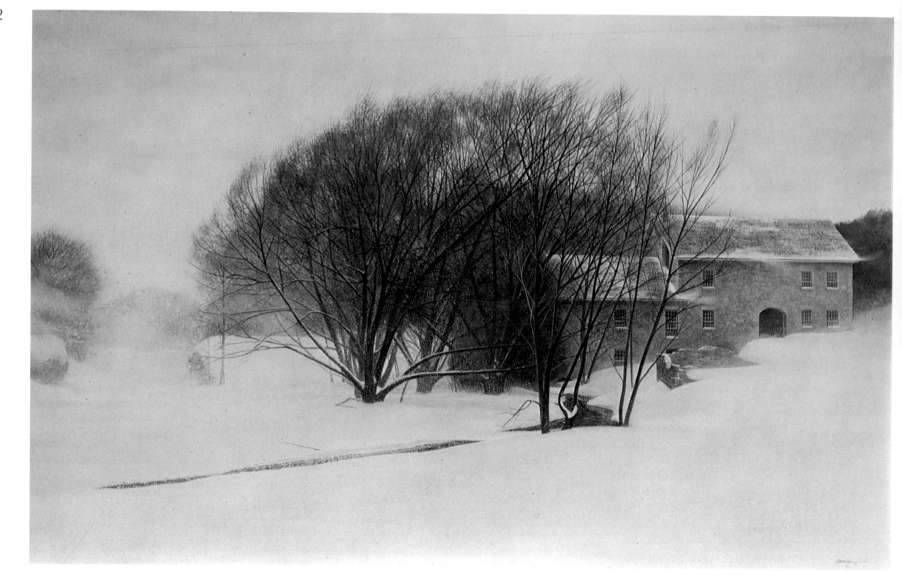

*Blowing Up* ; 1971 Egg Tempera 28 x 44; Private Collection, Edmonton, Alberta

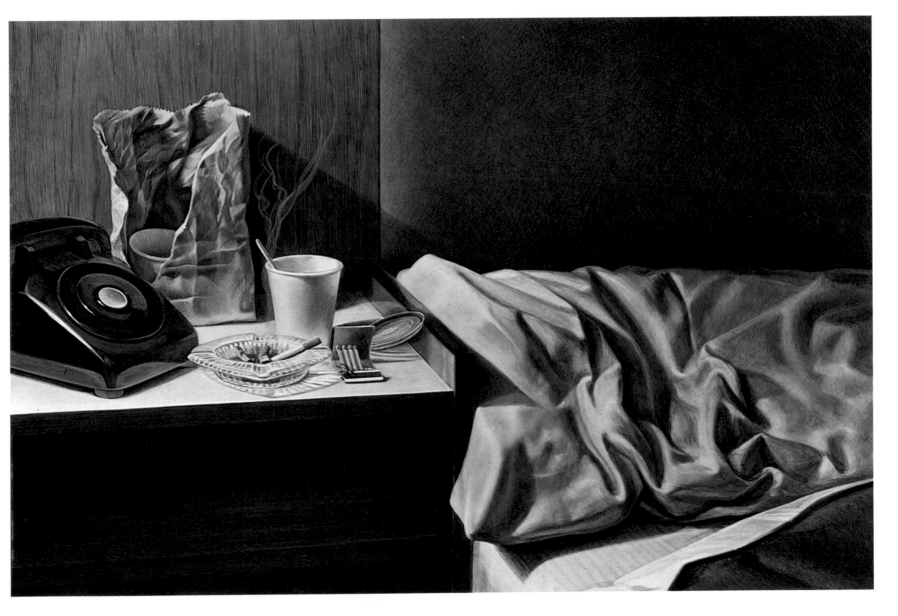

*Motel*; 1971 Egg Tempera 16 x 24; Mr. and Mrs. Julie Hanson, Toronto, Ontario

shaped touch of lemon yellow on his machine. This is one of the artist's most telling and attractive portraits in watercolour and possesses much of the same freshness and intimacy as his earlier (1966) study of his wife Judy, *Beside the Fireplace.* Sean appears later in two 1971 serigraph prints, *Early Autumn* and *On the Gate.* Danby pulled his first serigraphs in 1970, and that year saw his largest yearly output — five prints: *The Wagon, Mill Window, The Prowler, Butterbowl* and *The Miller.*

Danby's first New York solo show was held in 1972 (February 5 to 26) at the William Zierler Gallery, and was composed solely of paintings done in 1971. It included eleven temperas, plus seven watercolours and drawings, all of them reflecting the strong creative advances made by the artist during 1970.

1971 was the most productive year of Danby's career. Although the usual annual exhibition at the Gallery Moos was held, from November 23 to December 7, the most important works were reserved for the New York debut two months later. In that Zierler exhibit were eleven new major temperas including *Delicious, Snooker, Sharpshooter, His MGB,* (previously shown at Moos), *Blowing Up, Draft, Motel, Flatbottom* and *The Silver Bird.*

Although Danby, who loves his Mill and its rural setting, had said, "I will never get completely away from country themes," he began in 1971 to explore the neighbouring towns of Guelph, Kitchener, Fergus and Elora. He felt that the world of tomorrow was already happening in the teenage activities of today, and in town he found themes to add to such earlier studies of adolescence as *Boy on Fence* (1965), *On His Way* (1966), and *Pulling Out* (1968).

*Delicious* is undoubtedly the most appealing of Danby's 1971 teenage subjects. It combines a timeless charm and simplicty with an unmistakably contemporary setting. In it, a commonplace scene is transformed into a memorable and winning work of art. In *Delicious,* the dual source of natural and artifical light, with the main accent of illumination coming from the popcorn machine, offered Danby a new chiaroscuro problem that intrigued him, and recalls the compositions of some of the European seventeenth-century "candlelight masters."

Danby had been planning to do a still-life of the popcorn machine in *Delicious* until he happened upon the scene as it was eventually painted. "When I saw the girl in the windbreaker at that machine in the old Kitchener market that day I knew that was it," he says. "It was one of those compositions that just offers itself to you."

Although its concept simply presented itself, technically *Delicious* offered many complications. It called for the maximum of the artist's virtuosity with the tempera

medium to render the variety of surfaces, luminosity and textures. He sought a complete image, but not an accretion of dead detail. The painting of the popcorn itself offered one of the greatest technical challenges. It was necessary to find a pictorial compromise between a description of each separate kernel and a mere misshapen mass. Before attempting to portray it in the final tempera, Danby painted a watercolour dry-brush of the popcorn. Judy popped a fresh batch for him, and he pinned pieces of it to his drawing board to paint it from life. When he studied it closely, Danby discovered that "each kernel was a beautiful abstract sculpture." Painting the gleam of metal, the gloss of the girl's hair and the steamy reflections of the glass all supplied further technical difficulties. Towards the end of painting *Delicious,* Danby gambled the whole picture. In order to represent the grease stains on the machine window he simulated it by spattering areas with paint, then, tilting his painting so the wet spatter would run downwards in streaks, dabbed at it with a piece of Kleenex. That gamble paid off as successfully as the rest of the picture, which shows no evidence of the labours needed to achieve it. *Delicious* emerges as a warm and convincing icon of contemporary life, its counterpoint of machinery and humanity bound together by reflected light.

*Delicious* finds two companion pictures of youth in *Snooker* and *Sharpshooter.* The key concept of *Snooker* is intense concentration—the concentration of the player upon his cue tip and the ball lying on the table in the foreground. To focus the spectator's attention, Danby has divided his composition with a perfect diagonal, its axis running through the cue and set of the player's arms, and ending in the target of the ball. To emphasize the singular effort of will represented, he has closed in on his subject in the same way utilized for *The Armstrong Miller* a year earlier. As in that picture, he has divided *Snooker* basically into a light half and a dark half, the hanging coats in the shadowed background paralleling the seed bags in *The Armstrong Miller.* The snooker player's left hand, splayed and tense, is given the same emphasis of light as the miller's hands. Characteristically, in *Snooker* Danby builds a strong abstract design into his representational format, utilizing the two balls, placed perfectly equidistant, the severe hard edge of the table top, and the diagonal of the cue to compose a formal pattern that should please even the most pure of abstractionists.

As do almost all of Danby's 1971 paintings, *Snooker* adds a fresh richness of colour to his use of chiaroscuro, without lessening the impact of light and shade. The artist was fully aware in doing such 1971 paintings that he was beginning to disprove the old adage that egg tempera was exclusively a medium for high-key pastel effects. Even Daniel

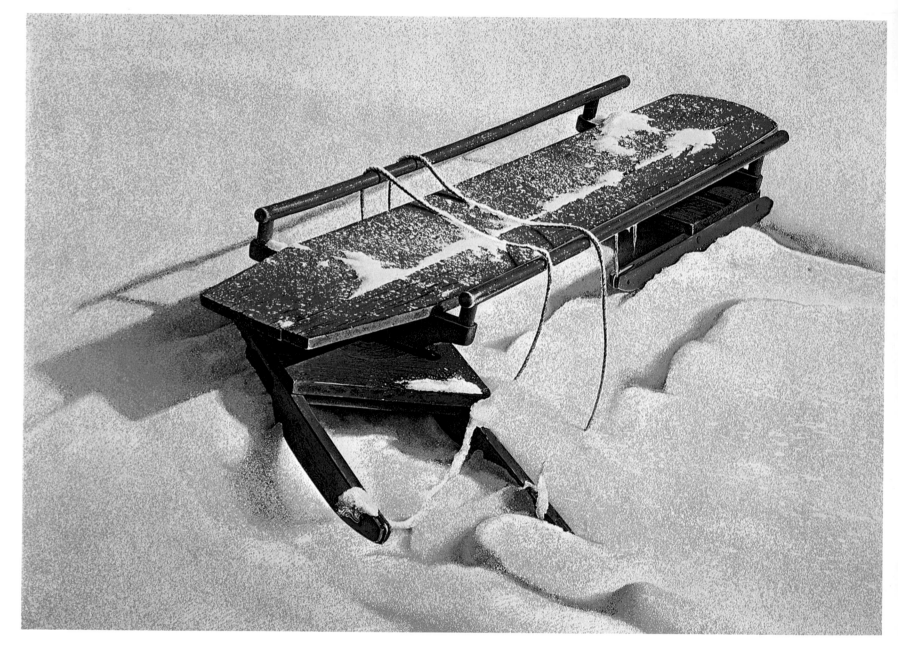

*Bobsled*; 1971 Colour Serigraph 18 x 24, 11 Colours; Edition of 100

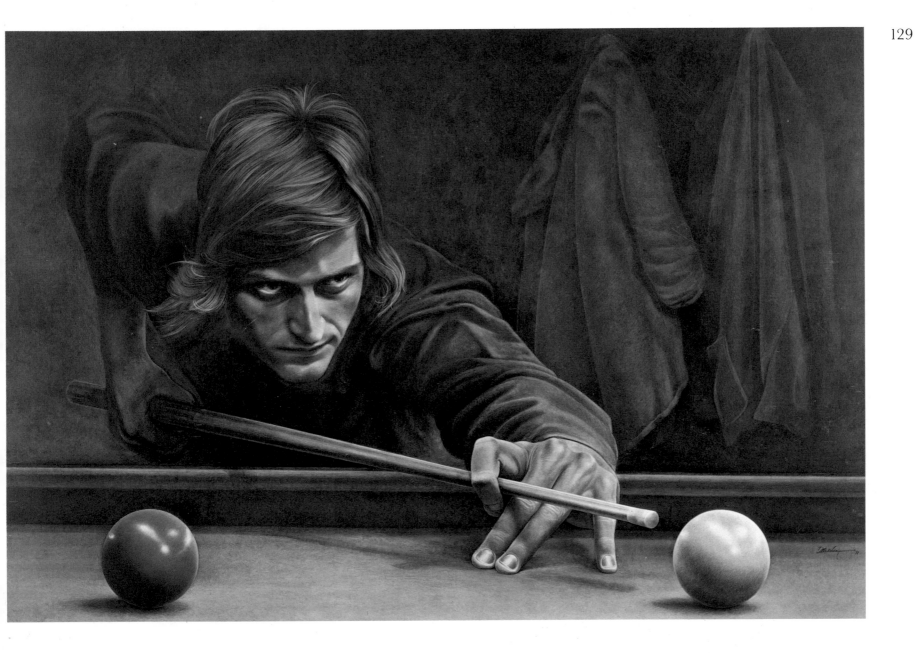

*Snooker*; 1971 Egg Tempera 22 x 32; Private Collection, New York, N.Y.

Thompson, the greatest modern authority in tempera techniques, preached that the medium could not be used for strong chiaroscuro interpretations. Danby amply disproves this in *Snooker* and *Sharpshooter,* as he was to do so dramatically later with *Pancho* (1973). Although Danby had found the source for the subject matter of *Snooker* in a Kitchener pool hall, the only model for it was his brother Marvin, who posed for details of the hands at a drawing table in the artist's studio.

*Sharpshooter* represents an exact reversal from *Snooker,* its line of concentration being turned *away* from the spectator. The direction of both the subject and the action have been reversed, with its dark figure against a light background replacing the lighter subjects against a darker ambience found in *Delicious* and *Snooker.* (Yet, as in *Delicious,* he has worked the title of the picture into the actual painting.) To collect material for *Sharpshooter,* Danby spent a day looking at shooting galleries at the Canadian National Exhibition and in Toronto's penny arcades. He was looking for, and found, the same close-up of concentrated attention which appeared in *Delicious* and *Snooker* — a theme which held his attention throughout 1971.

Humanity and still-life share an equal role in *Delicious* and *Sharpshooter.* In *Draft,* humanity is reduced to a supporting role, and the still-life of beer pitcher, ashtray, glass and salt cellar move up to centre stage. *Draft* could as easily be titled "Still-Life with Man." The subject is once again the Canadian commonplace often favoured by Danby. Beer is as much a national institution as hockey. The beer parlour provides a relaxing home away from home for hundreds of thousands of people and the beer drinker is a subject that has given birth to masterpieces from Frans Hals to Manet and Picasso. Danby's *Draft,* in fact, does reveal the same forthrightness of approach found in many seventeenth century Dutch still-life paintings.

Danby discovered the theme for *Draft* at the Breslau Hotel in the village of Breslau near Kitchener. At first he intended to do a large tempera incorporating a full portrait, with the objects on the table as accessories, but as he drew the studies for the pitcher, salt shaker and ashtray at the hotel, he decided that by themselves they supplied almost enough material for his needs. For the headless figure in the middle ground, Danby's brother Marvin stood in as he had done earlier for *Snooker.*

In order to satisfy his original interest to do a full-figure composition in a beer parlour, Danby followed *Draft* with the watercolour *At the Taps,* one of the most fluid and forceful of all his works in that medium. It is executed with complete authority and that

appearance of inevitable ease which arrives only after years of patient experience. The full solidity of the bartender's figure, the gleam of his taps, and the moist gold of the full beer glasses are captured in washes of colour that seem almost impatient in their directness. By now, Danby can literally play with light. Whereas in *Draft,* he had been fascinated by the concrete solidity of his subject matter, in *At the Taps* he is involved in capturing a sense of motion, and he has adapted his style accordingly. "I was intrigued," he says, "by the hypnotic circular motions of the tap man's hands as he poured continual draft after draft."

With his painting *Motel,* Danby progresses from such figure themes as *Delicious,* through the reduced role of humanity in *Draft,* to the near elimination of mankind. Here is an invisible, recently departed, presence, yet a presence still close enough to leave behind a smoking cigarette and a pillow still creased from a sleeping head. Although small in size, *Motel* ranks among Danby's most eloquent works. As a still-life it rivals *The Rose Bowl* of 1966. It is very deliberately designed, with the composition divided into four simple areas. The superbly painted still-life in the upper left rectangle is balanced against the deeply crumpled pillow in the lower right segment, with the dark lower left and upper right rectangles offering a sense of quiet space. Danby has once more taken a most commonplace experience, one shared by millions, and converted it into a masterly display of chiaroscuro.

*Motel* is one of those pictures which challenges our imagination, and questions inevitably come to mind about the owner of the still-burning cigarette, who one suspects must be just out of the painting's range—and does the second coffee cup mean a second person? *Motel* is a story-telling picture in the best sense of the word. In it the ultra-contemporary telephone, plastic cups, and book of matches suggest a timeless traveller's tale, invoked by the purest of pictorial terms. The concept for *Motel* was born during a sketching trip in the Trenton, Ontario region in the spring of 1971, when Danby was getting ready to leave his own motel. At the time, he made a few quick notes, later setting up at his studio the actual objects seen in the completed picture.

Among the many outstanding pictures which made 1971 such a vintage year for Danby, *Blowing Up* holds a special place. It is the most poetic, and at the same time the largest, of all his pure landscapes. Its subject is the Armstrong Mill on a bitter, mid-winter day, with the Mill Race snaking away from it in a thin black line. In its subtleties of tone, precision of execution, and almost oriental simplicity of design, *Blowing Up* is removed from most major Canadian landscape painting of the past. It does not exhibit the heavily-pigmented, swirling patterns that such a subject might have provoked in the

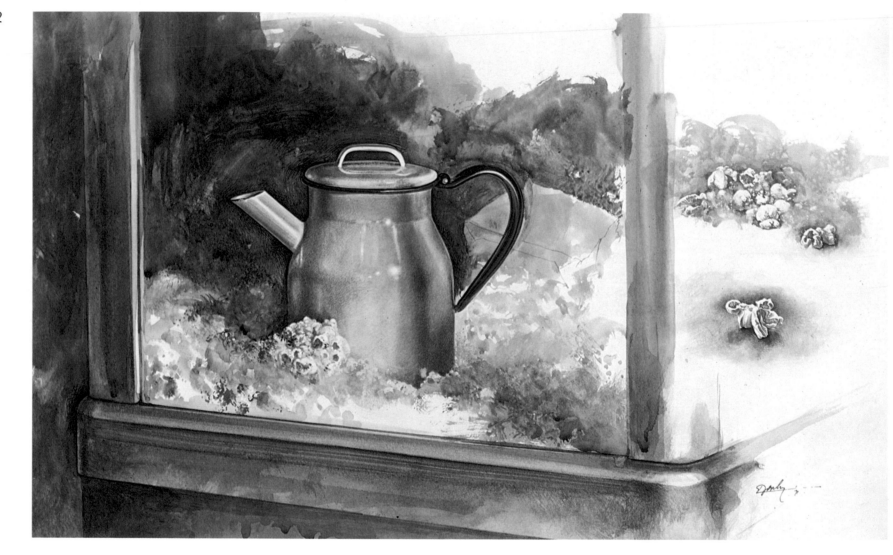

*Popcorn*; 1971 Watercolour 21³/₄ x 21¹/₄; Private Collection, Toronto, Ontario

*At the Taps*; 1971 Watercolour 13 x 21³/₄; Mr. Charles H. Renthal, New York, N.Y.

*Study for Sharpshooter*; 1971 Pencil Drawing 21 x 27; Mr. and Mrs. Julius Davis, Minneapolis, Minnesota

*Study for Snooker*; 1971 Pencil Drawing 21³/₈ x 26³/₈; Private Collection, New York, N.Y.

Group of Seven, yet its cameo-like image suggests the power of the elements with no less eloquence.

Another serene Danby landscape of 1971 is *Flatbottom,* a composition which seems almost effortless in its simplicity. With its water-edge dividing the painting almost into two horizontal halves, the geometry of *Flatbottom* has an almost Euclidean inevitability. Its boat, riverbank and trees are portrayed with a mirror-like precision, while retaining the romanticism of the theme.

For *His MGB*, Danby reverted to an earlier favourite model, Robert Gray, who had posed for the temperas *Robert* (1968) and *The Runner* (1969). This time Robert is shown in a pose of masculine pride and power, leaning against his metal mechanical mistress with his arms crossed defensively. His head is raised almost aggressively like a knight with his favourite steed. (Although the car belonged to Danby, Robert always showed a great affection for it.) The setting for *His MGB* is the garage beneath the artist's studio, which was originally the limestone foundation of an ancient barn. The light which falls from a small side window and the open front of the garage illuminates Robert's figure sharply against an inner wall of darkness. The right side of the picture, with its tattered passage of light and rich textures recalls Danby's abstract collages of the early 1960s.

Danby's 1972 show at Gallery Moos was evenly balanced in interest between humanity and nature. It was dominated by the four egg temperas: *At the Crease, The Sunbather, Trillium,* and *Through Fergus.*

*At the Crease* was undoubtedly the major work of 1972, and in painting it Danby realized a long-standing creative ambition. Ever since he played hockey for his collegiate team in Sault Ste. Marie he considered sport as a possible subject for painting. It wasn't until *At the Crease* and the serigraph *The Skates* of the same year that he actually attempted to depict a sporting theme. Sport as material for art has been with us since earliest times, although it has received little attention from major twentieth century painters, especially Canadians. Such European artists as Fernand Leger, André Dunoyer de Segonzac, and Raoul Dufy paid some passing attention to boxing, cycling and yachting. American artists have concentrated somewhat more intensely on sports and some notable masterpieces have emerged during the past century, such as George Bellow's *Stag at Sharkey's,* and Thomas Eakins' *Between Rounds* and *Max Schmitt in a Single Scull.* The subject of Eakins' *Baseball Players Practicing* (Rhode Island School of Design collection), a watercolour painted in 1875, shares some of the same competitive tension found in Danby's *At the Crease.* Eakins himself wrote about *Baseball Players Practicing,* to a friend: "The moment is

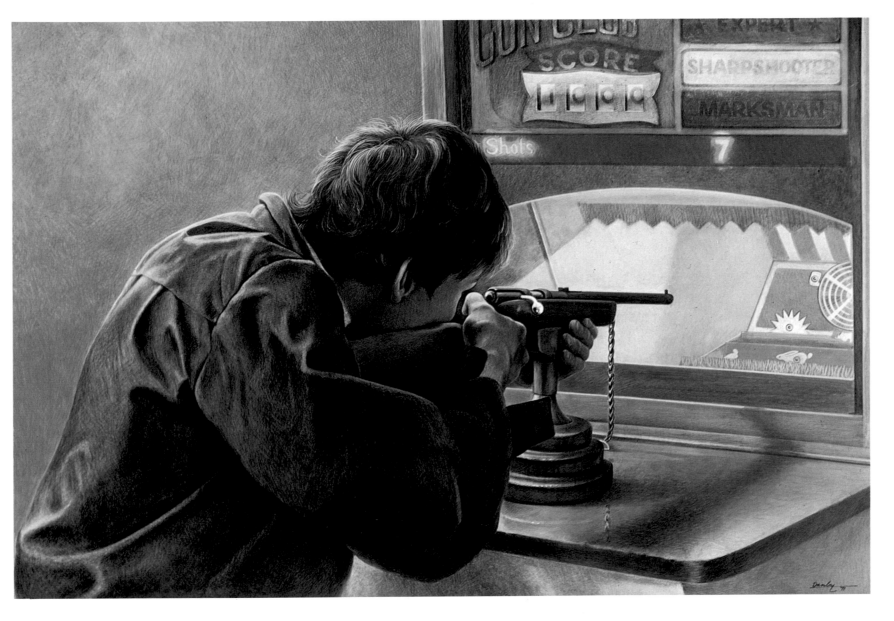

*Sharpshooter*; 1971 Egg Tempera 20 x 30; Mr. Daniel Hechter, Paris, France

138

*Sunday Morning*; 1970 Drybrush/Pencil 14¹/₂ x 23; Mr. and Mrs. R.D. Wadds, Stowe, Vermont

*The Bridge*; 1971 Watercolour 21 x 27; Guaranty Trust Company of Canada, Toronto, Ontario

140

*Early Autumn*; 1971 Colour Serigraph 18 x 24, 19 Colours; Edition of 100

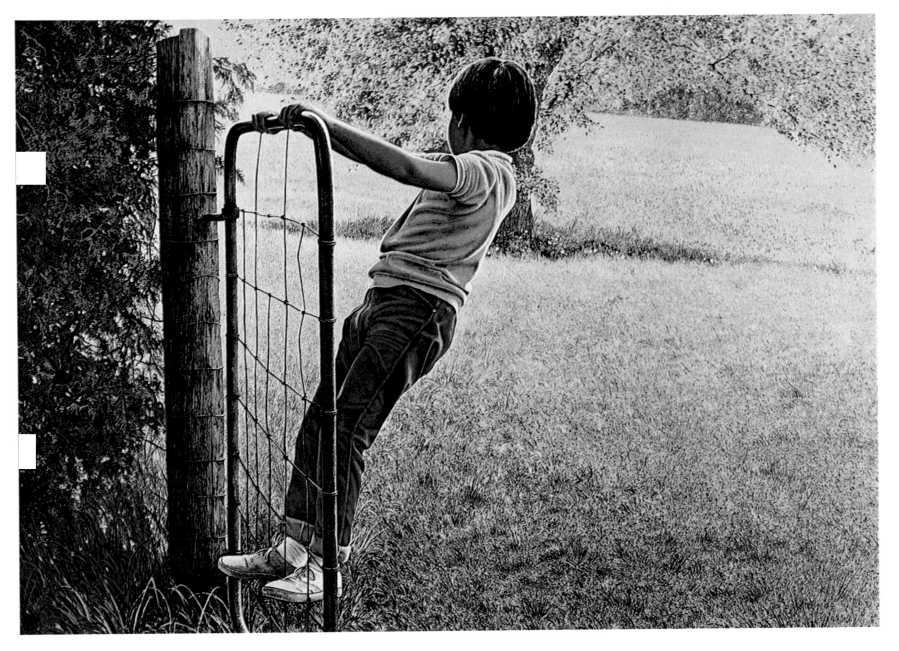

*On the Gate*; 1971 Colour Serigraph 18 x 24, 17 Colours; Edition of 100

142 just after the batter has taken his bat, before the ball leaves the pitcher's hand. They are portraits of athletic boys, a Philadelphia club. Baseball players are very fine in their build. I think I will try to make a baseball picture someday in oil. It will admit a fine figure painting."

There is a striking parallel to Eakins' words in Danby's comments about his painting *At the Crease:* "I have tried to capture the loneliness and vulnerability that beset a goalie, as he is lining up a puck about to be fired at him at speeds approaching a hundred miles an hour. The moment just before the puck is shot is one of the most dramatic and decisive in hockey. Its sequel can decide the winning or losing of a game. I felt that in portraying this subject I was describing a contemporary hero of Canadian sport, as popular in his way as the discus thrower was in ancient Greece."

Painting *At the Crease* did not come easily to Danby, despite his deep interest in the theme. (He still plays hockey once a week during the winter with a local team in the Guelph Centennial Arena and early in 1974 had his nose broken by a high stick.) He carried the initial idea for the picture around with him for three years before painting it. "I was afraid the idea was too commonplace," he explains. "I had real inhibitions about it being possibly a bit schmaltzy, but finally I thought, to hell with it, I've got to paint it." The result of that decision is one of Danby's most important works.

While retaining every naturalistic detail of the goalkeeper and his environment, Danby has constructed a strong, simple, underlying abstract composition for his picture. The horizontal red line at the rink edge divides the picture into two halves, while binding its contents together like a ribbon. The crouching masked figure is placed at dead centre, like a great inverted U, with the white mask and its two black holes making a compelling accent. The texture of the net, the dot-patterned rectangle covering the player's stick hand and the slicing angle of the stick all add to the pictorial interest of the work. The technical rendering of the varied surfaces, from ice to leather, and the consummate draughtsmanship displayed in the description of every form, provide ready evidence of the artist's phenomenal and ever-growing skill with his medium.

The crouching presence in *At the Crease* is at once an image of awe and familiarity. Although armoured and camouflaged like some prehistoric animal, the human being behind the mask is just as much a folk hero as the singers Danby associated with during his early days with the Mariposa Festival. In painting *At the Crease* he achieved what is possibly the finest sport picture in Canadian art.

In 1972, the same year as *At the Crease,* Canada's National Hockey Team won a

dramatic hockey series from the Russian National Team. In his enthusiasm for that
victory, Danby presented each member of the Canadian team with a copy of his serigraph *The Skates*. This represented thirty-seven prints from an edition of a hundred.

In contrast to the brute force of *At the Crease, The Sunbather* captures a mood as passive and idyllic as anything Danby has ever painted. It portrays an ageless theme—a tanned, young, nymph-like figure in gentle reverie on a sunny summer's day. The deep, shadowed recess of the woods behind and the bright green foreground grass form a cool jade and emerald setting into which the delicate human form is set like amber. *The Sunbather* is the first nude—or near nude—Danby had attempted for more than ten years. His model, Lynn Gray, a neighbour and babysitter for the Danby's children, appeared later in the watercolours *Lying in the Sun* (1973) and *Lynn's Hat* (1974).

*The Trillium* and *Through Fergus,* although devoid of humanity, are as rich in chiaroscuro contrasts as *The Sunbather. Trillium* is a small, intimate work, painted with a great tenderness fitting the fragility of the lone paper-white flower that is its focal point. The white brilliance of the small floral triangle is made to shine, diamond-like out of the textured darkness of the giant tree trunk beneath which it grows. Passages of secondary light are made to move around the picture between deep shadows in a sunlit counterpoint. *The Trillium* is an intimate and triumphant exercise in style; more important, it reveals in every closely rendered detail the deep love the artist has for the land upon which he lives.

In *Through Fergus,* Danby returns to the almost monochrome tonalities and textural problems solved so triumphantly in *Reflections* (1970), only this time the challenge is a study in movement—the rushing passage of the Grand River as it falls, tumbles and foams on its way through the town of Fergus.

*Always aim at brightness — even in the darkest effects there should be brightness.*

*Your darks should look like the darks of silver, not of lead or slate*

JOHN CONSTABLE

During 1973, Danby concentrated all of his efforts toward his second exhibition at New York's William Zierler Gallery (December 1 to 29) and for the first time since 1964 he failed to hold an annual show at Toronto's Gallery Moos. Six temperas and ten water-colours and drawings were hung at Zierler's, including the artist's most dramatic portrait, *Pancho*. The 1973 temperas represent close-ups, where the artist zeros in on an area of his subjects, whether portrait, still-life or figure detail. This intensely cropped compositional approach is in stark contrast to the more panoramic attitude represented by his landscape and genre subjects of earlier years.

Danby's subject matter in 1973 revealed as great a change as his compositional approach. The broad fields of golden grass, the millstones and the barn have been left behind, although his themes remain local and basically rural. There was no effort in the Zierler exhibition to appeal to any popular taste; market-wise, the pictures on view represented tough, even difficult, material — a truck driver, a store mannequin or a bundle of newspapers. Danby has always painted what deeply concerned him, regardless of popular or critical opinion. He was always his own man as an artist, and the paintings in the second Zierler exhibition only underlined this. The event also presented an opportunity to make some comparisons between Danby's realism and that of the American new realist school exhibiting in New York.

By 1973, Danby had been exclusively involved in realist painting for ten years — longer than many of the members of the burgeoning U.S. movement. His work had evolved in a deliberate, slow and organic way. It has never been conceived as art for a fashionable moment and has been free of mere trickery in technique or the *outré* in subject matter—which might attract the attention of the jaded or immature critic or curator. His painting is in strong contrast to those members of the American school who blow up their photo images to gargantuan size, to the scale of ten-foot passport pictures. His complex technical approach could not accept the flat, poster-like minimal texture effects adopted by many current American realists. In spirit and approach, he is most closely related to such brilliant U.S. figures as Richard Estes, Audrey Flack and Tom Blackwell, though their techniques vary from his. Danby has continued to use the classic egg tempera technique throughout his career, while most realists south of the border utilize oil or acrylic and such executive methods as airbrush and direct photo slide projection.

In a special issue of the American *Arts* Magazine (February 1974), devoted to "Super Realism," there appeared this estimate of Danby's art: "Ken Danby's realism is a triumph of technical virtuosity and clearly reveals his primary interest in utilizing and synthesizing

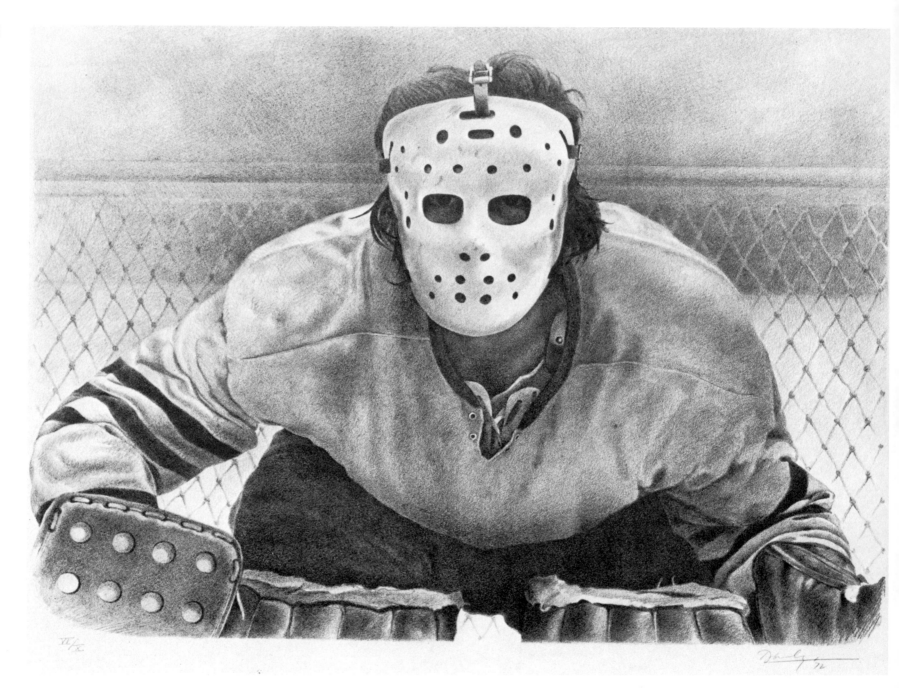

*The Goalie*; 1972 Lithograph 18 x 23; Edition of 100

all the formal elements of art. That in itself is commendable enough, but he infuses each work with a personal and sympathetic view of his subject which adds warmth and meaning to an otherwise coolly photographic and visually objective style. Danby chooses the motifs and subjects which naturally provide the realist with special opportunities for displaying his skill. The raindrops on Pancho's poncho, the gleaming steel of Wally's truck, the light streaming in on a mannequin all provide Danby with unlimited opportunities for showing off his realist competence. Though these paintings, done in egg tempera, are extraordinary examples of skill, his watercolours are interesting as well. Danby has managed to render mechanical objects with such verve that it reveals a whole new exciting dimension of the watercolour medium." Danby's success in New York, the centre of contemporary realism, underlines his position as a realist artist of international stature.

The concept for *Pancho* required that long period of creative gestation which often precedes Danby's paintings. The idea for the picture was conceived more than three years before its production, when Danby was visiting his Spanish-born neighbour on the latter's farm. Pancho had been on his tractor in the rain and when he returned home Danby caught the image of him standing in his yellow slicker beneath a bare light bulb. The image remained with the artist until he finally arranged for Pancho to pose for him in March 1973. For a background, Danby chose one of his favourite settings, the limestone wall of his studio garage. To sustain the effect of rain-soaked wetness that had attracted him years earlier, he poured bucket after bucket of water over his patient model. The actual painting of *Pancho* required more than four months, with the artist working seven days a week, twelve hours a day. The result justified the tremendous labour involved. *Pancho* represents a triumph of technical achievement in an age when most artists are searching for short cuts. It is a high realist painting of a scale and finish probably unequalled in Canadian painting. Its tonal range, from the brightest highlight to the deepest dark, remains rich and luminous throughout and never bogs down into opacity. Here is a truly Hals-like presence in modern dress, portrayed with compelling vigour.

*The Mannequin*, like *Pancho*, brings a direct confrontation to the spectator, only this time from the half-world of imitated reality. There is an almost eerie suspense created between the dynamism of the pose and the dead nature of the inanimate plaster figure itself. The living-room setting, with what appears to be sunlight pouring through windows, heightens the visual paradox.

Danby first conceived *The Mannequin* when he was passing through the town of Fergus

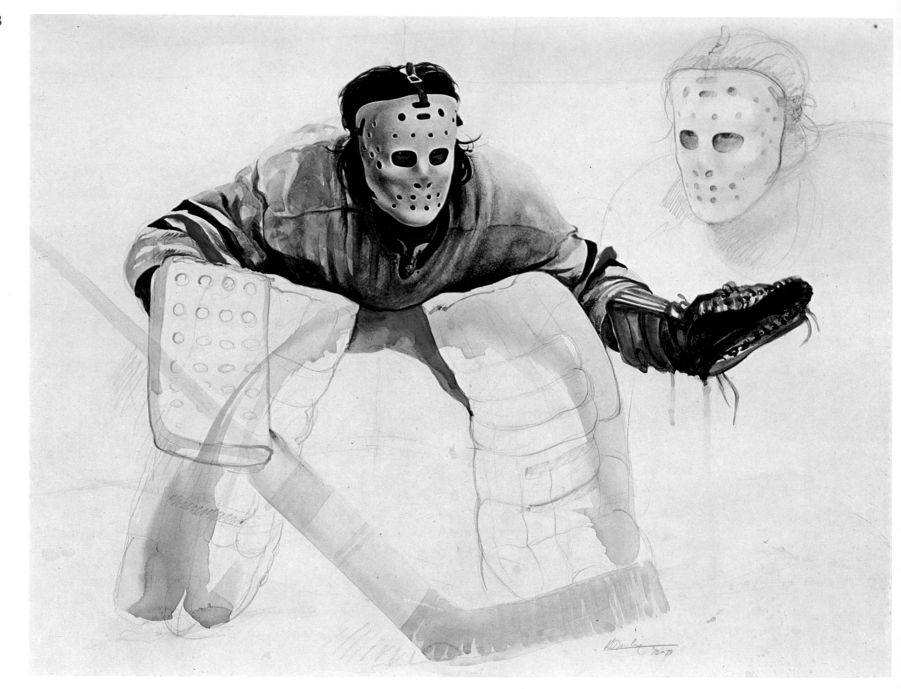

*Study for At the Crease*; 1972 Watercolour and Pencil Drawing 21 x 26³/₈; Private Collection, New York, N.Y.

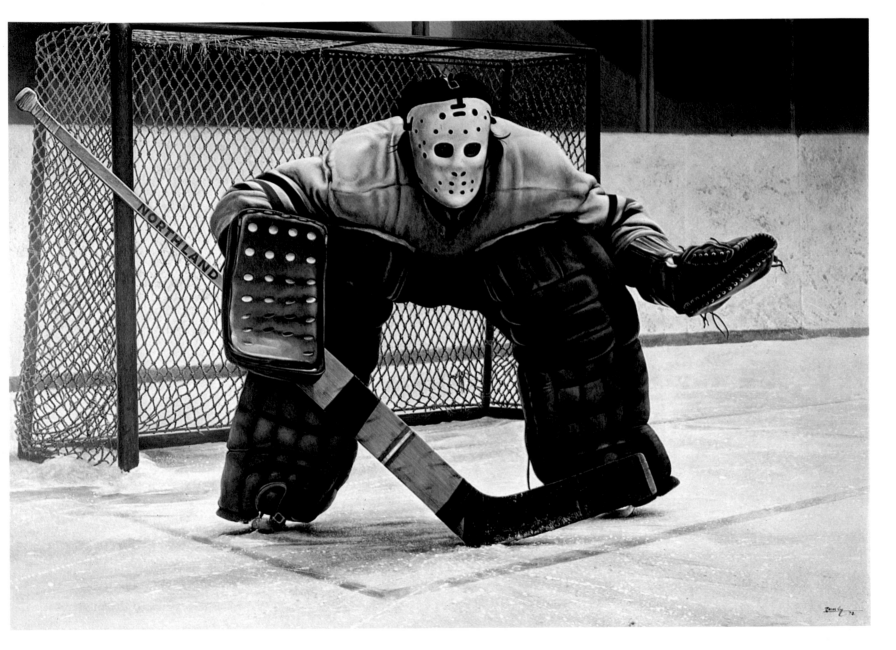

*At the Crease*; 1972 Egg Tempera 28 x 40; Private Collection, Toronto, Ontario

late one day and observed a naked dummy standing in a sunlit store window. "It was a hokey image, I suppose," says Danby, "but it had a spookiness and an air of unreality that appealed to me." For his model, he bought an old mannequin from Eaton's in Kitchener, and it stood around his studio throughout the summer of 1973 before he began painting. (It still remains in the studio, as a sort of mascot.) The mannequin was posed near a window, with light flowing in from behind. As a result most of the painting is in a high key, with the main darks reserved for the figure.

Like *The Mannequin* and the earlier *Motel, First Edition* is a still-life with evocative overtones. The setting is early morning in a pool room cigar store, with a bundle of newspapers covered by the protective wrapper used before the days of plastic. (Danby obtained the wrapping paper from a local butcher shop.) The artist's rendering of the glass case front and the subtle tonalities recall *Delicious* in their subtlety, while the painting's geometric precision of abstract arrangement rivals *Motel.* Also as in *Motel,* there is a sense of pending humanity, that someone is close by and about to step forward to untie the knot binding the papers. Like all of Danby's paintings, *First Edition* loses almost immeasurably in a reduced reproduction, which can only hint at the variations of tone, colour and texture possessed by the original.

*Summer Driver* and *Lacing Up* are two portrayals symbolizing timeless manhood. *Lacing Up* recreates in modern terms the fastening of armour by the knight-warrior of earlier times—the preparation for battle against one's fellow man. Danby has chosen to focus on the tensed arms and clenched hands of the hockey player tugging at his laces which lead to the boot and skate blade with their hint of armoured power. The player's weapon rests behind him, while the red stripes of his stockings suggest an emblazoned heraldry. Today's hockey player equates the gladiator or jouster of the past. The spectator still clearly identifies with his strength and skill and his ability to physically handle his opponent. The concrete block wall, the bare wooden bench and tense preparations of the players convey a scene repeated daily each winter in a thousand dressing rooms. In *Lacing Up,* Danby, through his intimate knowledge of hockey and his genius as an artist, has elicited from those simple visual facts one of his most compelling works.

Danby's abiding interest in sports led to a signal honour in 1975, when he was selected to be the first recipient of the R. Tait McKenzie Chair for Sport. The R. Tait McKenzie Chair was conceived in 1974 by Lou Lefaive, President of the National Sport and Recreation Centre in Ottawa. It was his idea that a chair should be established by the Sport and Recreation Centre to act as a base from which talented Canadians could make

specific contributions to their chosen field of endeavour. This aid would have the effect of identifying sport as a significant and integral part of Canadian culture. Ken Danby was appointed first holder of the Chair in late summer of 1975, his term to last for a period of six months. During that time, Danby was to paint six major watercolours representing Olympic sports. The Chair was to be funded by the Labatt's Breweries of Canada.

R. Tait McKenzie was an ideal name for the Chair. He was one of the most remarkable Canadians of his time, combining careers as physician, physical educator and artist. He was also a notable musician, author and gymnast. Born in Almonte, near Ottawa, in 1867, McKenzie spent much of his life and accomplished his greatest achievements in the United States, where he died in 1938. McKenzie always retained his Canadian citizenship and preserved home ties through ownership of an old mill home situated near Almonte. There, he created many of his most familiar sculptures of athletes, many of which are still to be seen at his Mill of Kintail, now a public museum operated by Ontario's Mississippi Valley Conservation Authority.

During his years of study at Montreal's McGill University, McKenzie, though small in stature, was the collegiate gymnastic champion, as well as a football player and high jump champion. After his graduation, he became medical director of physical education at McGill, and shortly afterwards went on to the University of Pennsylvania, where he held the Chair of Physical Education. At this period, and for the rest of his life, McKenzie continued to pursue sculpture, both as a creative art and as a means of advancing public interest in physical activity. In 1912, he joined these interests, art and sport, in his sculpture *Joy of Effort*, which was commissioned for the Stockholm Stadium during the 1912 Olympics in Sweden. It was thus ideally fitting that the first holder of the R. Tait McKenzie Chair should be an artist portraying Olympic sports — and one who, by chance, also owned a mill-home.

For the Chair, Danby chose to portray the following six Olympic sports: rowing, platform diving, sprinting, gymnastics, high jumping and cycling. Each of these was portrayed in a large watercolour measuring twenty-two by twenty-six inches. Many of the initial studies for these were made in Mexico, at the Pan-American Games, in October 1975. The entire collection of paintings, plus preliminary studies, was later purchased by the National Sport and Recreation Centre for exhibition throughout Canada, after being previewed at Toronto's Gallery Moos from March 11th to 24th, 1976.

The largest single exhibition of Danby's work was mounted in late 1975 by the Kitchener-Waterloo Art Gallery. The show was a retrospective covering the previous ten

*The Sunbather*; 1972 Egg Tempera 22 x 32; Private Collection, Toronto, Ontario

*Through Fergus*; 1972 Egg Tempera 20 x 30; Mrs. L. Chesler, Toronto, Ontario

years of creative activity, and opened on December 5th, 1975, prior to a nine-month tour of public galleries throughout Ontario.

The large retrospective wound up its tour on September 18th, 1975, when it opened in Danby's home town of Sault Ste. Marie. It proved an auspicious homecoming for one of the city's favourite native sons. The exhibition, shown at the Sault Ste. Marie main library, was the outstanding feature of the city's annual Algoma Fall Festival. It contained thirty-five temperas, watercolours and prints, and included such outstanding works as *Pancho, Delicious, The Red Wagon* and *The Sun Bather*. A place of honour was reserved for one of the artist's most recent paintings, commissioned by the municipality of Sault Ste. Marie, *Opening the Gates,* a depiction of the Great Lakes vessel, Yankcanuck, passing through the Soo Locks. The preparatory stages for *Opening the Gates* were among the most demanding for any of Danby's paintings. Many detailed studies of both the vessel and the locks were made before the final composition was painted. All of that effort was rewarded by the warm reception given the picture by local audiences. Danby himself was delighted by the welcome he received on his triumphal return to his birthplace. No previous exhibition had given him as much personal satisfaction.

Danby had achieved much during the relatively few years since his birth in Sault Ste. Marie. At the age of 35, after only twelve years of tempera painting, he had become a master of his medium. (During this time he produced more than 140 temperas and innumerable watercolours.) This remarkable achievement at such a young age was the result of the simplest of old-fashioned creative virtues and manifest proof of Thomas Edison's adage: "Genius is one percent inspiration and ninety-nine percent perspiration." From his earliest years in art Danby possessed the dedication, ambition, discipline and diligence required of almost any truly successful artist. Those factors, combined with his rich native talents, enabled him to find his own direction in art at an early age. The forceful realist drawings done in his teens already pointed to the way his abilities were to grow. His personal creative needs could not be met by formal training, and the basis for all of his main achievements has been self-instruction. At his Armstrong Mill home, with the warm support of his wife and the company and welcome distractions of his three sons Sean, Ryan (born December 12, 1970) and Noah (born April 24, 1974), Ken Danby is continuing to carve a special niche in the annals of his country's art. As a human being and as an artist, he is very much his own man.

In June, 1974, Danby won a competition to design the third set of special Olympic coins to be issued by the Royal Canadian Mint in honour of the Olympiad to be held at Montreal in 1976. The conditions for the design competition specified: "The designs on these coins must depict early Canadian sports that have a clear identification with the Summer Olympic Games. For instance, lacrosse would be acceptable, whereas skiing would not."

Danby chose to portray lacrosse and bicycling as earthbound sports on the two $10.00 coins, while the water activites of rowing and canoeing appear on the two $5.00 coins. These winning designs, released in late 1974, are among the most beautiful coins to be minted in Canada.

The care with which the artist chose and prepared his themes is illustrated in the explanatory text which accompanied his official design presentation:

"There are two *individual* activities (rowing and canoeing) and two *group* activities (lacrosse and bicycling).

"The importance of the Indian's role in our sport history is indicated by two designs, lacrosse and canoeing, and the historical aspect is easily seen. The historical aspect of rowing and bicycling is also indicated in their designs. The style of rowing shell frame, and the oarsman's hair and mustache suggest an earlier era. Of course, in the bicycling design, the penny farthing style of machine immediately depicts the early days of this sport.

"Lacrosse and canoeing have a very clear identification with Canada. Naturally, as lacrosse was legislated to be Canada's national sport, and originated in Canada, it deserves inclusion. This highly competitive sport was invented by the Indians. The canoe has played a vital role in Canada's early history and has always been a popular activity. It is historically synonymous with the Indian as well.

"Rowing and bicycling, while not as easily related to Canada as lacrosse and canoeing, are both activities which have been extremely popular in this country. Canada's oarsmen have been world champions in this sport. The first world champion of anything was Ned Hanlan, the great Canadian sculler. Rowing has a great Canadian heritage and is included for that reason.

" 'In no country was rowing more popular or more advanced than in Canada. From the year of Confederation until the turn of the century, it was the nation's major sport' (from *Great Canadian Sports Stories*, The Canadian Centennial Library).

156 "Bicycling has since its inception been an activity which has been a very popular Canadian sport: 'The Canadian Wheelmen appears to have been the first cycling club on the North American continent' (from *The New Encyclopedia of Sports* by F. G. Menke). 'The cycling pioneers, one must remember, used the high-wheeled bicycle—the only kind in existence' (from *Sports and Games in Canadian Life, 1700 to the Present,* by Howell and Howell).

"Bicycling was also extremely popular in most major centres across Canada: 'An early interest in cycling was also evident in Manitoba and the Northwest Territories. The city of Winnipeg boasted many cyclists' (from *Sports and Games in Canadian Life*). (Regina and British Columbia are also mentioned as avid areas of cycling.) Bicycling, therefore, is certainly an activity which represents a broad *geographic* representation of Canada, in early sport."

*Trillium*; 1972 Egg Tempera 14 x 20; Mr. and Mrs. W. Julian, Palgrave, Ontario

*Preliminary Sketches for Series III, Olympic Coins*; 1974 Mixed Media 7¹/₈ dia.

# Serigraphs

Along with his exhausting production of egg temperas, watercolours and drawings, Ken Danby has been engaged in an ambitious print-making programme since 1965 when his first lithograph, *Boy on Fence,* was published. Since then he has issued eleven other black and white lithos. In 1970 he published the first of his now famous serigraphs (or silk-screen) prints, *The Wagon.* Altogether, until the middle of 1974, Danby has created fourteen of these complex and unique editions, ranging from seven colours per print to twenty-nine. Danby's serigraphs are considered by many to be the most ambitious fine art serigraphs ever published. They have won him international acclaim at exhibitions around the world and are represented in the print cabinets of many of the world's leading museums, including the Museum of Modern Art, New York, and the Art Institute of Chicago. Each new edition of his prints is divided between Canada, the United States, and Europe, and is rapidly sold out.

Technically, Danby has turned the medium of the serigraph print into one as complex and original as any of his tempera paintings. Some of the complexity of his technique may be gathered from the following explanations of his process prepared by the artist to accompany an exhibition mounted by the Visual Arts Bank of Canada.

"Artists, by their nature, are constantly searching for and exploring various mediums and techniques, in hope of finding one that responds to their particular needs. This is especially prevalent today when we continually witness the use of such materials as plastics, resins and synthetics as mediums of the modern artist.

"Although I enjoy the graphic quality of lithography, as in a drawing, I wanted something that would take me further into multicolour work, with as much versatility as is possible in an actual painting. In 1966, after a considerable amount of study and experimentation, I concluded that the only graphic medium suitable for this purpose was the silk-screen process. I decided that by incorporating this process with the procedure of my egg tempera painting, I could produce a full colour image to whatever degree I preferred. It would be possible to create a full colour print which would possess the qualities of a quick sketch, or it could be controlled as carefully as an egg tempera painting, and taken to whatever degree of completion was felt necessary.

"During the next four years, I made many inquiries of experienced silk-screen craftsmen and suppliers regarding the various techniques involved, and found a general agreement that what I wanted to do was possible, although it had not been done before.

"Finally, in 1970, I acquired the necessary materials and equipment to test my theory, and completed my first full colour serigraph.

"Since that time, through experience, I have been able to refine and expand the degree of scope attainable by allowing each stage in the metamorphosis to follow more closely the procedure of painting. However, this does not mean that a definite formula is arrived at. In fact, no two images or editions will follow the same procedure exactly. What takes effect is simply the continual assessment of the individual stages as in painting. A certain direction is pursued in order to complement or alter the previous direction in relation to basic elements of painting, e.g. colour, dimension, composition, and so on.

"The following is a basic outline of the technical procedure involved:

"The first stage is a black ink brush drawing, which determines the placement and composition of the subject, as well as a general description of tone. This drawing, and each of the succeeding drawings, is done on clear acetate, using a watercolour brush and, at times, a pen, or a litho pencil.

"In order to make the screen stencil, this drawing must be done in an opaque ink. A screen is prepared, by cleaning, washing, and taping the outer edges, and then is dried. At this point, a light-sensitive emulsion is mixed and the screen is given a thin coating of this emulsion, on both sides. This naturally must be done in a 'dark room.' When the emulsion is dry, the acetate drawing is placed on the coated screen and carefully taped in position.

"Still kept in soft light conditions, the coated screen and attached drawing are then placed in a vacuum table, under glass. The vacuum table is activated and removes all air from around the screen. This procedure forces the drawing into an even contact on the screen, eliminating any spaces between the acetate and the screen. Allowing the vacuum table to continue operating, a strong 'arc lamp' light is then placed in line with the glass of the table and positioned at a predetermined distance from it. The light is then turned on for approximately three minutes (relative to the distance). This light strikes all areas of the emulsion-coated screen, except those areas which are protected by the opaque ink. When the emulsion is exposed to strong light, it hardens, while the areas covered by the ink remain soft.

"Following this exposure to light, the screen and drawing are removed from the table, and the drawing is taken from the screen and set aside. The screen is then quickly sprayed and washed down with warm water (110 degrees) on both sides. This action loosens and dislodges all soft areas of emulsion (those areas protected by the drawing), and opens the mesh of the screen in those areas. When this has been done, the resulting screen has become a stencil of the drawing.

"This screen is carefully dried, and then retouched, by applying a glue 'blockout'

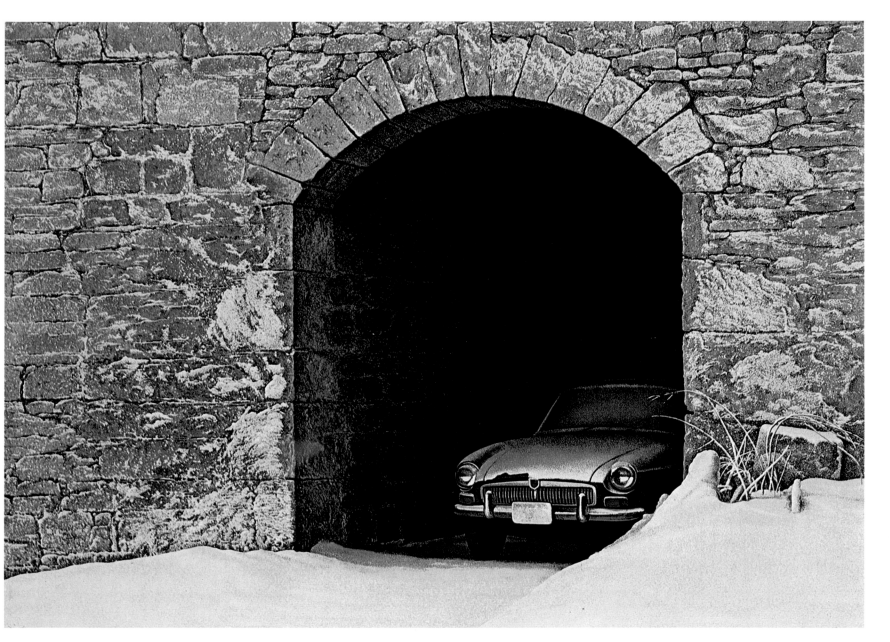

*Under the Arch*; 1972 Colour Serigraph 18 x 24, 17 Colours; Edition of 100

162    solution to all areas of open mesh which are not intended to remain. (Dust specks, for example, can create pinhole openings in areas where not desired.) The screen is now ready for placement on the printing table. It is positioned and locked into a hinge arrangement, which allows it to be raised and lowered.

"At this point, the ink must be mixed. For the first stage, black is used, and although not critical, its consistency is still controlled. The ink is poured, in manageable amounts, onto the screen, and the actual printing is begun. The ink is forced through the mesh openings by pulling a rubber squeegee across the screen, thereby placing the ink onto the paper beneath it. After each pull, the screen is raised, and the proof removed and replaced by another sheet. This procedure continues until all proofs are printed. The wet prints are placed on racks for drying.

"Anticipating a completed edition of 100 final prints, the print is initiated by printing approximately 500 proofs. Throughout each stage many proofs are lost, due to colour testing and registration changes.

"Following the completion of this first printing (almost always a black), a proof is selected and placed on the drawing table. A second sheet of acetate is then placed over this proof. At this time, a second colour is decided upon, mentally. This colour must be carefully considered, as to how it will alter and cover the preceding colour beneath it, and to what extent this is desired. Once this colour is *envisioned* in this regard, the drawing is made on the acetate, in opaque black ink. By using acetate, I am able to see the proof through it, and am able to place the ink directly on it, according to the effect desired. However this acetate drawing must be corrected for total opaqueness of ink upon completion, by removing the proof beneath it and retouching.

"Regardless of what colour the drawing may represent in the printed state, the drawing itself must be done in opaque ink. It must constantly be remembered while drawing that each brush stroke in black ink will represent the next colour, even if the next colour is a soft white, or transparent glaze, or whatever. Consequently, one of the most important aspects is the ability to analyze the effects of the intended colour, mentally, while creating the drawing in black.

"A screen is then made from this second drawing, following all stages previously mentioned. When the screen is placed on the printing table, the colour envisioned for this stage must be mixed. It must be mixed to the desired translucency and strength of colour, and can only be done by testing and changing. Proofs are pulled and the changes are made until the colour is found. At the same time, this second colour must be placed in the exact

position, or 'registration' with the first colour. This also requires testing, by actually printing, or 'proofing,' and moving the screen until the correct registration is found. Finally, when the position of the screen is secured, and the correct colour of ink is realized, the remaining quantity of prints are all individually printed.

"Each 'proof' (or sheet of paper) must be placed in exactly the same position under the screen, so that when the screen is lowered and the squeegee pulled across, the ink will be placed in the correct registration consistently. This is accomplished by utilizing registration guides (small strips of card), secured to the printing table. Each sheet of paper is placed against these strips, and carefully held in this position.

"Finally, when all proofs are taken through the second printing and are placed in the racks, the screen is then removed and cleaned for further use.

"A proof is then selected from this stage and is placed on the drawing table. The third colour is then considered, by assessing the results of the second stage, and an acetate drawing is then begun for the third colour—again keeping in mind the changes desired and how they can be achieved.

"This can only be determined by assessing the preceding colour stage, and envisioning the colour desired to follow. Therefore the number of colour stages required cannot be predetermined. In order to decide what the eighth colour will be, I must see the results of the seventh. The print grows and is altered, stage by stage, each time following this procedure, and by taking all proofs through the change.

"There is a separate drawing and screen prepared for each colour.

"All steps are repeated with each stage, and all proofs are printed in each stage, until the print is considered to be complete. Following approximately twenty or so stages, the initial quantity of 500 proofs will have diminished, through testing, to approximately 150. The remaining 150 or so are then carefully edited, and any imperfect prints are set aside to be destroyed. The final prints, being the best quality possible, are individually signed and numbered, and represent the completed edition. The acetate drawings are then destroyed, and the screens (stencils) reclaimed and cleaned for future use by dissolving the emulsion with a powerful solvent. At this point the completed edition can never be duplicated, and is indeed 'limited.' It is then impossible to recreate the resulting image.

"The technique is a creative rather than a reproductive one. There is no original which is being reproduced. The print is taken through stages of assessment and change, very similar to those stages which a painting undergoes. Consideration is given to composition, colour, light, texture, and dimensional characteristics in an identical procedure as

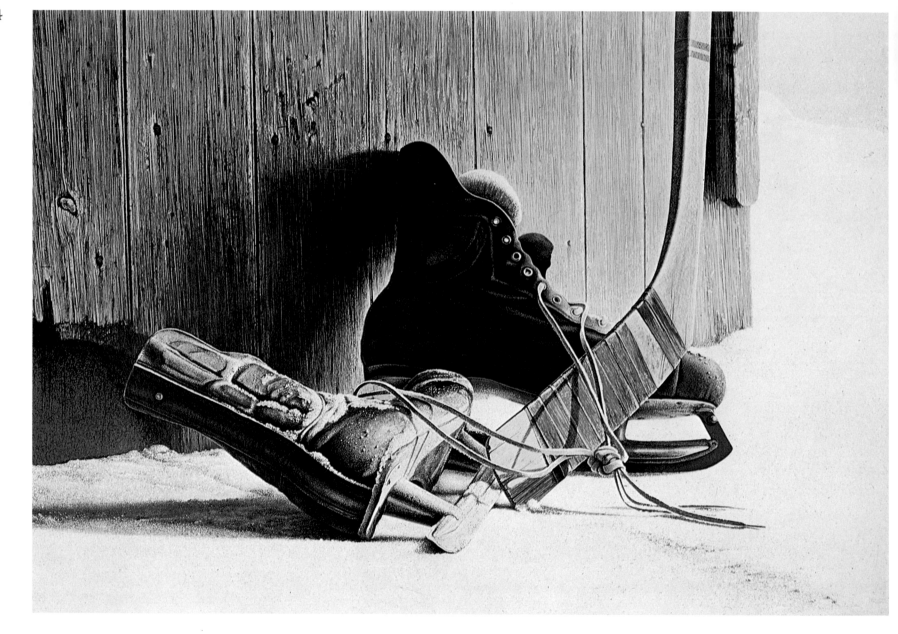

*The Skates*; 1972 Colour Serigraph 18 x 24, 22 Colours; Edition of 100

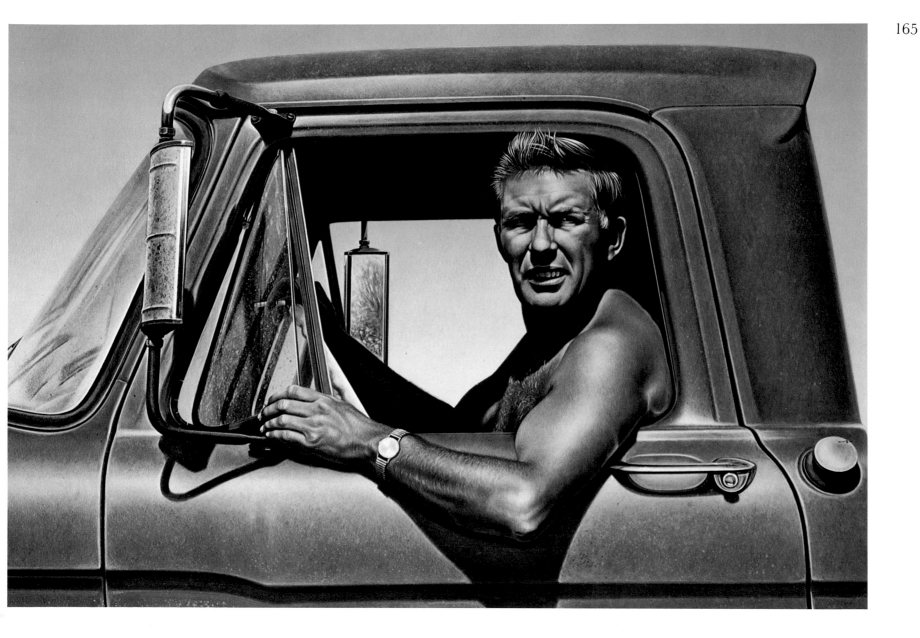

*Summer Driver*; 1973 Egg Tempera 24 x 36; Mr. J.H. Clark, North Bay, Ontario

166 painting (in egg tempera). Of course in a painting these changes may be very quickly interchanged and repeated. The very nature of the serigraph's time-consuming preparatory mechanics forces one to consider the next step much more carefully. However, the metamorphosis is the same.

"It is a very time-consuming process. Some drawings require a week or more of continuous work. It is also a technically difficult process, made easier by my experience in egg tempera. By following the basic considerations employed in egg tempera painting each stage can be assessed as to its requirements.

"In summary, the technique is an intuitive and creative one, combining silk-screen mechanics and tempera procedures of painting. There is really no limit to the extent that the print may be taken, as in a painting. I take pride in the fact that this is an innovative technique, which I am told no other artist in the world is using to this extent. On the other hand, I regret that the complexity of it has caused people to misinterpret the result, thinking that photography or reproduction of an existing painting is involved, when it is not."

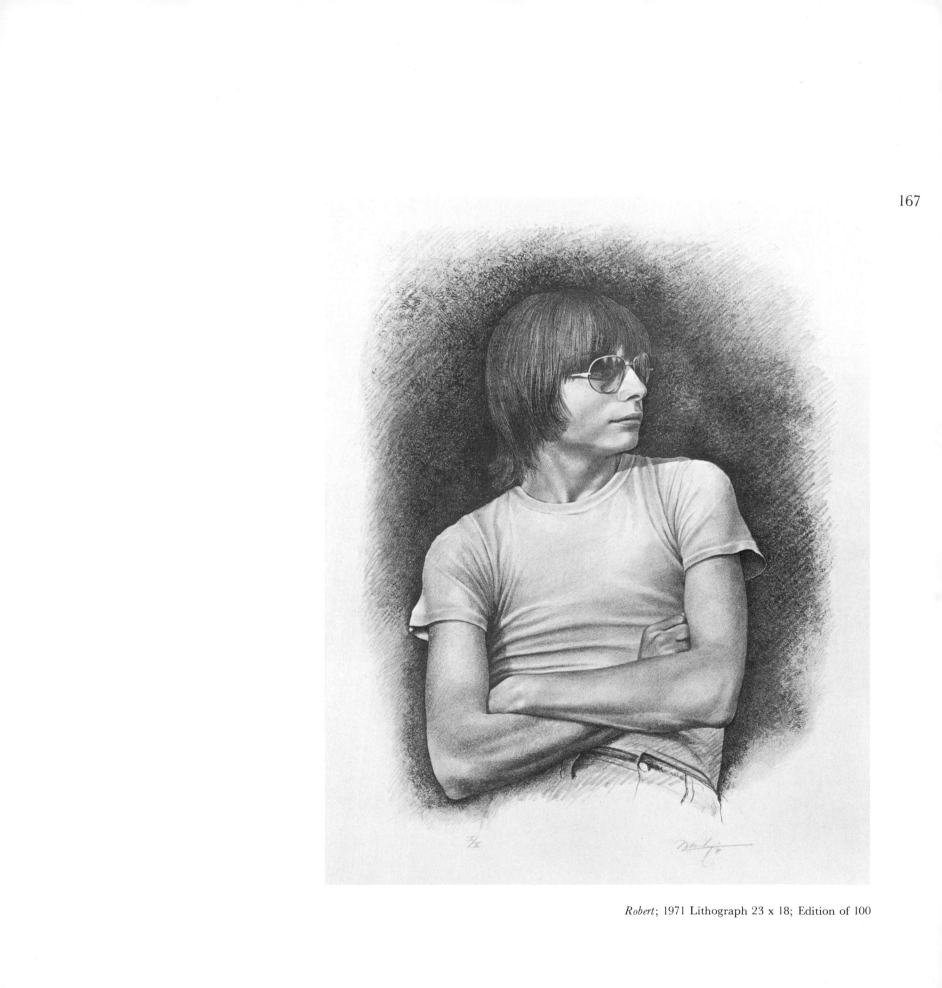

*Robert*; 1971 Lithograph 23 x 18; Edition of 100

# The Artist's Studio

Ken Danby works in a small studio building located a few hundred feet from his home at Armstrong Mill. Built on the limestone foundation of an old barn, the studio consists of two large rooms—one for drawing and painting and a second for print-making. Daylight in the painting studio enters mainly through a large northwest studio window, with draw curtains to control the amount of illumination. This workshop is simply furnished with an easel, an old roll top desk, two draughting tables, a couple of enamelled work tables, a few swivel chairs, storage cupboards, a sink, a small refrigerator and an antique cast iron stove which still sees use. While working, Danby often listens to a radio. Attached to the walls of the studio are proofs of a number of his serigraphs, a few reproductions of paintings and snapshots of his family. The walls are of wood panel and the wooden floor is bare. Pictures are stored in wall racks.

In the studio are Danby's various painting materials. On one enamel table are the paints, brushes and he small china nesting dishes he uses for palettes. The powdered dry pigments of his tempera paints are imported from the United States and stored in small jars. Once mixed with the egg, the colours can be placed in the refrigerator where the mixture will remain fresh for a week. Only distilled water is used to thin this egg tempera medium. For watercolours, the artist prefers tube colours from Winsor and Newton. He uses sable brushes exclusively and they are stored in ceramic marmalade jars.

Danby's palette of colours has remained basically unchanged since he began painting in egg tempera — titanium white, cadmium yellow medium, yellow ochre, raw sienna, burnt sienna (rarely used), raw umber, burnt umber, vermilion red medium, alizarin crimson, permanent green, Prussian blue and ivory black.

Danby's masonite panels for egg tempera painting are prepared in a separate room below his studio. Both sides of these panels receive five to seven coats of a gesso made from pure whiting, French sheet gelatine and Tetanox (an additive to heighten whiteness). Each gesso coating is added while the previous one is still damp, to ensure a strong bond. After gessoing, the dry panel is sanded with varying degrees of sandpaper, till every surface blemish is removed. After a final polishing with a very fine paper, the panel is delicately finished with a dampened ball of fine linen until the resulting surface has a marble-like smoothness. It is then ready for use.

To realize his remarkable achievements in egg tempera, watercolour and print-making, Danby averages more than ten hours each day working in his studio.

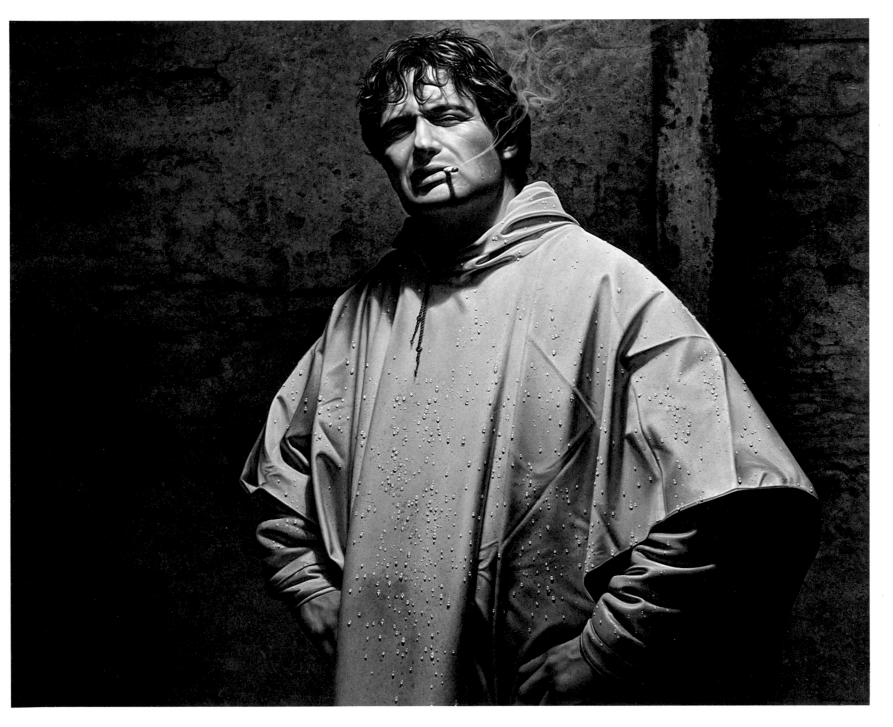

*Pancho*; 1973 Egg Tempera 34 x 42; Mr. and Mrs. Irving Ungerman, Toronto, Ontario

*The Dreamer*; 1972 Lithograph 23 x 18; Edition of 100

## Statements by the Artist

Throughout the history of art, we have witnessed a great metamorphosis taking place, which continues to alter and expand our appreciation of art. A constant exploration into the various elements of the visual world, together with individual interpretation, has always been at the hub of fine art.

As important discoveries and insights have been offered, the posture of the "art community" has been unsettled and then adjusted over a period of time, according to the degree of accommodation necessary. For centuries, a great effort was made to resolve the applications of simple perspective, in drawing and painting. Equally so was the attempt to create form and dimension through the use of strong light and shade: chiaroscuro.

As in most other endeavours over the past century, we have witnessed a tremendous rapidity of change in the visual arts. Artists have forsaken the resolved, in order to explore the unresolved. They have devoted their efforts to examining colour, in all its manifestations. They have explored design, shape, movement, and spatial areas, etc., as individual entities and as correlated forces. They have set aside all relationships to the literal and the natural, in order to investigate the totally abstract. They have parodied the norm in order to enlighten our perception. As a result, we now have a vast amount of information and insight into the visual world, and the artist today is in a far better position to communicate visually, than ever. Numerous individual elements of art, previously unexplored, have now been intimately assessed for their own characteristics and offer the artist information with which to create and communicate in a more knowledgeable and meaningful manner.

Unfortunately, as change takes place, and as new avenues of innovation are presented, the "art community" usually responds by forsaking the more traditional art forms and embracing only the most recent and radical. The artist today is encouraged to innovate, rather than communicate. (It seems to be an idiosyncrasy of "change" that we do not change by preferring one thing over another, but do so by rejecting one thing for another.)

While acknowledging that continued experimentation is essential, I also feel that it is time to integrate that which we have learned, in a cohesive and constructive manner. The individual entities of art: colour, shape, light, dimension, texture and so on, are but pieces of the whole. Rather than continue the procedure of assessing these elements separately, I prefer to utilize their particular assets collectively, in creating a complete statement — a total integration of all I have learned and am learning. Only in this way can I hope to communicate successfully, and be satisfied with the results.

My subject matter encompasses all that interests me, both visually and emotionally.

*Lacing Up*; 1973 Egg Tempera 22 x 32; Mr. John F. Bassett, Don Mills, Ontario

*First Edition*; 1973 Egg Tempera 20 x 30; Private Collection, Edmonton, Alberta

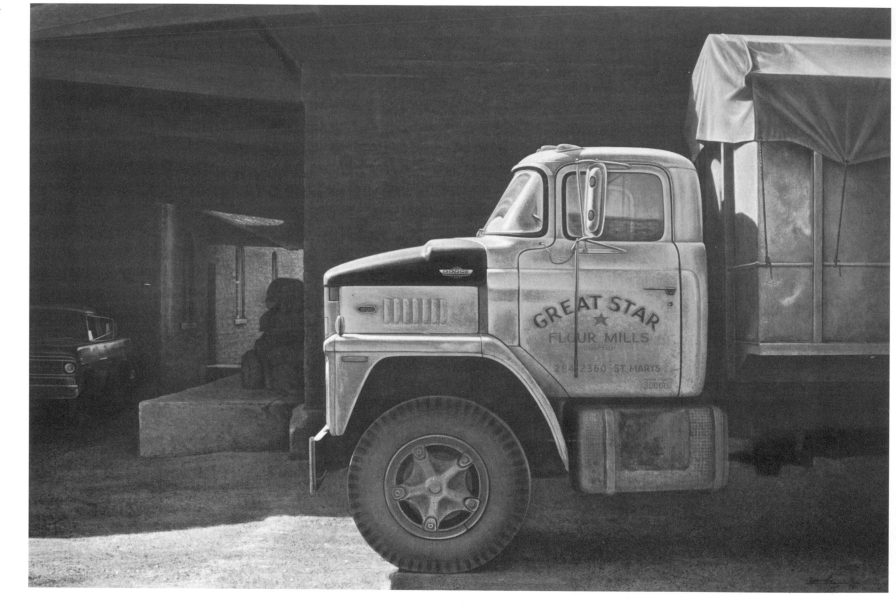

*Great Star*; 1974 Egg Tempera 22 x 32; Mr. and Mrs. J.S. Redpath, North Bay, Ontario

As with anyone's motivations, my interests stem from my experiences, both past and present. Of course, as these interests vary and expand my work will reflect this.

I am not concerned with fashion, or with exhibiting something radically new and different, for the sake of being different. It seems that in the art world we have an annual scramble to see who is the most radical.

Some artists are more preoccupied with showbusiness than with art. They tend to do one thing one year, and then frantically jump to another thing the next. We now have "seasons" for art, when galleries exhibit the "new look." We have "pseudo-critics," who, armed with their coffee-table volumes on art, manoeuvre themselves into the media and suddenly become "experts."

Consequently, an artificiality has surfaced which does nothing but expand the credibility gap that exists between art and the public. An artist's work should mature and grow, and not be concerned with change for the sake of change.

While I acknowledge that my work is considered to be relevant to the various "realisms," I am not consciously attempting to work within any school of art, nor any particular genre of painting, be it termed "magic realism," "high realism," "super realism," or whatever.

To my mind, to intentionally work within the confines of a specific style of art necessitates the conscious suppression of some visual elements, which is not my desire. I'm simply trying to create better paintings, by utilizing all of the knowledge at my disposal.

I have always considered drawing, that is, the ability to draw well, to be the most basic and most important technical asset of an artist. Good drawing is the essential element from which everything else can be structured. It is the keystone.

While it is fundamental that an artist must have imagination and creative thought, he or she must also develop a proficiency with the tools and the craft, so that the mind will have the necessary freedom and confidence.

The ability to draw well enables one to make a visual statement with complete confidence. A casual mental suggestion then becomes sufficient in directing the hand, and allows the mind to concentrate on the overall effort.

I do not equate the ability to draw with the ability to create, but I do feel that it is the most important asset.

Egg tempera is a medium which demands a confirmed approach, in order to take full advantage of its vast potential. Yet there is a danger with tempera in that it can become too predetermined, too methodical, and consequently rather boring, or lifeless. It can lose

that "zip," if one attempts to resolve everything in advance. It is a tremendously flexible medium and to my mind is the most versatile, even today, in this "acrylic world."

Once I begin a painting, I prefer to respond to it, rather than force it in one direction. I have to get into it, wrestle with it, and become part of it. I've done things that, in retrospect, are not as strong as I would now like them to be. I think this can happen when I don't jump in with both feet.

I am continually amazed at how my enthusiasm for work increases. While I can become physically exhausted from painting for days on end, my mind remains involved with the problems within the painting, or simply refuses to allow the excitement for it to diminish. Occasionally I have found that I am mentally irritated at my body's demand for rest, and it may be hours before my mind will allow sleep.

I am very conscious of time, and how extremely precious it is. The necessity of utilizing it to the fullest is something that constantly concerns me. It is disconcerting for me to realize that I will always have more in my mind that I would like to do, than I will ever be able to accomplish in my lifetime.

Painting, and creating in general, is a selfish endeavour. When I am painting, I must be alone. It is an unfortunate but necessary part of the occupation. I need to have total privacy in order to come to grips with my work. This, combined with the fact that a considerable amount of time is required, necessitates long and sustained periods in the studio.

Simultaneously, this imposes an unrealistic schedule upon my wife and family. It is difficult to rationalize and, at times, to justify, yet we manage to thrive. This is possible only because of my wife's extraordinary support and assistance. Judy copes with great effectiveness, and continually instills an exuberance and harmony into our lives that is an inspiration. Her understanding of my moods and her acceptance of my idiosyncracies are tremendous assets that contribute to everything I have done and will do.

Our sons, Sean, Ryan, and Noah, are a great source of pride for both Judy and myself, and fulfil all our hopes and aspirations. We need look no further than to our children to find total joy and contentment.

*The Visitor*; 1975 Egg Tempera 32 x 24; Mr. L.M. Bell, Saint John, New Brunswick

*Sunning*; 1974 Colour Serigraph 25 x 34, 29 Colours; Edition of 100

*Leather Hat*; 1974 Egg Tempera 28 x 40; Mr. and Mrs. Irving Ungerman, Toronto, Ontario

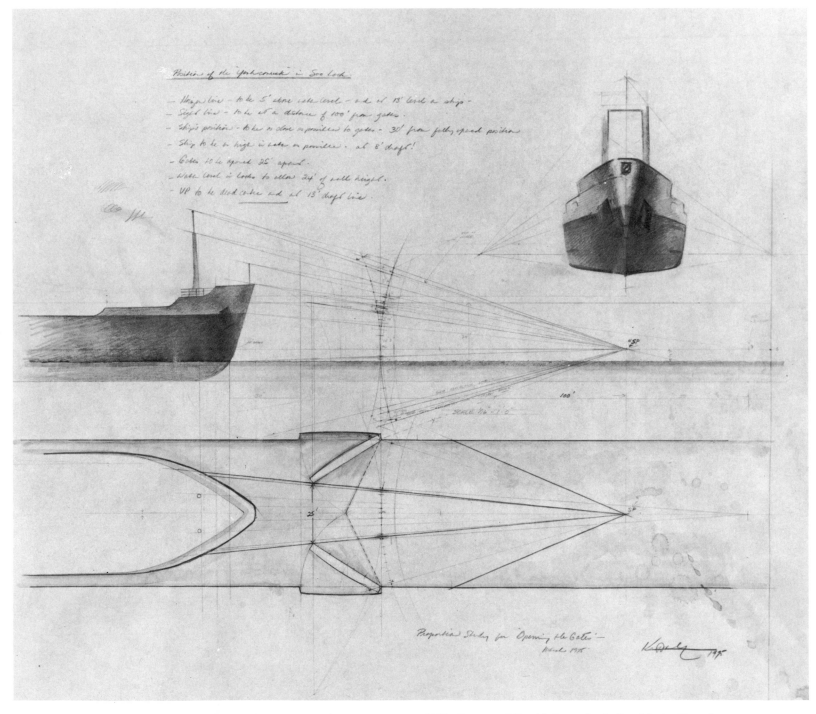

*Preparatory Scale Drawing for Opening the Gates*; 1975 Pencil and Watercolour 18 x 20¹/₂; Susan and David Gray, Sault Ste. Marie, Ontario

*Opening the Gates*; 1975 Egg Tempera 28 x 38¹/₂; The Corporation of the City of Sault Ste. Marie, Ontario

*Carousel*; 1975 Watercolour 21 x 27; Mr. Gordon Lightfoot, Toronto, Ontario

## Exhibitions: 1964 to 1976

*One Man Exhibitions*

Gallery Moos, Toronto, Canada 1964, 1965, 1966, 1967, 1968,
    1969, 1970, 1971, 1972, 1974, 1975, 1976

Galerie Godard Lefort, Montreal, Canada 1966

Cologne Kunstmarkt, Cologne, Germany 1969

William Zierler Gallery, New York, U.S.A. 1972, 1973

Images Gallery, Toledo, Ohio, U.S.A. 1972

Nancy Poole Gallery, London, Ontario, Canada 1972

Galerie Allen, Vancouver, Canada 1973

Fleet Gallery, Winnipeg, Manitoba, Canada 1973

Galerie Moos, Montreal, Canada 1974

Wallack Gallery, Ottawa, Canada 1974

Ken Danby Touring Exhibition, Canada 1974 –75;
    Kitchener-Waterloo Art Gallery
    London Art Gallery
    Brantford Arts Place
    Rodman Hall, St. Catharines
    Art Gallery of Hamilton
    Windsor Art Gallery
    Sarnia Art Gallery

Damkjar-Burton Gallery, Hamilton, Ontario 1975

Algoma Arts Festival, Sault Ste. Marie, Ontario 1975

Retrospective Exhibition circulated through Southern Ontario
    Galleries 1974 – 75

*Group Exhibitions*

Four Seasons Exhibition, Toronto, Canada 1962

Spring Exhibition, Museum of Fine Arts, Montreal, Canada 1964

Jessie Dow Award for Best Painting, Montreal, Canada 1964

Exhibition of Drawings and Watercolours, National Gallery of
    Canada, Ottawa, Canada 1964

24th Western Ontario Exhibition, London, Ontario, Canada 1964

Canadian Prints and Drawings Exhibition,
    Cardiff Festival, Wales 1965

Award for Drawing, Hadassah Exhibition, Toronto, Canada 1965

New Trends in Canadian Painting, Queen's University, Kingston,
    Ontario, Canada 1965

Magic Realism in Canadian Art, London Art Gallery, London,
    Ontario, Canada 1966

C.I.L. Collection Exhibition, O'Keefe Centre, Toronto, Canada 1966

Spring Exhibition, Museum of Fine Arts, Montreal, Canada 1967

Magic Realism in Canada Exhibition, University of Guelph,
    Ontario, Canada 1969

20th Annual Exhibition of Contemporary Canadian Art, Art Gallery
    of Hamilton, Ontario, Canada 1969

3rd International Drawings and Watercolours Exhibition,
    Darmstadt, Germany 1970

Group Exhibition, Cologne Kunstmarkt, Germany 1970

Canadian Print Exhibition, Carleton University,
    Ottawa, Canada 1970

Survey 70 – Realisms, Art Gallery of Ontario, Toronto, and
    Museum of Fine Arts, Montreal, Canada 1970

Biennale des Jeunes, Paris, France 1971

1st International Graphics Mart, Zurich, Switzerland 1971

Man and His World Exhibition, Montreal, Canada 1971

Silk Screen – History of a Medium Exhibition, Philadelphia
    Museum of Art, U.S.A. 1972

3rd British International Print Biennale, Bradford, England 1972

American Realists Exhibition, Galerie des 4 Mouvements,
    Paris, France 1972

2nd American Biennial of Graphic Arts, Cali, Colombia 1973

6th International Triennial of Coloured Graphic Prints,
    Grenchen, Switzerland 1973

Canadian Cultural Centre, Paris, France 1974

Canadian Embassy, Brussels, Belgium 1974

Canada House Gallery, London, England 1974

Canadian Consulate, New York, U.S.A. 1974

Owens Art Gallery, Mount Allison University, Sackville,
    New Brunswick, Canada 1974

Oklahoma City Art Center, Oklahoma, U.S.A. 1974

Selections in Contemporary Realism, Akron Art Institute,
    Ohio, U.S.A. 1974

3rd American Biennial of Graphic Arts, Cali, Colombia, 1976

Washart '76, International Art Fair, Washington, D.C.

Aspects of Realism, Stratford, Ontario, travelling throughout Canada
    1976 –1978

*Parked*; 1973 Watercolour 21 x 27; Private Collection, New York, N.Y.

## Public Collections

The National Gallery of Canada, Ottawa, Canada
The Museum of Modern Art, New York, U.S.A.
The Montreal Museum of Fine Arts, Montreal, Canada
Saskatoon Art Centre, Saskatoon, Canada
The Art Gallery of Vancouver, Vancouver, Canada
C.I.L. Collection, Montreal, Canada
Power Corporation of Canada Ltd., Montreal, Canada
Mendel Art Gallery, Saskatoon, Canada
The Toronto-Dominion Bank, Toronto, Canada
United States Steel Company, New York, U.S.A.
Indianapolis Museum of Fine Arts, Indiana, U.S.A.
White-Weld & Company, New York, U.S.A.
Pittsburgh National Bank, Pennsylvania, U.S.A.
Art Gallery, University of California, Berkeley, California, U.S.A.
Achenbach Foundation, Palo Alto, California, U.S.A.
Norman McKenzie Art Gallery, Regina, Canada
Rothmans Art Gallery, Stratford, Canada
Bradford City Art Gallery and Museum, Bradford, England
University of Guelph, Guelph, Canada
The Art Gallery of Hamilton, Canada
The Art Institute of Chicago, U.S.A.
Visual Arts Bank, The Canada Council of Canada, Ottawa
National Sport and Recreation Centre, Ottawa, Canada
American National Insurance Company, Galveston, Texas, U.S.A.

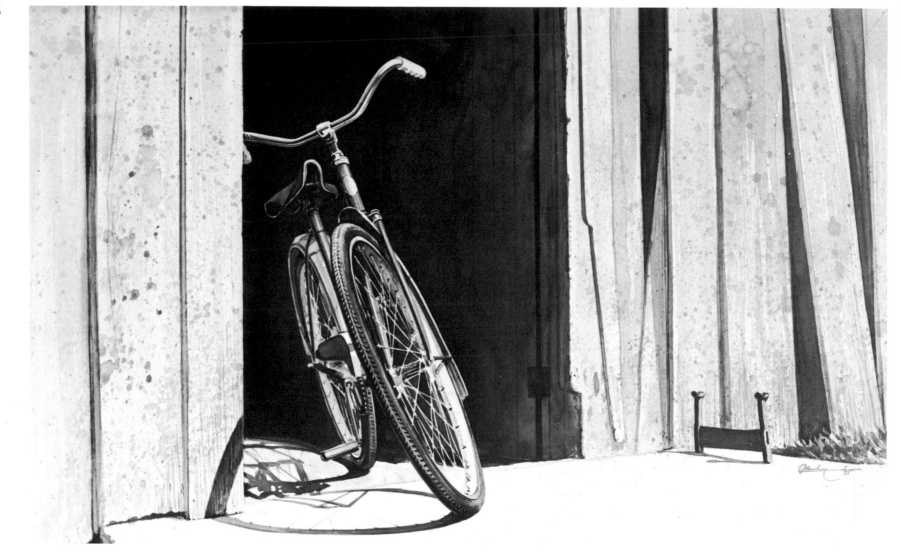

*The Bicycle*; 1975 Watercolour 13¹/₂ x 21¹/₂; Mr. and Mrs. D. Goodman, Toronto, Ontario

# Index

Italic numerals signify pages containing reproductions of Danby works. Roman numerals refer to Paul Duval's text.

192    *This book was filmset in 12 pt. Baskerville;*
*colour separations are by Herzig-Somerville Limited.*
*It was printed on 200M Imperial Offset Enamel*
*by Sampson Matthews Limited*
*and bound by T.H. Best Printing Company Limited.*